The Darkroom Handbook

A Complete Guide to the Best Design, Construction, and Equipment

Dennis Curtin and Joe DeMaio

Curtin & London, Inc. Somerville, Massachusetts

Van Nostrand Reinhold Company New York Cincinnati Toronto Melbourne

Published in 1979 by Curtin & London, Inc.
and Van Nostrand Reinhold Company
A division of Litton Educational Publishing, Inc.
135 West 50th Street, New York, NY 10020, U.S.A.

Van Nostrand Reinhold Limited
1410 Birchmount Road
Scarborough, Ontario M1P 2E7, Canada

Van Nostrand Reinhold Australia Pty. Ltd.
17 Queen Street
Mitcham, Victoria 3132, Australia

Cover design: Karyl Klopp

Interior design: Nancy Benjamin

Cover photograph: Neal Slavin

Illustrations: Laszlo Meszoly

Although the information in this book is based on industry sources and is as
nearly complete as possible at the time of publication, the possibility exists that
the manufacturers have made changes that are not included here. Although
striving for accuracy, the Publishers cannot assume responsibility for any
changes, errors, or omissions leading to problems you may encounter. The
Publishers recommend that you confirm all electrical and plumbing work with
your local building authority to ensure that its installation meets local codes.

10 9 8 7 6 5 4

Library Of Congress Cataloging in Publication Data

Curtin, Dennis
 The darkroom handbook.

 Includes index.

I. DeMaio, Joe, joint author. II. Title.
TR560.C87 1979b 771'.1 78-24163
ISBN 0-930764-06-4
 0-930764-08-0

 1. Photography—Studios and darkrooms

Preface

In the past few years there has been a phenomenal growth in the number of people with a serious interest in photography. More and more people are taking, and making prints of, their own photographs. Interest in color photography has also grown rapidly. Many serious photographers realize that the only way to make fine prints is to do it themselves. The negative or slide is only the first step in turning an idea into a print that conveys that idea effectively. The machine processing available from commercial sources is almost always unsatisfactory and custom processing, even if you could convey what you want the print to look like exactly, is generally too expensive. The best solution is to build one's own darkroom, ensuring that the print you obtain is the one you want.

Building a darkroom can be an intimidating thought. The information on how to do it well is scattered in the literature and the vast majority of it has traditionally been transmitted verbally from one photographer to another. *The Darkroom Handbook* is the first serious attempt to gather together in one source the ideas and techniques that have been developed over the years by trial and error. It is the result of the efforts of thousands of photographers who have overcome the difficulties of locating a darkroom in a bathroom, kitchen, bedroom, or basement of a house or apartment. Almost any problem you might encounter in building a darkroom has been encountered by others and successful solutions have been devised. This book is a compilation of those successful solutions from which you can benefit.

Those interested in building a darkroom are confronted with many problems, ranging from where it should be located, to installing partitions, plumbing, and electricity. This book is a comprehensive treatment of darkroom design and construction. Like most such "first" efforts it is the end result of the trials and tribulations of many people who not only spent long hours and suffered through many mistakes to find the answers but who have also been willing to share that information freely with others.

The authors take the ultimate responsibility for shortcomings, but any appreciation should be directed to those who found the answers and shared them so willingly. The list is long and incomplete, but among others our thanks are extended to:

Harry Callahan, George Tice, Neal Slavin, Naomi Savage, Anthony Hernandez, Aaron Siskind, Berenice Abbott, Jim Stone, Lou Jacobs, Jeanloup Sieff, Steve Hess, Barry Goldberg, Tom Petit, Lista Duren, Robb Smith, Gil Amiaga, Ron Harrod, and Debbie Vander Molen.

In addition the authors would like to extend their gratitude to Leslie Palmer, who typed and retyped the manuscript, and to Nancy Benjamin, who somehow turned the pile of typescript into a coherent whole. Peggy Curtin was responsible for much of the time-consuming research on which the book is based.

We would also like to extend our appreciation to Lee Fischer who typeset the book and also made numerous editorial suggestions which have been incorporated by the authors.

Contents _____

Preface • **iii**
Introduction • **vi**
Darkroom of the 1880s • **viii**

1 Darkrooms of the Professionals • 2

Harry Callahan • **4**
Aaron Siskind • **6**
George Tice • **8**
Jeanloup Sieff • **10**
Naomi Savage • **12**
Neal Slavin • **14**
Berenice Abbott • **16**
Lou Jacobs • **18**
Joe DeMaio • **20**
Bill Shaw • **22**
W. Eugene Smith • **24**

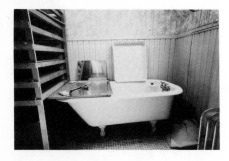

2 Ideas for Placement • 26

Darkrooms in Closets • **28**
Darkrooms in Kitchens • **30**
Darkrooms in Bathrooms • **32**
Darkrooms in Spare Rooms • **34**
Workrooms • **36**

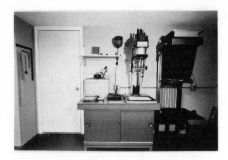

3 Designing the Room • 38

What Are Layouts and Elevations? • **40**
How to Do Layouts • **42**
Planning Grids • **44**
Dry-Side Cutouts • **46**
Wet-Side Cutouts • **48**
Light-Trap Cutouts • **50**
Light-Trap and Drying Rack Cutouts • **52**
Preparing Elevations • **54**

4 Building the Room • 56

Tools • **58**
Installing Partitions • **60**
Hanging Doors • **62**
Installing Sheetrock • **64**
Getting to Know Your Plumbing • **66**
More About Your Plumbing • **68**

Typical Darkroom Plumbing • **70**
Roughing in the Plumbing • **72**
Installing Supply Lines • **74**
Installing the Drain • **76**
The Easy Way Out and Unique Solutions • **78**
A Modular Plumbing System • **80**
Introduction to Electricity • **82**
Electricity in the Darkroom • **84**
Tools and Materials for Electrical Work • **86**
Wiring the Circuits • **88**
Modular Control Panel • **90**

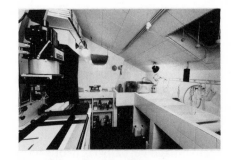

5 Building the Inside • 92

The Lighting Circuits • **94**
Lighting Equipment • **96**
Building a Darkroom Sink • **98**
Building a Sink Stand • **100**
Installing Counters • **102**
Building a Print Drying Rack • **104**
Making the Drying Frames • **106**
Building a Light Box • **108**
Mounting the Enlarger • **110**
Building an Adjustable Enlarger Baseboard • **112**
Air Quality • **114**
Light-proofing • **116**
Those Added Comforts • **118**

6 Processing Equipment • 120

Sinks • **122**
Water Quality • **124**
Temperature Regulation • **126**
Automatic Temperature
 Regulation • **128**
Processing Trays and Tongs
 • **130**
Wet-Side Accessories • **132**
Roll Film Tanks and Reels • **134**
Washers • **136**
Timing Systems • **138**
Chemical Storage • **140**

7 Enlarging Equipment • 142

Enlargers • **144**
Enlargers, Continued • **146**
Enlarging Lenses • **148**
Easels • **150**
Focusing Magnifiers • **152**
Negative Cleaning and
 Dusting • **154**
Printing and Exposure Controls
 • **156**
Negative Storage and Proof
 Printers • **158**

8 The Color Darkroom • 160

Introduction to Color • **162**
Color Enlargers • **164**
Color Analyzers and
 Calculators • **166**
Color Processors • **168**

9 Print Finishing • 170

Dryers • **172**
Mounting • **174**
Matting and Storing Prints
 • **176**
Framing • **178**
Surface Effects • **180**

Index • 182

List of Manufacturers • 184

Introduction to the Darkroom

There is nothing quite so important to photographers as the darkroom they use and the equipment it contains. Ansel Adams once said, in relating photography to music, that "the negative is the score, and the print is the performance." If one expects to make fine prints or fine music some consideration should be given to the environment in which the attempt will be made. In the case of the photograph that environment is the darkroom.

A photograph goes through many phases from the time the shutter is snapped until the final product is hung on the wall to be admired, questioned, debated, or ignored. Although those phases are more a result of the photographer's imagination and wit than they are of particular hardware, equipment is necessary to translate the ideas into a finished print. Not to give as much thought to one's darkroom as one gives to a camera purchase or a given camera image is being shortsighted. Most photographers delight in taking the photograph because in that stage they are in contact with the world and that in itself can be a joy. The darkroom, however, is more demanding in its isolation and labor. Every obstacle to making it pleasant and efficient should be removed. It is the purpose of this book to give ideas and plans both for the darkroom itself and to the equipment it contains. This book uses ideas that have worked successfully for other people and shows how they have built darkrooms that fit their needs, their space, and their budgets. It contains the end results of many photographers' efforts, and allows you to benefit from their mistakes, not your own.

How many of us, when we dream of that ultimate darkroom, have a mental image of wall to wall stainless steel, interrupted periodically only by chrome and optical glass? It's easy to equate the expensive equipment you can buy with the quality of the image you expect, and yet almost without exception there is no direct correlation. Some of the finest images in the history of photography have been produced in darkrooms that would strike terror into the heart of today's most avid photographers. The history of photography is full of tales of photographers such as William Henry Jackson developing 20" x 24" glass negatives in black canvas tents where the temperature hovered well above 100 degrees and the photographer worried about the effect his perspiration would have on the development of the image. Building a well-planned darkroom in the bathroom of a high-rise New York apartment or in the garage of a Dallas ranch house is luxury compared to a black tent staked high on a cliff with the blazing sun making the inside into an oven.

To make a comfortable darkroom that meets your own needs is a challenge and reflects your personality just as your pictures do. Photographers have always expressed their creativity in their equipment and the design of darkrooms has not been an exception. Edward Weston recounts in his "Daybooks":

> With no workrooms as yet, finishing has been a problem: hanging blankets over windows, we have developed in my "ropero"—closet —a hot, sweaty, suffocating job; reminding me of my boyhood days in photography, the improvised workrooms, closets, kitchen sinks, bathtubs pressed into service.
>
> How well I recall one brilliant idea for a darkroom, a hoop around which was sewn a long black bag; this bag, open at the bottom, closed at the top, could be lowered by pulley and cord from the ceiling to cover a table below. In this "darkroom" many a now forgotten masterpiece was developed. But that was fun, pure joy, while developing "business" sittings in my ropera, and in my "declining years," is not.

Published in **The Daybooks of Edward Weston,** copyright© 1961, 1973 Nancy Newhall and the Estate of Edward Weston.

It is not the chrome and stainless steel that will make your darkroom the place you want to be. Much more important is the planning, design, and the inclusion of those inexpensive extras that makes it work well enough and be comfortable enough to attract you and make your attention focus on what photography really is all about: the image.

It's easy to forget that photography today, where the taking of the picture and the development of the negative are two distinct acts, is quite different from what it used to be. During the wet plate era of photography (1853-c.1890) the characteristics of the glass plate negatives were such that the negative glass had to be coated with the emulsion, the exposure made, and then the development completed while the plate was still wet. Since the negatives could not be taken back to a darkroom for development the only solution was to take a darkroom along. Early photographers may have looked strange to passersby, but they did come up with creative solutions to problems that make ours pale by comparison.

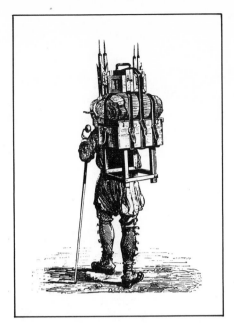

A photographer of the wet plate period loaded with camera and darkroom equipment.

Gernsheim Collection, Humanities Research Center, The University of Texas at Austin

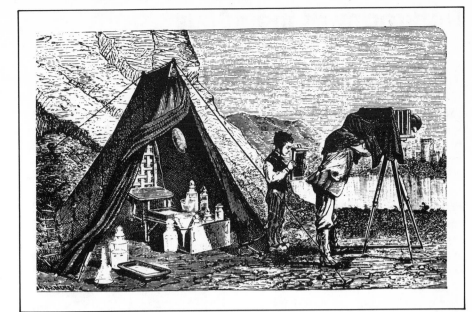

An engraving showing a portable darkroom set up close to the camera so the plate can be coated, loaded in the camera, and then returned to the darkroom for development after the exposure and before the emulsion dried (c.1865).

Photo, Science Museum, London.

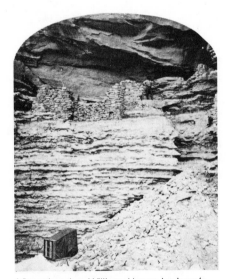

View showing William Henry Jackson's darkroom set up amongst the rocks.

R. A. Ronzio Collection

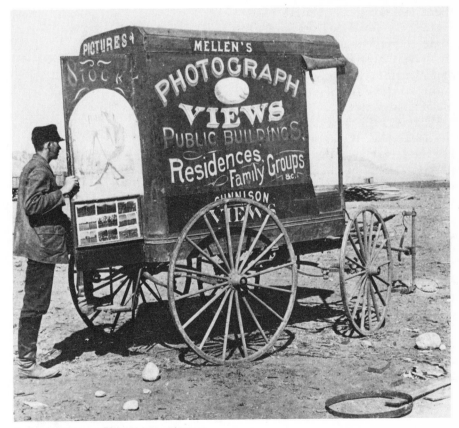

A mobile darkroom that was a step up in class from the tent; it gave slightly more comfort to the photographer.

Courtesy Colorado Historical Society

Darkroom of the 1880s

The 1880s was a time of transition to the modern period in photography as new, faster emulsions were introduced, simplifying the making of enlargements. Prior to this period, the slow paper emulsions required very bright light and the paper was so slow that contact printing was the only feasible way for amateurs to make prints. This meant that prints were the same size as the negative. If one wanted large prints, one needed large negatives and a large camera to take them. The simplification of making enlargements enabled the photographer to use smaller negatives and cameras; with access to a darkroom and the new faster paper emulsions large prints could be made.

The introduction of dry plates contributed to making the photographer more mobile as well. With these technological changes photographers were free from burdensome equipment on their travels. They were now able to travel light and return periodically to a darkroom to develop negatives and make enlargements.

What was this new darkroom of the 1880s like? It was surprisingly like the darkroom of the 1980s. The photographer's needs were essentially the same as today's and Victorian ingenuity developed many gadgets to make work easier and more exact. Many of these have survived the passage of time and the fickleness of photographers to appear in only slightly revised form today.

Some of the illustrations from a hundred years ago on this page bear a striking resemblance to products shown on other pages of this book.

Safelights

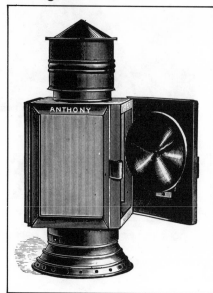

Safelights. 1880s safelights came in kerosene and candle versions.

Enlarger

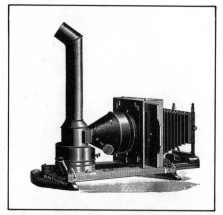

Enlarger. Since electricity was not yet widely available, even the enlarger had to be operated with kerosene.

U.S. Photo Clip

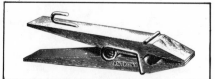

U.S. Photo Clip. Not at all unlike the venerable old clothespin still used to hang negatives and prints to dry.

Chemical Storage

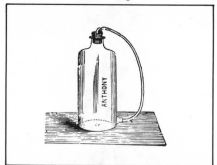

Chemical Storage. This innovative developer bottle had a tube to draw the fluid from the bottom of the bottle and a thin layer of oil on top to keep the air and developer from making contact. This enabled the developer to last longer.

Print Mounter

Print Mounter. This is basically the same design still used today.

Timing Plummet

Timing Plummet. It must have been difficult to swing, count, dodge, and burn at the same time.

A Portable Darkroom Tent

A Portable Darkroom Tent. Similar units are in use today, especially for color photography where the print is exposed, put in a light-tight drum, and then processed in daylight.

Print Dryer

Print Dryer. This print dryer revolved, increasing the air flow over the print surface to speed drying.

Allderige's Developing Rocker

Allderige's Developing Rocker. Agitation during development was as important in the 1880s as it is today. This is the forerunner of Ambico wave trays and drum processors.

A Typical Darkroom of the 1880s

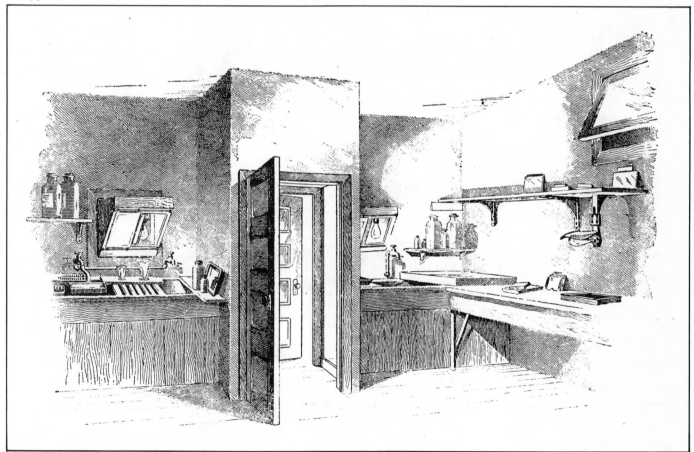

A Typical Darkroom of the 1880s. Papers were contact printed and produced the same sized print as the negative. They were exposed in the frames mounted to the wall on either side of the door.

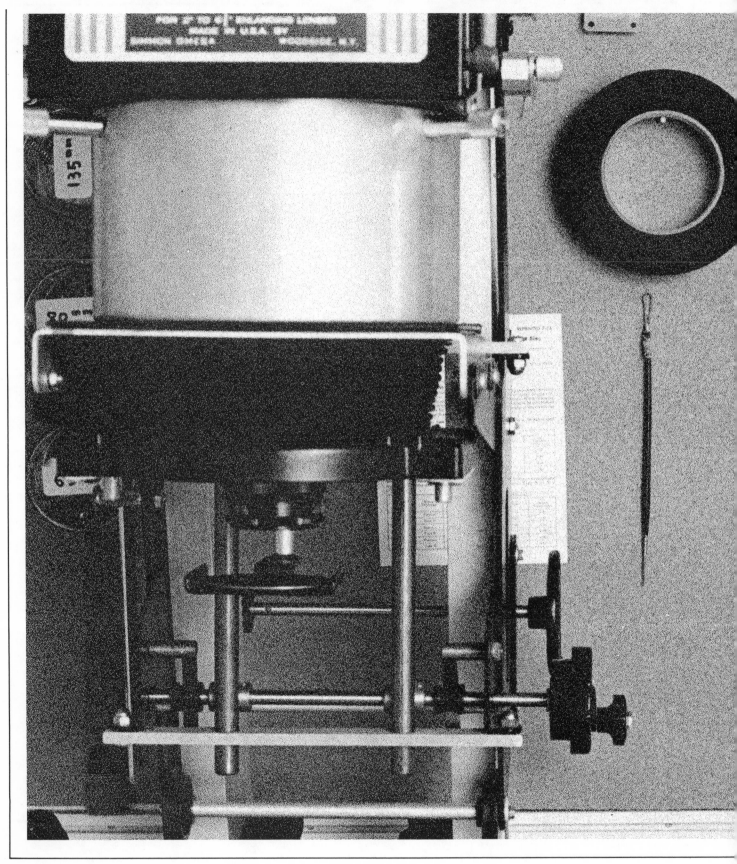

Contents

Harry Callahan ● **4**
Aaron Siskind ● **6**
George Tice ● **8**
Jeanloup Sieff ● **10**
Naomi Savage ● **12**
Neal Slavin ● **14**
Berenice Abbott ● **16**
Lou Jacobs ● **18**
Joe DeMaio ● **20**
Bill Shaw ● **22**
W. Eugene Smith ● **24**

Harry Callahan

To get to Harry Callahan's darkroom you walk up 3 flights of a wide-pine spiral staircase to the top of a house on a historic street in Providence, Rhode Island. Just across the hall from the darkroom is his workroom, a spacious oak-floored room with a view across Providence to the Capitol building and the hills beyond.

Callahan moved to this house in 1964. He made the down payment with money made from selling prints. He was delighted with his darkroom because it was the first darkroom he had with a sink in it. He had been printing for almost 25 years without a sink—bringing water into a room, carrying it out to dump it, washing prints in the bathroom. "I had always had just makeshift things. To have a sink was remarkable." But when he finally had a real darkroom, he laughs, "I felt I was more on the spot. I really had to produce."

He is spending more time in his darkroom these days. The good news is that he is selling prints; the bad news is that he has to spend time in the darkroom that he would rather spend photographing. "I don't mind printing, though I've gotten tired of it lately because I've been doing so much of it. I think I like just about everything about photography. I don't even mind mixing chemicals."

He has a new washer to help cut down on the drudgery, a Zone VI workshop washer that will take about 30 8 x 10 prints, and one that is much more efficient than his old one, which took 6 hours to wash 12 prints.

Other equipment that makes his darkroom work easier is a water temperature regulator (to set washing temperatures), a sodium safelight (he likes the brightness of it compared to regular safelights), and air conditioning (because the top floor of the house gets very hot in summer). One amenity is the view from his workroom; he likes to make a print, then be able to take a little break by walking out of the darkroom to look out the window.

In retrospect, Callahan might have built a bigger sink. An 8' sink seems very big when you've never had a sink before, but in recent years the need for archival processing (which, among other things, requires 2 trays of fixer and a large washer) has made his sink seem too small.

Callahan never really designed his darkrooms, but just used whatever space was available. He says he knows the present darkroom could be reorganized more efficiently, especially with more shelves and better storage, but "you get used to something, you reach, and you can find it in the dark. I think I have a very dumb darkroom, but I like it."

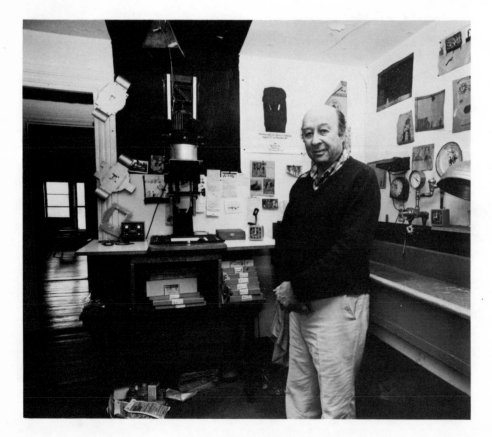

Callahan in His Darkroom. Harry Callahan's darkroom is as warm and friendly as Harry himself is. There are no elaborate arrangements and the equipment is as straightforward as his prints. It is clearly a room for a photographer whose ultimate concern is the print and not the hardware necessary to produce it.

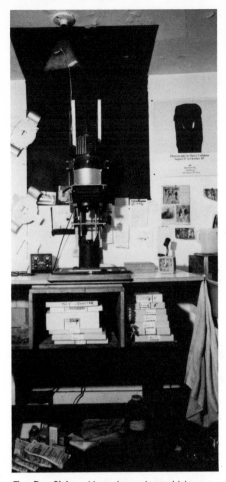

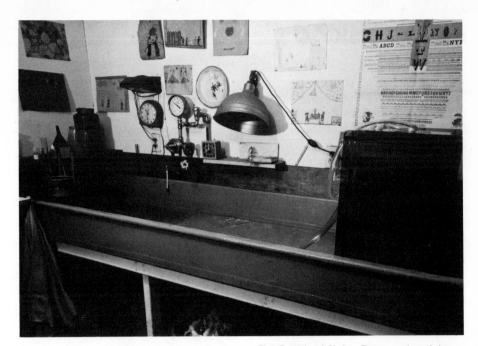

The Too-short Sink. The wooden sink built for Harry by a boatbuilder is used to hold processing trays and a Zone VI workshop print washer. The narrowness of the sink requires that prints be processed in two cycles with a change in solutions in between.

The Dry Side. Harry has placed his enlarger adjacent to the sink, only a few feet from the developer tray, minimizing steps from one to the other. The enlarger is set on a sturdy table, and paper and chemicals are within easy reach.

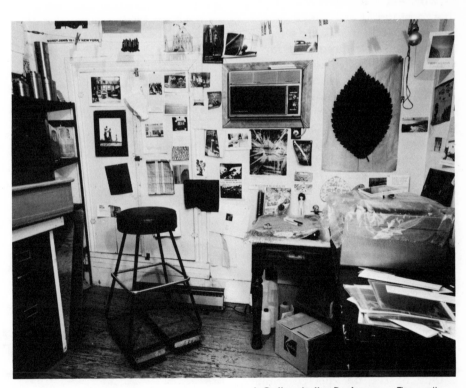

Time and Temperature. The artwork by Harry's child when she was younger almost hides the temperature regulating valve, which Harry thinks is a great convenience, an old wall clock used to check processing times, and a somewhat battered print viewing light.

A Gallery in the Darkroom. The wall covered with posters and announcements provides a backdrop for a stool on rollers for those long sessions at the sink, a wall-mounted air conditioner, and a wire strung across the room with film clips and clothespins used to hang negatives and prints to dry.

Aaron Siskind

Aaron Siskind lives on a quiet residential street in Providence, Rhode Island, a long stone's throw from Harry Callahan. Like Callahan, Siskind came to Providence to teach at the Rhode Island School of Design. Siskind is much more proficient with a camera than he is with a hammer, so much of the actual construction of the darkroom was done by his students.

Like many well-known photographers, Siskind did not have a complete darkroom for most of his career, and within the past few years he has had both the time and inclination to construct one. The increasing sale of his prints led to long hours in the darkroom to meet the demand and making things comfortable and efficient became of prime importance. Siskind made the entire darkroom one that could be worked comfortably from a sitting position. Both the enlarger baseboard and the sink are set lower than would be required for a standing position. In addition, the enlarger has a focus attachment that allows the machine to be focused without having to reach way up for the knob. This also allows for easy focusing when very large enlargements are being made and the knob is raised high above the baseboard.

Siskind spends a great deal of time making prints and rewashing and reprocessing older vintage prints that were made in the days before archival processing. In tune with modern theories, he no longer dry mounts; he uses his dry mount press only to flatten prints. As he says about the new archival processing theories, "They really have us running scared."

One of the unexpected fringe benefits of buying an older home was the walk-in cedar closet in which he now stores many of his own prints and prints from his collection.

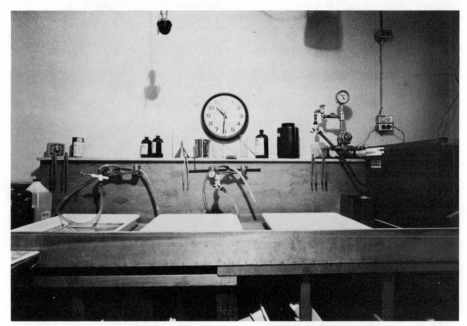

The Wet Side. The sink has several water outlets so that print washing and other processing steps can be handled simultaneously. The Zone VI washer is connected to the temperature-regulating valve so that washing temperatures do not have to be continually monitored. Rubber hoses are used to connect all of the outlets and are more than long enough to reach to the floor of the sink. This arrangement allows water to be used anywhere in the sink without moving trays around and also prevents splashing. A shelf over the sink provides convenient storage of frequently used chemicals and print tongs.

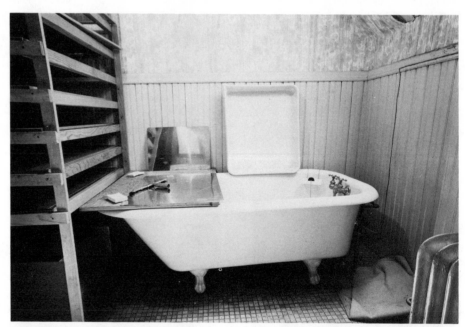

Print Drying. One of the several bathrooms in the house serves the dual function of print drying room and bathroom. Siskind denies that he drys prints while sitting in the tub but in any event the ferrotype plate used as a squeegee board allows the runoff water to drain directly into the tub and down the drain. The print drying rack made from aluminum frames and fiberglass screens is conveniently located next to the squeegee area. The line above the tub can be used for drying film and the excess water that runs off takes the same exit into the drain system.

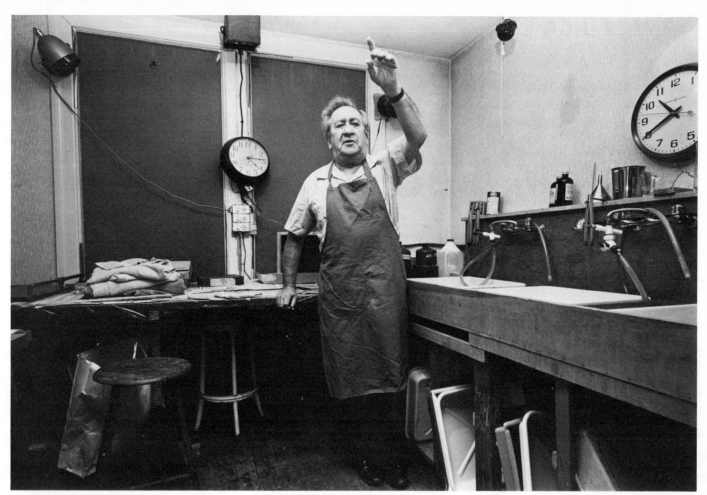

Aaron Siskind in the Darkroom. When one is concentrating on making fine prints, everything is relative—even the time of day. If that were not so Siskind would set the clocks to read the same time. Here he stands next to the sink at which he can sit while working. "I had a student build it. I paid him well . . . but it works." The trays are stored under the sink and the room has a number of stools conveniently located. The windows have been light-proofed by nailing masonite panels over them.

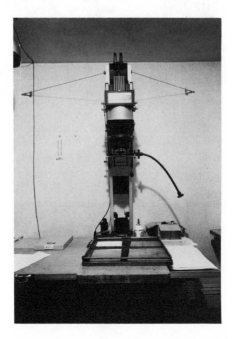

The Dry Side. This view shows the Omega enlarger with a focusing extension that makes focusing easy. Siskind also uses a Micromega focusing magnifier but feels that its high degree of magnification makes it difficult to interpret. The enlarger is supported at the top of the column with picture-framing wire connected to eyebolts in the wall. This reduces the possibility of column vibration that makes prints less than sharp. The enlarger timer is mounted to the front of the counter within easy reach while sitting at the baseboard.

George Tice

One of the interesting photographs in George Tice's extensive collection is one taken of him as a very young boy by his father, who first got him interested in photography. When Tice started making his own prints, he was living in a trailer, and his equipment was far from what most beginners would accept today. He developed prints in ice cube trays and enlarged with a slide projector, which was less expensive than a regular enlarger.

After a tour in the Navy he became the printer for Edward Steichen and, later, a master of the platinum printing process. This process, first used in the nineteenth century, uses platinum rather than silver to form the photographic image. Platinum paper makes a print with an extremely long tonal range but was replaced by silver-based paper because of the exceptionally high cost and very slow emulsion speed.

Tice makes classic full-scale, sharply focused "straight" prints and often uses an 8 x 10 view camera. He is flexible, however, and his latest book, *Artie Van Blarcum,* is illustrated with photographs taken with a 35mm camera.

His darkroom is in the lower level of his suburban New Jersey townhouse, adjoining his workroom/office. The house and darkroom are like his prints, crisp and clean and in immaculate good taste. Because he often prints using platinum he has designed a contact printer to reduce the long exposure times required. He also uses an 8 x 10 enlarger to enlarge these large-format negatives. The enlarger is made of wood and is reputed to have belonged to Adolf Fassbender, a nineteenth-century pictorialist.

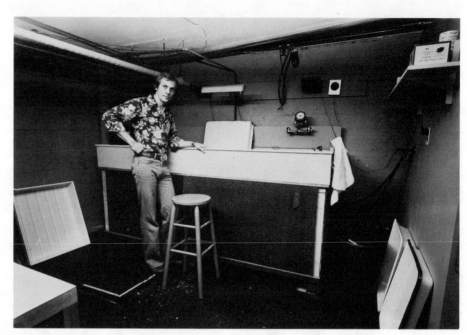

George Tice. The size of the trays gives you some idea of the size prints Tice makes from large negatives. The homemade sink is made of plywood covered with fiberglass and epoxy resin. The stool makes things easier during long portfolio printing sessions. When you are issuing portfolios of one hundred sets with ten prints in each you had better have a place to sit.

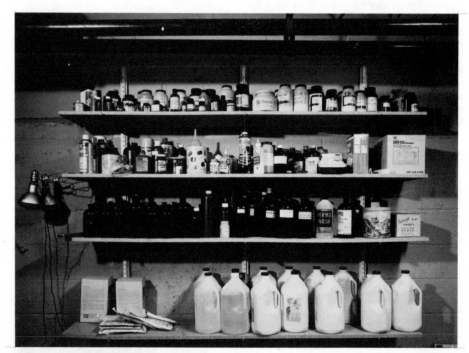

Chemical Storage. Whoever said neatness doesn't count was never a photographer using more than one process. Tice's chemical collection is extensive and stored for easy access.

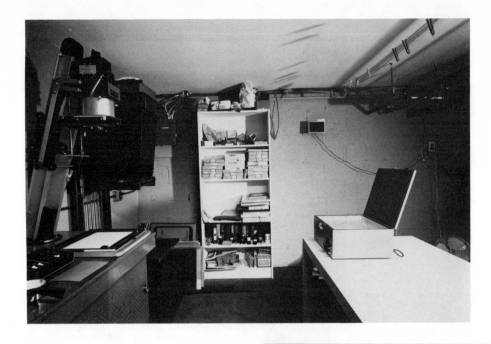

The Dry Side. This larger-than-usual darkroom is approximately 12' x 15'. This view shows the enlargers on the left and an "island" table in the middle of the room on which sits the contact printer Tice designed to use in making platinum prints. Paper is stored at the far end of the room. The wires and clothespins above the table are used to hold negatives and prints for drying.

The Enlargers. The 8 x 10 wooden enlarger with coldlight head dwarfs the smaller format enlarger next to it. The 8 x 10 enlarger has both an adjustable bellows and adjustable easel baseboard for maximum enlargements. The door on the left is the entrance to the workroom/office.

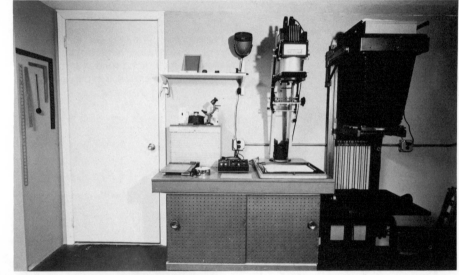

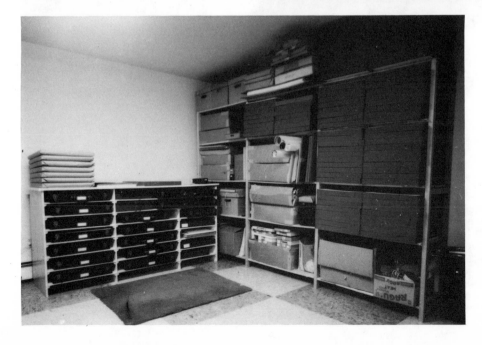

Storage. Storage in the darkroom/work areas is essential given the extensive portfolios that Tice prints. Racks have been built to store the archival boxes and mats used in the preparation of these portfolios. The cabinet to the left holds print cases in which he stores finished prints.

9

Jeanloup Sieff

Jeanloup Sieff is a prominent French photographer known both for his commercial work in advertising and fashion and also for his personal work. A great deal of the personal work is in black and white.

Sieff has published extensively, including a basic book on photography, *La Photo,* coauthored with Chenz. His most recent publications include a series of which he is the editor entitled *Diary of a Journey.* The first volume in the series, *Death Valley,* is by Sieff and was published in 1978.

The darkroom is located in his Paris studio and occupies a room with a sloping roof. It is among the more functional darkrooms we have encountered and one of few to be tiled for easy cleaning and elimination of dust problems.

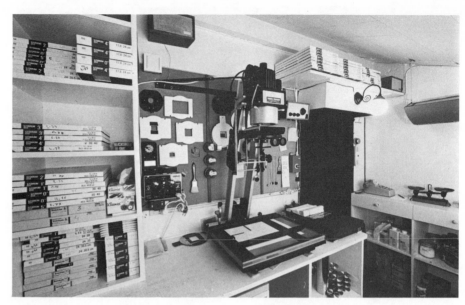

The Dry Side. The dry side on the left and the work area in the background are used for loading reels and mixing chemicals. The darkroom is also equipped with a phone extension.

The enlarger is braced at the top of its column through a wall-bracket attachment.

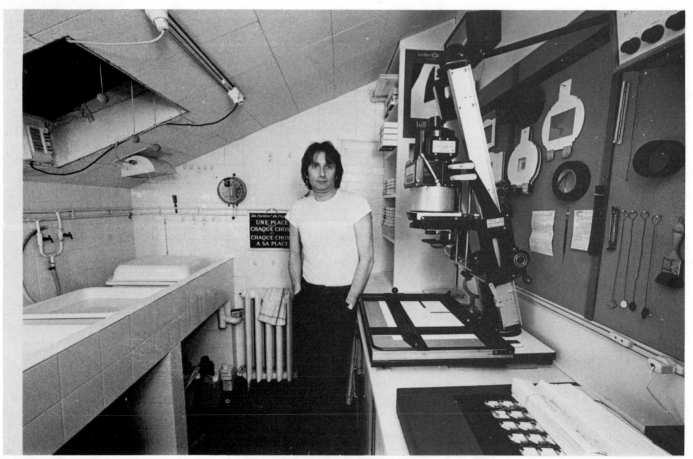

Jeanloup Sieff. The photographer stands next to the 4 x 5 Omega enlarger. The walls on all sides are covered with tile and all equipment is stored where it is immediately accessible, but still out of the way.

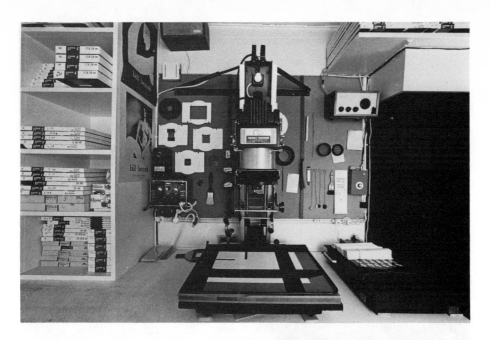

The Enlarger Area. This view shows the careful placement of frequently used equipment. The wall immediately behind the enlarger has small hangers on which can be placed the various negative carriers, dodging and burning tools, and controls for amenities such as the stereo system. The wall immediately to the left has shelves for paper storage.

General View. The darkroom is entered through a light trap shown here just past the enlarger. The entrance is light-proofed with hanging cloth.

The wet side on the right has room for large processing trays in the sink and the far end is occupied by a revolving print washer. All water outlets feed through rubber hoses.

The white tile makes the darkroom a bright and pleasant place. Space under the sink is used for storage of chemicals and trays.

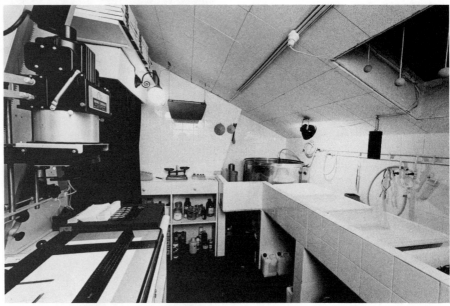

Printing Controls. To the immediate left of the enlarger, within easy reach, are the timer and other enlarger controls.

Naomi Savage

Naomi Savage is one photographer who often uses the photographic print as an intermediate step in the development of a final idea that may incorporate photoengraving, gum-bichromate, and other non-silver techniques. One of her major projects was the preparation of five etched magnesium plates, each 8' x 10', for the Lyndon Baines Johnson Library in Austin, Texas.

Her darkroom is in her home in Princeton, New Jersey, on the edge of town where it begins to give way to the surrounding countryside.

One entire end of the house is devoted to her studio and darkroom. The design is contemporary and the studio is bright with natural light entering through large windows on two sides. The cathedral ceiling gives a feeling of spaciousness. The darkroom is tucked off to one end, adequate in size but small in comparison to the adjoining work area.

On the wall outside the darkroom door is a framed receipt from the Museum of Modern Art for the purchase of two of her early prints. It is for $10.00 and signed by Edward Steichen. A prestigious but less-than-lucrative sale for a young photographer.

The Wet Side. The area to the left of the sink is used for additional storage of frequently used wet-side equipment. Kitchen sink racks are used to dry funnels, graduates, and other wet-side equipment. The two units built into the wall are light boxes designed for medical x-ray viewing and although expensive they work well and serve a dual function. One part serves as a white light to view negatives and the other as a safelight when prints are being made.

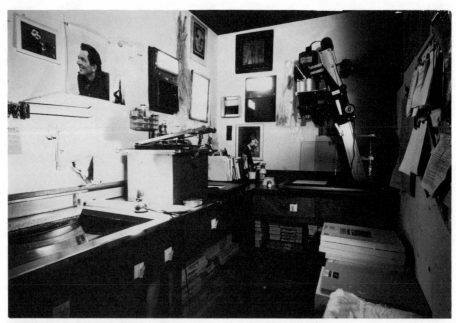

The Dry Side. With space at a premium the enlarger has been turned sideways to permit a narrower dry-side counter. The space on the left holds a contact printer; paper is stored beneath the counter surface; and the wall to the right is used as a bulletin board for technical information. Small clips mounted along the front edge of the work counters provide a convenient place to hang instructions and other technical data.

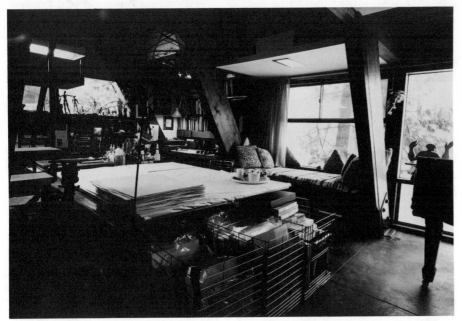

The Work Area. Using the photograph as an intermediate step in the development of large nonsilver works requires a spacious work area. This view shows the work area adjoining the darkroom. The metal baskets in the foreground are used for print storage. The large, paper-covered table is used for print manipulation and finishing. The space directly behind this work area serves as an office and library.

The Entrance. The entrance into the darkroom leads in from the workroom, with the wet side facing the door. The enlarger is off to the right and cannot be seen from this angle. The walls are lined with artwork and photographs of the photographer's family.

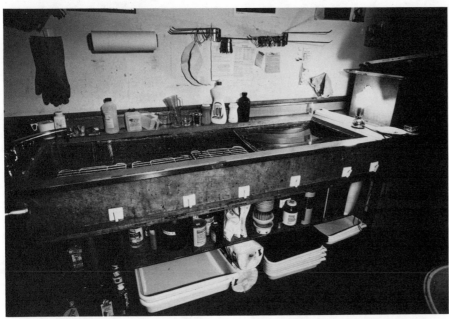

General View. The darkroom space is relatively small and is arranged along three sides of the room. The area to the left and in front of the door is used for the wet side and the remaining end for the enlarger. This view shows the sink (made from lead and therefore heavy and difficult to move) and the storage area underneath. Small, removable duckboards line the bottom of the sink.

13

Neal Slavin

Neal Slavin's studio is located in the SoHo section of New York City. The street, built in the late nineteenth century, is lined with five- and six-story buildings festooned with elaborate cast-iron facades typical of the period. Slavin's studio is located midblock on the second story of one of these buildings.

The space itself was a large loft used for storage before Slavin bought it a few years ago. The plans for the combination studio/office/darkroom were done with the help of an architect. Most of the actual construction, however, was completed by Slavin and his staff. The two-story-high ceilings, supported by cast-iron, fluted columns, allowed for the addition of a balcony on one side that now houses the office and darkroom on a raised level.

Slavin became fascinated with photography while studying art in college and turned professional in 1966. Since then, he has become successful as a commercial photographer as well as building a strong following for his personal work. The majority of his work is done in color. Initially, he sent it to commercial labs for processing, but finding that unsatisfactory, he built a darkroom in which all processing can be done under his total control. His previous darkrooms were dry—without sinks; this one was designed to his personal specifications and is more functional and elaborate than his previous ones.

When Slavin was asked if this was a "professional" darkroom he replied, "All of my darkrooms have been serious. When you think of a professional darkroom you think of very modern and the latest in working kinds of things. As you have probably seen, most darkrooms are more of personal identity and character than a laboratory. I think that's one of the reasons we don't call darkrooms laboratories. My newest darkroom looks very scientific . . . it's very together, very modern but in fact it's very personal, very orderly. It works very well but it's not fancy when you look at it. It's very reasonably done, there's no elaborate equipment in it, all my processing is done by hand."

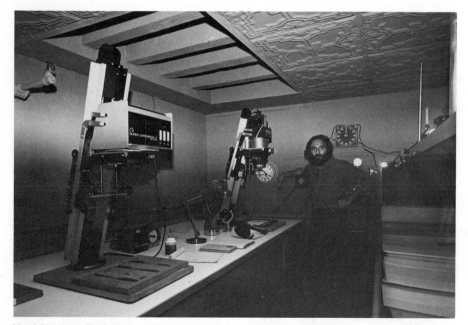

Neal Slavin in Darkroom. Slavin stands between the dry side and the large sink. All of the enlargers are arranged along the large counter space to the left. The counter is large, with a great deal of working space between enlargers, and because they are not permanently wall-mounted the equipment can be moved to provide even more working space should it be required.

The Entrance. The entrance to the darkroom is equipped with a phone, a fire extinguisher (not seen frequently enough in darkrooms), and a tape deck. The sink holds processing baskets and the entrance is light-proofed with a sliding door.

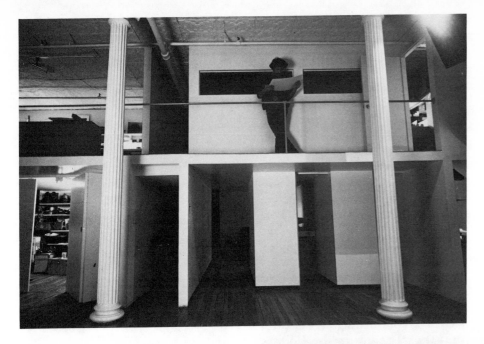

A General View. Originally the loft space was two stories high with the ceiling supported by a row of columns. One-half of this space has been divided by the addition of a second-story office and darkroom. The lower level is used for reception and storage and the upper level has the office space on the left and the darkroom/workroom area on the right.

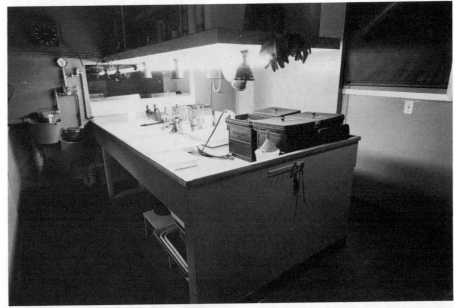

The Wet Side. The sink in the darkroom has been designed to provide access from three sides. The fourth side connects the sink to the sliding plexiglass windows used to pass wet prints into the workroom for washing, drying, and finishing. The sink is wood coated with fiberglass resin. The space under the sink and a large shelf over it provide additional storage space.

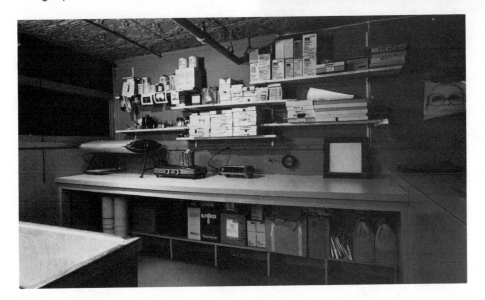

The Work Areas. The darkroom has a large work area located at one end. The space above and below this area is used primarily for storage. The work counter holds a hot plate used to raise the temperature of chemical solutions quickly, a dryer to dry color prints for evaluation, a paper trimmer, and a small light box. The windows on the left are made from red plexiglass with pull-down, homemade light-proof shades. They can be left open when printing in black and white because the red plexiglass acts as a safelight filter.

Berenice Abbott

When the snow is melting in Boston and spring is in the air, the lakes and rivers of Blanchard, Maine, are still locked in ice. Backed against the Piscataquis River, in a small hollow in the hills, stands an old frame farmhouse that is now the home and workspace for Berenice Abbott. A magnificent back room hangs over the banks of the river and the sound of water rushing over the rocky river bed can be heard throughout the house. Berenice Abbott has integrated photography into her daily life as can be seen by the way workspaces are located in central parts of the house.

Berenice Abbott first became involved as an assistant to Man Ray in Paris in the 1920s and her involvement and contributions still continue. She became well known in the 1920s for her portraits in Paris and in the 1930s produced a large series documenting New York. She also has devoted a large portion of her career to scientific photog-

raphy using strobe and multiple exposures to illustrate the laws of physics. She discovered the photography of Eugene Atget, whom she met in Paris, and later brought his work to the attention of the photographic world. Atget is now considered to be one of the leading photographers in the history of photography and his images have been a major influence on many contemporary photographers.

Her home in Maine is isolated from the hectic pace of Paris and New York but it provides the quiet needed to concentrate on her photography. The entire top floor is devoted to the office, workspace, and darkroom. An old wood-burning stove heats the floor, and the atmosphere is warm and relaxed. Prints by Abbott and Atget are piled on the desk and nearby work surfaces.

The darkroom, dominated by a Durst 8 x 10 enlarger, is connected to the office area by a light trap.

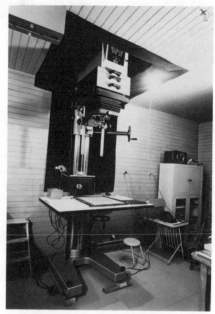

The Enlarger. The huge Durst 8 x 10 enlarger rises through a hole cut in the ceiling. Without the added height the maximum size of prints would be substantially reduced. The large baseboard built into the enlarger eliminates the need for a nearby counter because focusing magnifiers, timers, and other pieces of equipment can fit in the space not occupied by the easel.

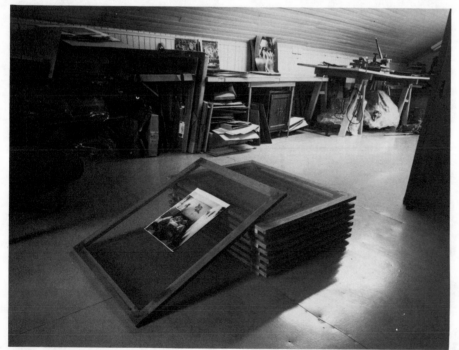

Print Drying. Ms. Abbott uses fiberglass screens and frames for print drying. However, she has eliminated the need for a rack to hold the screens by gluing small spacers on the bottom four corners of each frame so that when they are set on top of each other the frames are separated by a few inches to allow for air to circulate.

Duckboards. The bottom of the sink is lined with duckboards, which reduce wear and tear on the waterproof sink coating. They also raise the trays so that water flowing from the washer through the sink does not float the trays. These duckboards are made in sections so they can be easily removed and stored. A stool is on the left, used to sit on when it is not holding extra print processing trays.

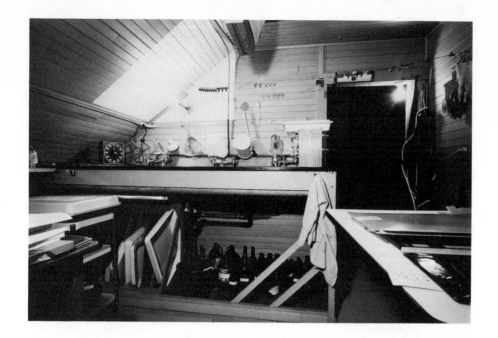

The Wet Side. This view, with the enlarger baseboard on the right, shows the sink and the light-trap entrance to the darkroom. The space directly under the sink is used for tray and chemical storage. Floor mats are located in front of all work areas to make standing at the sink and enlarger more comfortable. Aprons and gloves hang on the wall to the right.

The sink has several outlets for water and pegs mounted into the wall provide a convenient place to store mixing graduates, funnels, and other wet-side paraphernalia. The line suspended over the sink is used to dry film so that the runoff water drains directly into the sink. A bright bulb on the left is used for print viewing when prints come out of the fixer.

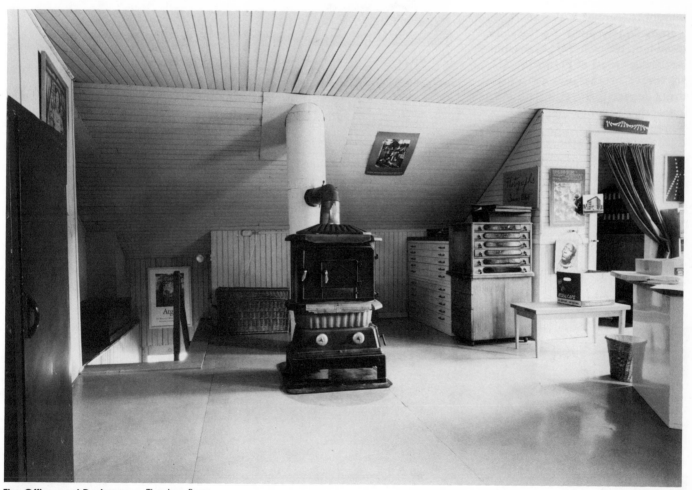

The Office and Darkroom. The top floor, containing an office and darkroom, is heated by a large wood-burning stove and the entire area, except the darkroom, is flooded with natural light. This view shows the stairs leading down to the main part of the house. The desk used for paperwork is on the right as is a storage closet.

Lou Jacobs

Lou Jacobs, Jr., is one of the leading writers in photography. He has written numerous books and many technical articles for the *New York Times* and photographic magazines. His darkroom is located in his home in Studio City, California, and occupies a small building a short walk from the main house. A nearby shaded patio and swimming pool are a pleasant adjunct.

The darkroom is 12′ x 5′ and has been designed mainly for processing and printing black and white photographs. It is a very personal space designed and decorated to meet the needs of only one person, the photographer.

Immediately next to the darkroom is an office/library area where Jacobs does most of his writing. The proximity of the two spaces and their separation from the main house make them a quiet and functional work area.

Jacobs is a prolific writer who also continues to practice photography. He does both personal and commercial work and it is this ongoing involvement between his practice and his writing that makes his work authoritative and reliable

Organization. A long pegboard panel is mounted along the entire length of the wet side and provides a convenient place to store neatly many accessories such as reels, print tongs, and so on. Pegboard allows you to rearrange items as needed without having to go to a great deal of effort. A paper towel dispenser mounted directly over the sink makes it easy to locate in the dark.

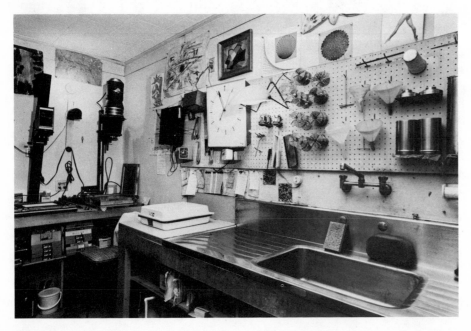

A General View. The wet side of the darkroom is arranged against the longest wall with the dry side to the left. Safelights (two over the enlargers, one over the developer tray) are all on one switch. A bare bulb worklight is wall-mounted between the enlargers and another, in a diffused reflector, is located over the fixer tray. Additional white light is provided by a ceiling fixture. A fan located between the office and darkroom circulates cool air in warm months, and a small electric floor heater is used when it gets cool.

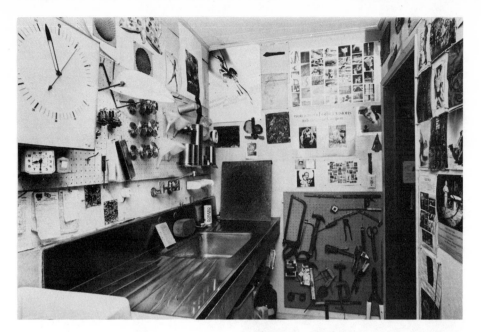

The Wet Side. The darkroom sink is a used 72″ Tracy restaurant model to which Jacobs has added an extension finished in Formica. The large timer on the left was made by a friend for timing prints, and includes two fluorescent bulbs for viewing negatives. The upright board at the far end of the sink is used to squeegee prints. The posters on the wall add a personal touch.

The Dry Side. The dry side holds a relatively new Omega B66XL and a vintage Dejur 4 x 5 enlarger. The black rectangle to the right of the enlargers is a green safelight used for inspection of 4 x 5 sheet film during development. On the left are wires stretched between the walls which are used to hang processed film to dry. Both safelight and white light illumination are conveniently located near the enlargers.

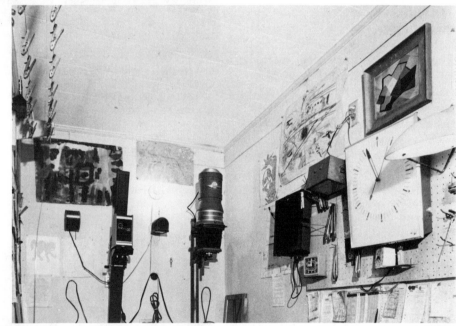

Storage. All of the work surfaces have been designed to allow the dead space underneath to be used for storage. Trays and chemicals are stored under the wet side and printing paper beneath the dry side. The stool between the dry and wet areas provides a place to rest while printing or processing. A stool such as this is almost a necessity when long hours are to be spent in the darkroom.

Joe DeMaio

Winchester is one of the many nineteenth-century towns located on the immediate outskirts of Boston. It is dominated by large, ornate, Victorian homes and it is in one of these that Joe DeMaio lives and has his darkroom.

DeMaio began his career as a chemical engineer and at some point chose the more risky, but for him more interesting, life of a photographer. He now spends all of his time either making prints and photographs or teaching at local colleges and universities.

DeMaio, like many photographers, has installed darkrooms in several apartments and houses as he has moved from one to another. These darkrooms have been located in bathrooms, kitchens, and basements. His kitchen darkrooms worked well but the problems of eating and processing with toxic chemicals in the same space made them less than ideal.

His new darkroom is shared with Debora Vander Molen and making the space work well for two people required careful planning. The darkroom and adjoining work areas are near each other on the second floor of the house. The darkroom is entered through a light trap constructed by removing the back wall from an adjoining closet and light-proofing the space with hanging light-proof drapes.

The darkroom has a feeling of being part of the living space and yet does not need to serve two purposes. It is a great improvement over his last darkroom, which was in a basement and had a distinctly subterranean feeling. In the new space DeMaio can open the windows when processing roll film and the view makes the long development cycles easier to live with.

The Wet Side. This sink and plumbing have been located in six houses during the past ten years; careful planning considerably reduced the difficulties of that many relocations. The sink plumbing is modular and when moved only needs to be connected to the existing supply lines to make it operate. The water is filtered and the temperature regulated with an automatic mixing valve. All of the outlets feed from rubber hoses that lie in the sink bottom when not in use. The sink has a separate washing area to the right where the print washer is located. It drains through a separate drain so that its overflow does not flow through that portion of the sink used for print processing.

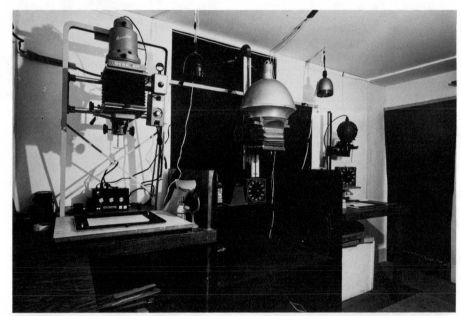

The Dry Side. The dry side accommodates three enlargers, including a 35mm Leitz, a 4 x 5 Beseler, and a 5 x 7 Elwood. The 5 x 7 is equipped with an adjustable enlarger easel baseboard allowing for oversized prints without having to reorient the enlarger itself. The enlarger mount and the adjustable baseboard are both freestanding to allow for easy relocation. Debora Vander Molen uses the 4 x 5 Beseler to the left and Joe DeMaio the 5 x 7 and 35mm enlargers on the right.

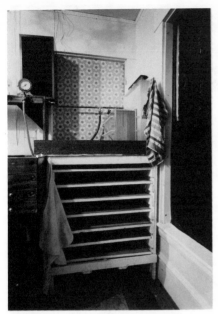

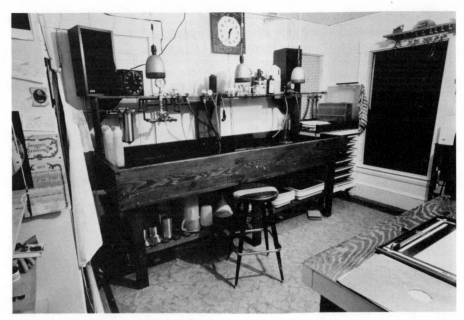

Print Drying. The print drying rack has been constructed from plywood and holds wooden frames covered with fiberglass screening. The frames slide in and out on slats of wood allowing for easy placement and removal of prints. Like everything else in the darkroom, this unit stands alone and is not built in so it can be moved intact from one darkroom to another.

To the right of the print drying rack is a window light-proofed by taping black garden plastic (available from most garden supply or hardware stores) over it. This is the easiest and fastest way to light-proof a window in any darkroom.

Storage. This view of the wet side shows the storage under the sink and the stereo speakers located over it. The darkroom also is equipped with a phone extension.

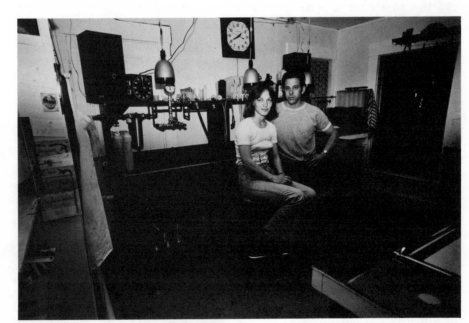

General View. The two photographers share the darkroom although they have separate work spaces for all of the operations that can be completed in daylight. The dry-side areas are also separate so the only overlap is in the wet-side and storage areas. The "separate" but "related" arrangement allows both to pursue their photography with a minimum of confusion while eliminating the need for two entirely separate facilities.

Bill Shaw

Bill Eglon Shaw had already established a reputation as a home portrait photographer, traveling from town to town in Yorkshire, England, when he was invited to take over a photographic practice that had been started in 1876 by Frank Meadow Sutcliffe in the coastal town of Whitby.

Sutcliffe, in addition to his studio portrait work, had made many pictorial photographs of Whitby and its residents. In 1965, Shaw began to get requests for prints from Sutcliffe's negatives, first from a television company for a documentary on Sutcliffe, and then from museums and art galleries in England and the United States. A growing interest in the history of photography, as well as in the life of the community as recorded by Sutcliffe, created an increasing demand for prints. Gradually Shaw made the transition from a general practice to a photographic gallery specializing in Sutcliffe's work.

Shaw's aim is to produce modern prints from Sutcliffe's original glass-plate negatives in a way that is faithful to Sutcliffe's earlier prints, then to mat and frame them to high standards of quality. Because of the growth of the practice, Shaw hired and trained Erica Braithwaite in 1967 to print according to his own methods and standards. Unmanipulated prints are made from Sutcliffe's negatives, without the use of cloud negatives or masks that were at one time introduced into Sutcliffe's work through the influence of his contemporary Francis Frith. The only alteration is toning to match the reddish brown color of Sutcliffe's original prints.

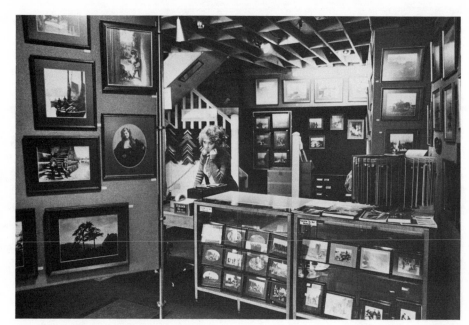

The Sutcliffe Gallery in Whitby, England, founded by Bill Eglon Shaw, was the first independent photography gallery in Great Britain. There has been an increasing demand for prints of Sutcliffe's work, and the modern prints as well as vintage ones have become collector's items. The gallery and shop, managed by Bill's wife, Dorothy, is the focal point for the finished prints.

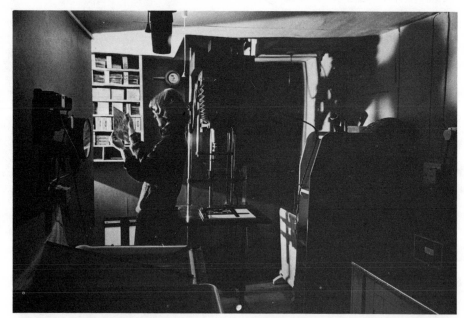

The darkroom, situated at the top of a winding staircase in a very old building, is functional and modern. Apart from a retouching table and the negatives, nothing of the original Sutcliffe equipment was taken over with the business. Erica Braithwaite uses Sutcliffe's original glass-plate negatives to make modern prints of his work.

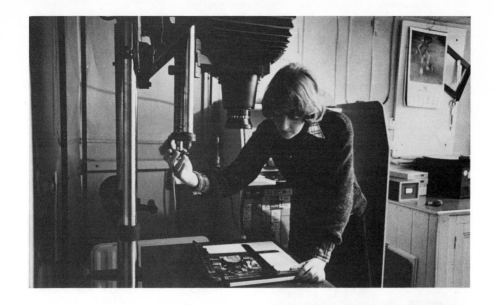

Prints are enlarged using an old De Vere Mark 7, a cold cathode 8 x 10 enlarger with a 240mm Rodagon lens. The print is developed in May and Baker Embrol, given a two-bath fix, washed in a DeVille washer, and air dried on gauze-covered racks.

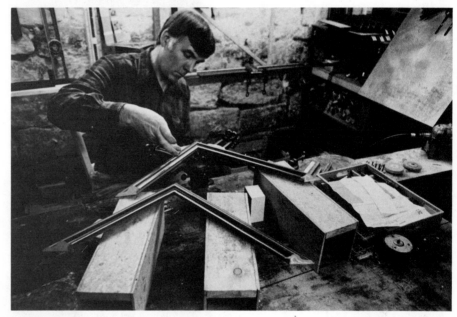

In addition to managing the gallery and a staff of six people Shaw also manufactures frames in his country workshop for use in the gallery. The glass used is imported from Spain and the moldings from Italy.

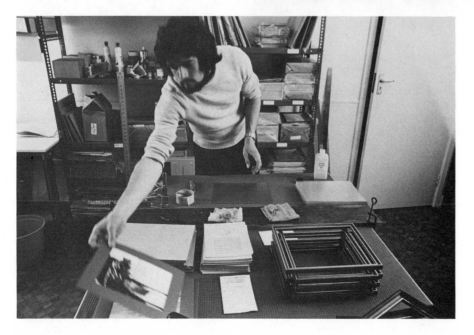

Batches of dried prints are finished by Mike Shaw and Peter Rayment. The prints are toned, spotted, and matted and framed as necessary, then sent to the gallery or packaged and mailed to other galleries, museums, and collectors all over the world.

W. Eugene Smith

W. Eugene Smith has been one of the leading American photojournalists since shortly before World War II. His involvement in photography began when, as a young man, he was interested in becoming an aircraft designer. In the course of taking photographs of airplanes his goals changed and he has since been committed to photography as a form of visual communication. Best known for his photoessays for *Life Magazine* ("Spanish Village," "Country Doctor," etc.), he has recently produced extensive photoessays such as "Minamata," which was published in book form.

Smith dislikes printing but he does not back off from its demands because it is only through the control of the entire process that he can be assured that his images convey the meaning that he intends. One of the ways he relieves the monotony is to listen to music while printing, and it is said that he has over 25,000 records from which to choose. He also occasionally watches television; as shown in the accompanying photographs he has covered the screen with a safelight filter that protects the printing paper from unwanted exposure.

Over the years Smith has developed his printing techniques to match his vision. He makes extensive use of ferricyanide to bleach out his highlights and open up shadow areas. He also uses diffusion screens of either wire mesh or black stockings, moved rapidly back and forth, between the lens and easel during the exposure to soften and break up the image grain.

Since he does considerable print dodging and burning he has equipped the darkroom with a foot switch that controls the enlarger while leaving his hands free. As a final step he tones most of his prints in selenium toner to enrich the midtones and blacks.

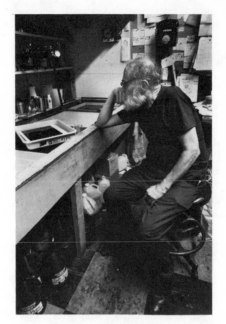

© 1978 Sherry Suris

Bleaching prints with ferricyanide takes time; the print is repeatedly bleached, then placed in the hypo to stop the bleaching action. One print from the famous series on Albert Schweitzer required over five days to produce to Smith's satisfaction. The stool and sink rail are wide enough to lean on, making things more comfortable for extended printing sessions.

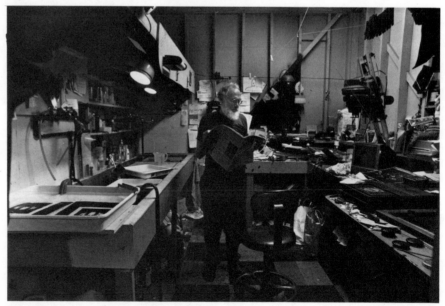

© 1978 Sherry Suris

This view gives a good indication of the overall size of the darkroom. Smith likes the darkroom to be large and comfortable with plenty of room to move about. A towel rack is mounted conveniently over the sink and safelights abound. A string running the length of the room overhead controls the white lights so they can be turned on from almost any location in the darkroom.

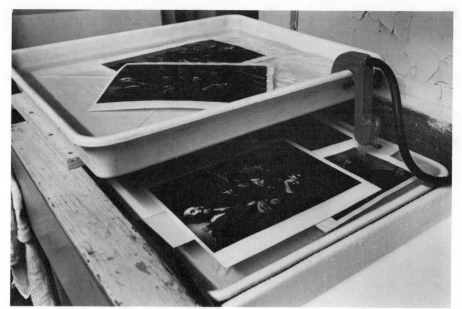

Smith uses two trays, one above the other as a print washer. Freshly fixed prints are placed in the bottom tray which rinses with overflow from the top tray. After partial washing, the final wash is given in the top tray. The water enters and leaves the top tray by way of the Kodak siphon attached. The lower tray overflows into the sink.

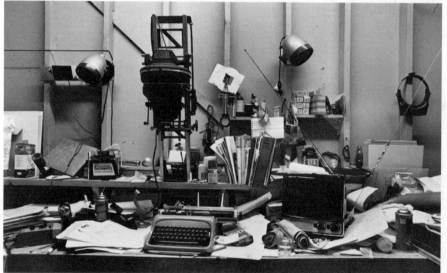

The dry side is a place to enlarge, finish prints, and also double as an office. The multiple use sometimes leads to confusion but everything is there . . . somewhere. Numerous focusing devices are in evidence. Smith's favorite enlarger is an old Leitz Valloy, which is no longer made, equipped with a Minolta color-corrected lens designed for color printing.

Here Smith examines a print during processing. The glass panel immediately behind the developing trays is used to hold the print while applying ferricyanide. In the background can be seen a thermometer used to monitor the temperature of water coming from that outlet. All water outlets are attached to rubber hoses which rest in the sink bottom when not in use.

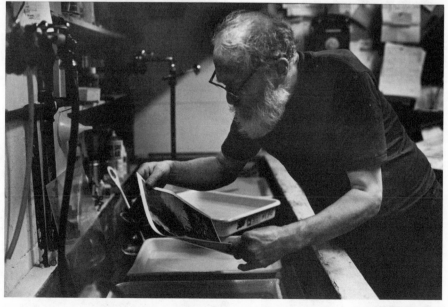

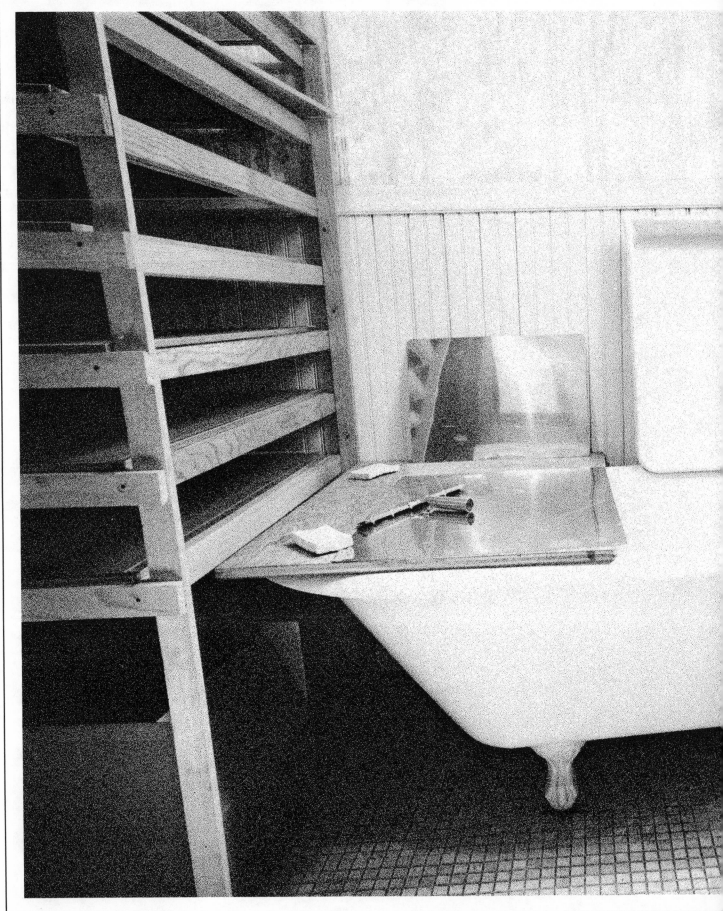

Contents

Darkrooms in Closets ● **28**
Darkrooms in Kitchens ● **30**
Darkrooms in Bathrooms ● **32**
Darkrooms in Spare Rooms ● **34**
Workrooms ● **36**

Darkrooms in Closets

Most closets hardly have sufficient space for clothes and other items needing storage space. Occasionally, however, you may be lucky enough to have a very large walk-in closet or a long closet with sliding or folding doors that can be spared for a darkroom. In most cases (but not all) working in a closet means you will have a "dry darkroom." Prints will be stored in a water tray after fixing and then carried in batches to another room for washing. If you are printing in color, all you have to do in the closet is make the exposure and insert the print into a light-tight drum (see page 162). All other processing can be done where there is more room.

Closets are generally so small that careful planning is required to make one acceptable for use as a darkroom.

Enlarger

Where possible, the enlarger should be wall-mounted because it can be difficult to find a small table that is steady enough for it. Or you can build a sturdy counter on which to set the enlarger and its baseboard. As closet space is at a premium, an adjustable enlarger base is not practical, since 11 x 14 prints can normally be made on the baseboard, and there probably will not be space to process larger prints.

Counter Tops

Shelves to hold the processing trays should be built at counter-top height. You will require a minimum of four trays (developer, stop bath, fixer, water-holding tray).

Storage

If the enlarger and processing trays fit, you should store everything else outside of the darkroom. If you have a tendency, however, to see how many people will fit in a phone booth, you can build storage shelves over cabinets in whatever space is available.

Ventilation

Working in a small space increases the problems of fumes and vapors. Good ventilation is almost a necessity for closet work, so plan on installing a fan and air vents in the closet.

Lights

The white light in the closet should be string-operated if the switch is outside the room. You can pick up a screw-in, string-operated adaptor at any hardware store if one is not already in the socket.

An extension cord can be run into the room to provide electricity for the enlarger, timer, and safelights. Be sure it has sufficient space so the door does not crush it when closed. If the cord is slammed by the door a few times, it could create a short circuit and possibly be a fire hazard.

Very Small Closet

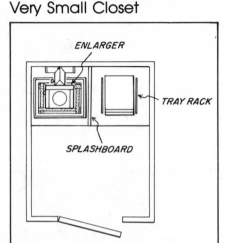

Very Small Closet. The most space-saving design consists of an enlarger and a tray rack that permits trays to be stacked on top of each other, which reduces the amount of counter space required. Timers and safelights should be wall-mounted so they don't use the scarce counter space. As you can see from the elevation, storage of paper and chemicals can be arranged on shelves under the enlarger. A splashboard made of plywood or masonite should be installed between the enlarger and the processing trays to reduce the risk of contamination.

Long Closet. These are ideal, but generally require that the entire room in which it is located be light-proofed. The closet can have wet and dry sides facing each other with one or the other permanently installed in the closet. If the wet side is built in, plumbing can be added. The enlarger can be mounted to an old (solid) desk and pushed into place when needed. The desk can also be used for storage.

Long Closet

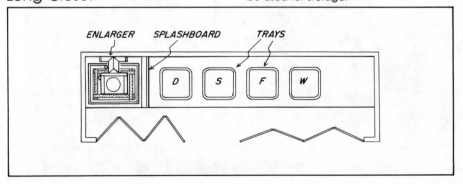

Walk-in Closet

Walk-in Closet. These are generally larger-sized closets and permit slightly more flexibility than a small closet does. An L-shaped darkroom layout is most common unless the closet is large enough to have a wet side and a dry side separated by an aisle. Storage and splashboard would be the same as for a very small closet.

Closet Elevation

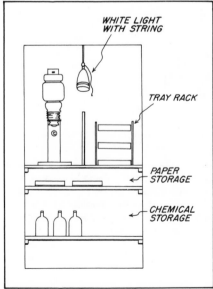

Closet Elevation. If you build a permanent darkroom in a closet, the space below the enlarger makes an ideal place to store chemicals and trays. The tray ladder used to hold the trays vertically is described in Chapter 6. A piece of paneling between the enlarger (dry side) and the processing trays (wet side) prevents splashes.

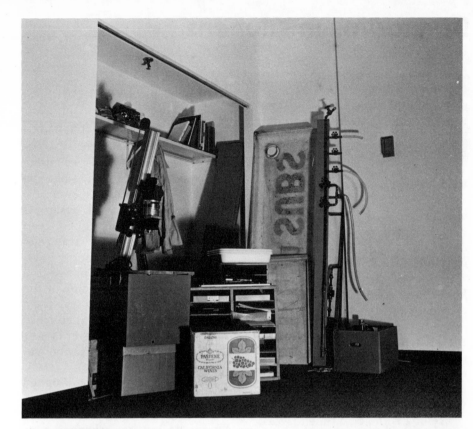

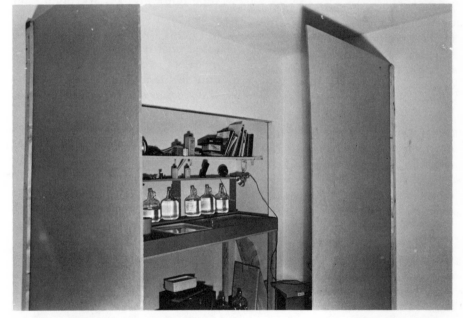

Photographs, Ron Harrod.

Before and After. These before and after photographs show how Ron Harrod installed his darkroom in a small closet. The sliding doors were removed (folding doors would not have to be) and the entire room light-proofed. Plumbing was hooked up to nearby pipes and a sink constructed out of a plastic sign. The plumbing system connects and disconnects with threaded fittings so if the darkroom has to move, the plumbing can go with it.

Darkrooms in Kitchens

Using a kitchen for a darkroom is only slightly more desirable than using the only bathroom in your house or apartment. Kitchens can be difficult to light-proof, must serve a second use on a daily basis, tend to have heavy traffic, and are more difficult to keep clean. You also have to worry about contaminating not only your developer but also your yogurt. Photographic chemicals are hazardous to your health, and when you work in the kitchen all food items should be stored away.

Yet it is still possible to work in the kitchen and do it well. Thousands of photographers do it every day, several of them known by the authors, so there is no reason why you cannot.

Evening is the best time to work in the kitchen because meals are over and after dark the light-proofing is simplified. A safelight can be screwed into the existing ceiling fixture, the windows and doors draped with light-proof cloth, and you're in business until dawn.

Finding a stable base for the enlarger can be a problem. If it will not fit onto one of the counters, it might be a good investment to buy a small sturdy table or old desk on which to keep it. Kitchen tables tend to be unstable and this will definitely show in your prints.

A better alternative is to wall-mount the enlarger (see page 110) in a place where it will be out of the way. If no such place exists, the enlarger can be attached to a wall mount with bolts and wing nuts so it is easy to remove.

The Work Triangle

The efficiency of any kitchen is based on a "work triangle," the distances between the three key units of refrigerator, stove, and sink. The efficiency of a darkroom superimposed over this initial design is based on a work triangle between the enlarger, developer tray, and fixer tray.

The wet side is determined to a large extent by the position of the sink and the processing trays should be arranged as close to it as possible. The placement of the enlarger should then be as close to the wet side as possible.

Kitchens are generally designed in one of four patterns. The following illustrations suggest ways of superimposing a darkroom over these existing designs. As you can see from the work triangles indicated on the drawings, the placement of the enlarger has a tremendous influence on the length of the walk required to expose and process a print.

If need be, work surfaces can be expanded by using plywood to cover the range (be sure pilot lights on the gas range are out) or to bridge other work surfaces, such as between two facing counters.

Corridor Kitchen

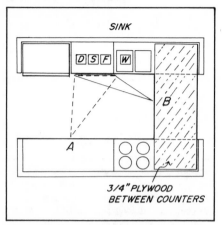

Corridor Kitchen. A piece of plywood can be placed as a bridge between counters. You should reinforce it with a wooden frame if you are going to place the enlarger on it. The enlarger would best be placed on the counter at the location indicated by "A" since this is both sturdy and convenient to the developer tray on the sink side of the kitchen.

U-Shaped Kitchen

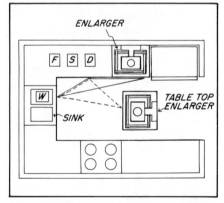

U-Shaped Kitchen. In a U-shaped kitchen the enlarger can be placed on the counter next to the developing tray, on a table in the middle of the kitchen, or on a facing counter.

L-Shaped Kitchen

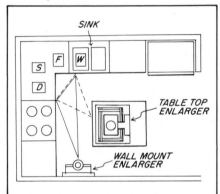

L-Shaped Kitchen. In a kitchen such as this the ideal place for the enlarger is on the counter between the wall and the stove. Barring that, a wall mount is possible, or the enlarger can be placed on a sturdy table in the center of the room and convenient to the developer tray.

Single-Wall Kitchen

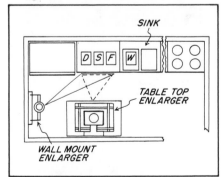

Single-Wall Kitchen. In many small apartments the kitchen occupies a single stretch of wall. In this case the only place for the enlarger is on a facing table or on a wall mount.

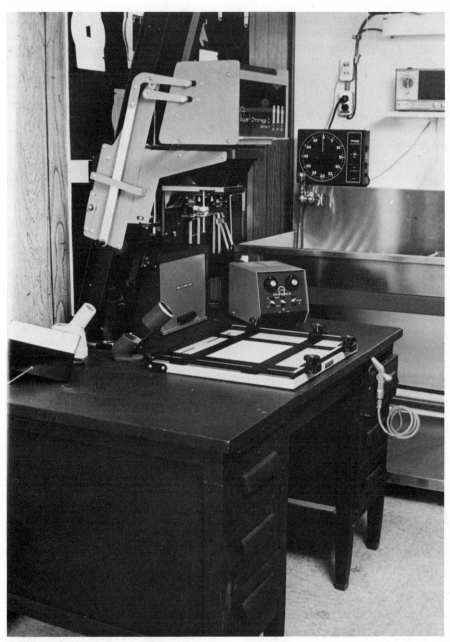

Photo by Metzger Studios, Rochester, New York.

Desk-Mounted Enlarger. An old-style oak desk, commonly found in second-hand stores or flea markets, makes an outstanding enlarger stand. This one, in the R&D darkroom of Saunders Photo/Graphic, was painted mat black, but the desk can be used in its natural finish as well. The drawers provide handy, dust-free storage for lenses and accessories. The enlarger should be securely bolted to the top. Do not use wood screws. A sheet of pegboard on the wall behind the enlarger, as shown, provides a handy place for negative carriers.

Darkrooms in Bathrooms

Most photographers at one time or another have used a bathroom for either a temporary or permanent darkroom. It has the advantage of having running water and is usually easy to light-proof. A bathroom can function well if its double use is taken into account. Its major drawback is, of course, that its use cannot be as carefully scheduled as a kitchen's can.

Layout

Most bathrooms lend themselves to using the bathtub side as the wet side and the sink and toilet side as the dry side.

Sink

In the beginning it may be acceptable to kneel alongside the tub while processing prints, but you will probably soon tire of this. For a more permanent arrangement, it is usually possible to build rails above the tub on which a wooden sink can be placed. When the sink is removed for storage the rails stay permanently attached. If good molding is used, and it is painted, the rails will not detract from the bathroom. The sink can drain, through a rubber hose, into the bathtub below without additional plumbing. A water supply can also be connected to the sink by connecting the shower head to a faucet mounted on the sink. It may be difficult to adjust the water temperature if the handles are near the tub (and under the darkroom sink) but it should be possible to live with this.

If the tub is installed along a single wall, rather than in a corner, a large box may have to be built around it to accommodate the sink and sink rails.

Enlarger

The toilet can be boxed in, providing room for both an adjustable enlarger baseboard and an enlarger mount. By removing the easel board, the toilet is accessible, especially when the enlarger head is raised to the top of the column. The instructions on page 112 for building an adjustable enlarger base can be followed to build this unit.

Working Space

Additional working space can be obtained by using two or three enlarger bases at one time. The top one holds the easel and the lower two hold unexposed and exposed paper. A piece of plywood can be cut to cover the sink if additional space is needed.

Bathroom Plumbing

When converting a bathroom to serve a dual function as a darkroom, it helps to adapt the faucets to accept the fittings of the darkroom equipment. Pfefer Products makes a complete line of adaptors to be used for this purpose. Other units are also available at your local hardware store. Some of the major ones are:

Shower Diverter. This unit can be permanently installed on the shower head. When adjusted it allows the water to flow out of either the shower head or a fitting to which a print washer can be connected.

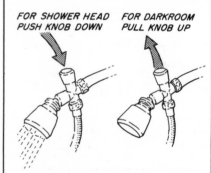

FOR SHOWER HEAD PUSH KNOB DOWN FOR DARKROOM PULL KNOB UP

Y-Adaptor. This unit allows two hoses to be fed from one faucet.

Standard Adaptor. This unit is designed to fit most kitchen and bathroom male or female threaded faucets. It will convert a faucet to accept male garden hose fittings.

Sink Over Bathtub

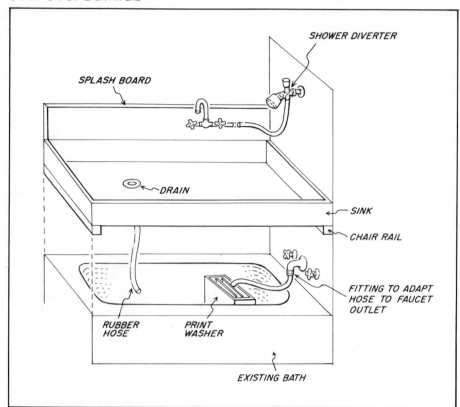

SPLASH BOARD

SHOWER DIVERTER

DRAIN

SINK

CHAIR RAIL

FITTING TO ADAPT HOSE TO FAUCET OUTLET

RUBBER HOSE

PRINT WASHER

EXISTING BATH

Sink Over Bathtub. A rail installed around the bathtub can be used to support a removable wooden darkroom sink. The sink can drain directly into the tub below, which eliminates any plumbing problems. Water can be obtained from the bathtub outlet or the shower head. The shower head might not have its own mixing valves so temperature regulation can be difficult. The print washer can be located either in the sink or in the tub below.

Bathroom Dry Side

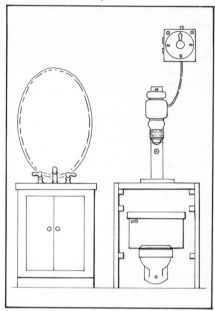

Bathroom Dry Side. This elevation shows how the toilet can be enclosed in a cabinet for an adjustable enlarger baseboard. Instructions on how to build one of these units are given on page 112. The sink can be covered with a piece of plywood to increase the amount of dry-side shelf space.

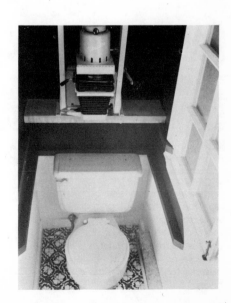

Wall Mount Over Toilet. The space over the toilet is usually wasted, although it makes a possible place to permanently wall-mount the enlarger. The shelf rails can be designed to permit lowering the shelf for greater enlargements. The shelves are removable, so the room can be converted to its original purpose.

33

Darkrooms in Spare Rooms

In most apartments and many homes it is inconvenient to convert a closet, kitchen, or bathroom into a darkroom. Therefore, one of the rooms that is normally used as a bedroom or spare room can be the location for the darkroom.

Unlike bathroom and kitchen locations, a spare room generally does not have a water source. This means that either the darkroom must be dry and the prints washed in another room, or a water source must be brought into the room.

Another problem with converting spare rooms is minimizing the damage caused to the room so it can be reconverted back to its original purpose should the darkroom be moved. Or perhaps the spare room must serve a number of func-tions simultaneously. At the very least, it may have to be both dark-room and workroom.

Anthony Hernandez, a Los Angeles photographer, was confronted with this problem when moving into an apartment. His solution was to convert a bedroom into a combination office, workroom, and darkroom. The room functions as an office and general working space during the day and is converted to a darkroom at night by pulling down the window shades.

The room is one of the major spaces in the apartment and was designed to be an elegant addition to the living space, with utilitarian features concealed in the overall design.

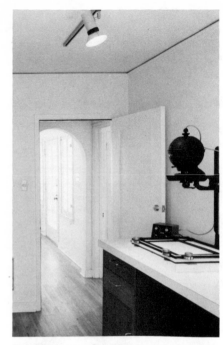

The Entrance. The entrance to the dark-room does not give a feeling that you have stepped into a different world. The room still seems to be part of the apart-ment and functions as a living space as well as a darkroom.

Organization. The darkroom is de-signed with the dry side on the left, the wet side on the right, and the office/ workspace at the other end of the room. The blinds are pulled at night to con-vert the room to a darkroom. Because they are not totally light-proof, it is not possible to print during the daylight hours.

The Dry Side. The dry side of the room consists of storage cabinets and a large formica-covered counter. The cabinets supporting the counter and the separate cabinet underneath are used to store equipment and prints. The track lights on the ceiling are used when the room functions as an office and the dry-side safelight rests on the counter along with the enlarger and timer.

The Wet Side. The wet side of a darkroom is the place where in most darkrooms the greatest disorder appears. The photographer solved the problem by designing the wet side so that the majority of the equipment is hidden from view when the darkroom is not in use. The exhaust fan is located in the ceiling over the sink, the print-viewing light on the right end of the sink complements the overall style of the room, and even the print drying screens directly over the sink do not detract from the room's clean appearance.

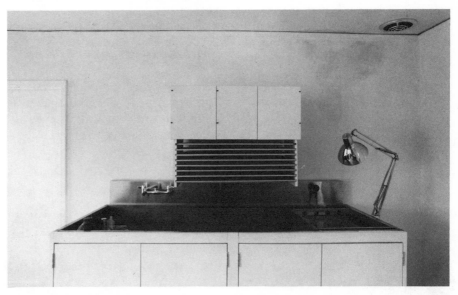

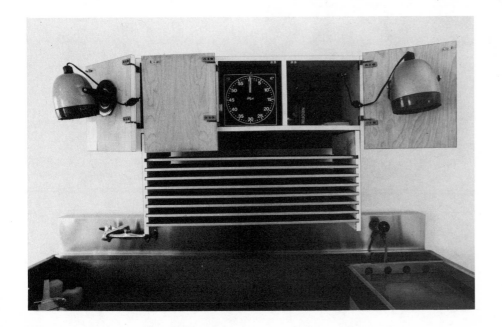

The Wet-Side Equipment. Opening the doors over the print drying rack reveals the wet-side timer, safelights, and equipment storage. When closed, the equipment is again concealed from view.

Workrooms

Generally all stages after print washing can be completed in an adjoining workroom. Print drying, spotting, matting, and mounting are some of the activities that can and should be done outside of the darkroom. Each photographer's situation is slightly different and many, where space is tight, will build their print drying rack in the darkroom itself but complete all other steps in a separate room. Most home darkrooms utilize whatever available space there is; to free up additional space for a workroom is a real luxury.

Given space limitations the best alternative is to use a room such as a bedroom for print finishing and storage. The main space requirements are for matting and mounting equipment, which can be space-consuming. Many photographers work on the kitchen or dining room table, so if you have to you will be in very good company.

Counter or Table Space

Counter or table space is needed for cutting mats and holding a dry mount press. If you do not have a press you might still need space to mount the prints with an iron or cold mounting tissue. Because of the cleanliness required it's best to have a permanent space set aside but if need be the table can be cleaned after dinner and the equipment set up. After all of the hard work it took to get the print to this stage, it is a heart breaker to find that you have set it in a puddle of giblet gravy.

Storage Space

For most photographers, what begins as a "little" darkroom starts to expand and consume incredible amounts of space. Very few photographers can bring themselves to throw out extra prints. Negatives and other supplies such as paper and mount board need a home. Because most of these materials are to some extent affected by humidity they cannot be tucked away in the basement or stored in a hot humid attic. This means that a space in the house must be found where shelves can be built or cabinets installed.

Light

An absolute necessity for a workroom is good light. This can be natural light from numerous windows or bright artificial lights. Natural light is excellent, especially when spotting prints or evaluating color proofs. Matting and framing under glass can be done in strong artificial or natural light.

Harry Callahan's workroom, which is a combination office and print finishing room, occupies the top floor of his Providence townhouse adjacent to his darkroom. This photograph was taken from the immediate vicinity of his desk and shows the side of the room where the dry mount press and print finishing equipment are stored and used. The light in the room is natural and bright, good for making those last final adjustments to a final print.

This photograph taken from George Tice's office shows the rest of the print finishing area. On the left are the print drying screens in an open frame. Paper is stored at the far end of the room and the right side is devoted to paper trimmers and the dry storage area.

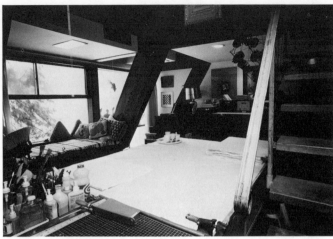

Naomi Savage's workroom is on the ground level and looks out on a landscape that includes her husband's welded stainless steel sculptures. The room is bright and full of light. This view shows a paper trimmer in the foreground and a large expanse of open counter space used for print finishing. The stairway rises to a storage area.

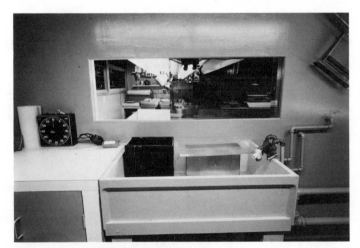

Neal Slavin's prints are given their final wash in the print finishing area. The window has sliding red plexiglass panels that are used as a "pass through" for prints from the darkroom to the washer. The red plexiglass acts as a safelight so the lights in the print finishing room do not affect the sensitive materials in the darkroom (color material excepted). The light entering the darkroom through the panels gives the room a pleasant open feeling. The cabinet on the lower left contains print drying racks concealed behind the swinging door.

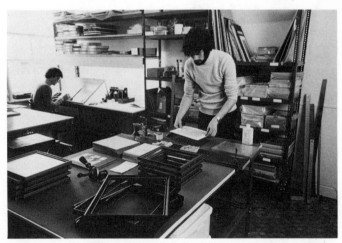

Mike Shaw and Peter Rayment handle the print finishing at the Sutcliffe Galleries in Whitby, England, in a well laid out workroom. Spotting and print finishing are done on a sloped drafting table with strong natural light entering from a nearby window. Shaw is shown framing prints on a large work table. Supplies are stored close by on the racks behind him.

3 Designing the Room

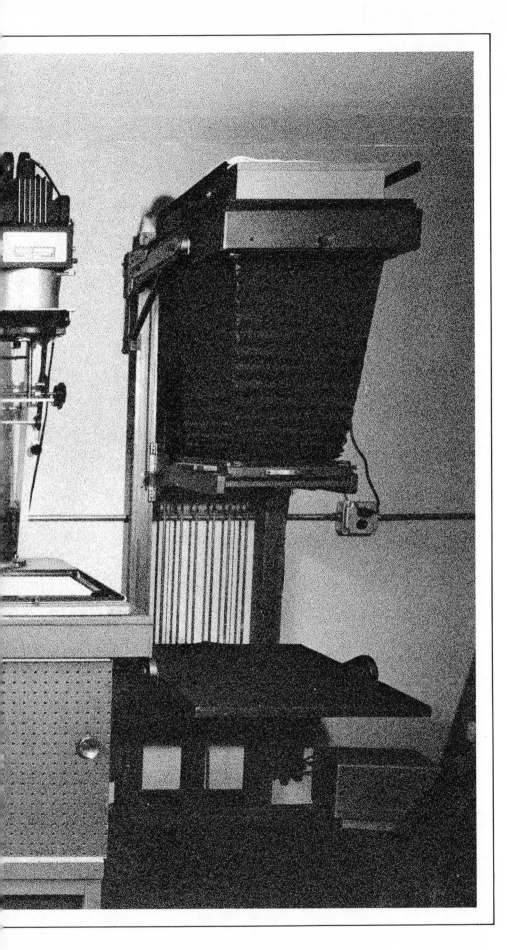

Contents

What Are Layouts
and Elevations? ● **40**
How to Do Layouts ● **42**
Planning Grids ● **44**
Dry-Side Cutouts ● **46**
Wet-Side Cutouts ● **48**
Light-Trap Cutouts ● **50**
Light-Trap and
Drying Rack Cutouts ● **52**
Preparing Elevations ● **54**

What Are Layouts and Elevations?

Designing a Darkroom

A well-designed darkroom requires the completion of a number of planning steps to ensure that the darkroom will function as well after it is built as you had hoped when you first conceived it. The major steps and the order in which they should be completed are:

• Determine the size and type of equipment to be used in the darkroom and the size of prints that will be made.

• Prepare a layout (floor plan) making provisions for all of the items to be used in the room and the print sizes that must be accommodated.

• Prepare elevations to show how storage shelves and cabinets are to be built and at what height the work surfaces are to be located.

• Prepare working drawings for those items that you plan on building yourself or having someone else build for you.

This section will help you follow these steps and ease the burden of making all of your drawings to scale. Before you begin it might help to explain the terms "layout," "floor plan," "working drawing," and "elevations."

Working Drawings

Layouts and elevations indicate the placement of items in a room and the outside dimensions of those items. However, they are not detailed enough to actually build from unless you are a very experienced carpenter or are willing to make do as you go along. To make the job progress more smoothly the best course is to prepare working draw-

ings that show the pieces that make up a major unit. Working drawings are shown throughout this book for such items as print drying racks, sinks, light table, etc. If you plan on building something that is not detailed in this book the drawings we have shown should give you a good idea of how to do your own.

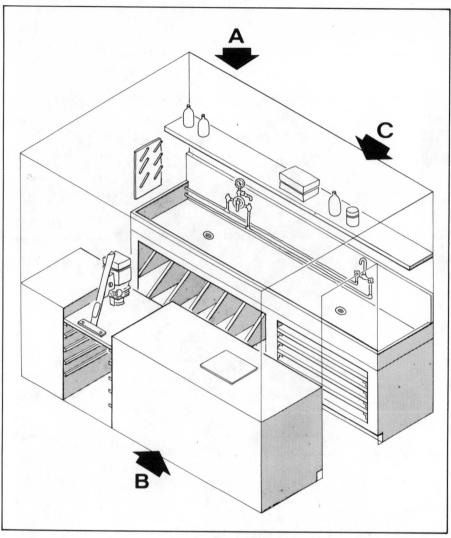

General View. This general view of a typical darkroom gives an idea of what the room would look like if the walls were transparent. The drawing clearly shows the placement of the wet side, the dry side and other major elements of the darkroom. Although it is very easy to understand it is difficult to draw, so a more simplified method has been developed to represent the major elements in a room. This simpler method consists of drawing separate sketches to represent the arrangement of items on the floor of the room (the layouts), and on each of the walls (the elevations).

Layouts

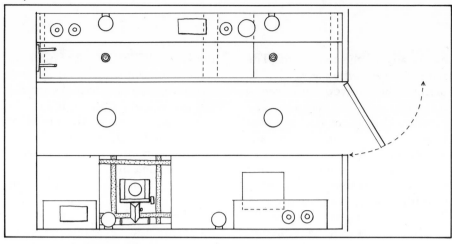

Layouts. If you were directly above the room and peering down from point A in the figure on the opposite page through the ceiling, you would see how items were arranged on the floor of the room. This view is what is called a "layout" or "floor plan" and its preparation is the first step in the design of any living or working space. At this stage the physical placement of equipment is determined to allow for working comfort by eliminating unnecessary steps.

Wet-Side Elevation

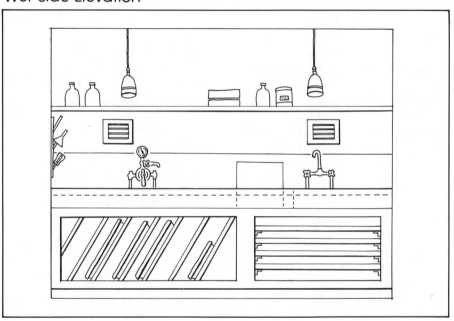

Wet-Side Elevation. If you were to stand outside of the darkroom and look through the transparent wall from point B in the illustration you would see the wall against which the wet side of the darkroom is built. This view is called an "elevation" and shows only the fronts of sinks, shelves, and other items on the wall. It is used to plan the placement of equipment and cabinets and should be based on the previously prepared layout.

Dry-Side Elevation

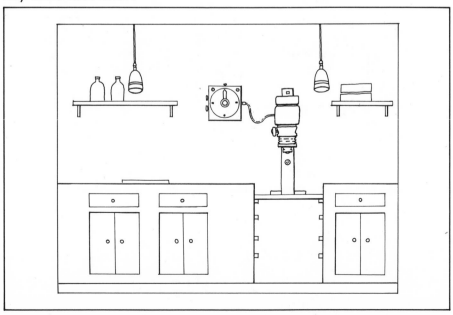

Dry-Side Elevation. Standing outside of the darkroom and looking in from point C would show the dry side elevation. This elevation will contain the enlarger, dry side counters, enlarger base, and under-counter storage.

How to Do Layouts

The preparation of a layout is the first step in building a permanent darkroom. This section has been designed to make this preparation as fast and easy as possible. It consists of grids and cutout parts drawn to the approximate scale they will occupy in the actual darkroom. Both the grids and the cutout parts are drawn to a scale of ½" to 1' in the actual darkroom. You might want to make a photocopy of both the grids and cutouts rather than cut up the book.

You can begin your layout in one of two ways. You can either draw the size of the room you plan to use on the grid, or you can assemble all of the elements you plan to use and then draw a room sufficiently large to hold them. The first approach is used when you have a room to convert in which you do not want to change any of the partitions. The second is used when you plan to partition the darkroom off from a larger area such as a basement and therefore the actual size and proportions of the room are initially unimportant.

If you plan to convert an existing room, start the layout by drawing the outline of the room on the grid. Measure the length of all 4 walls, then freehand sketch the room outline using 1 square on the grid to represent 1' in the room. Next indicate all existing doors, windows, and other major features in the room locating them on the drawing in the same scale they represent in the room.

After the room outline is drawn use the equipment checklist on the facing page to inventory the equipment you have, or plan to have in the future. The amount of material to be accommodated and the size of the prints you plan to make are the key ingredients in planning a workable room. Some of the pieces of equipment directly affect the amount of either counter space or storage space needed in the darkroom, so be sure to make provisions for these items.

All of the major darkroom elements can now be cut out and placed on the grid. The ability to shift and move them about will speed the time it takes to arrive at a final floorplan.

If you plan to include any equipment not provided in cutout form, or if your equipment is to be a different size, you can make your own cutouts by drawing them to the same scale of ½" to 1'.

Large Darkroom Layout

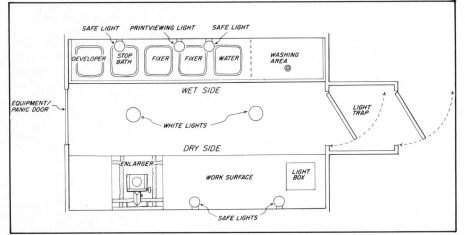

Small Darkroom Layout

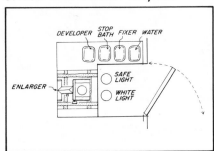

Typical Darkroom Layouts. These two darkroom layouts illustrate the extremes that you are likely to encounter. The smaller the space available the more creative you will have to be. Fitting everything in a large room is relatively easy compared to fitting it into a 3' x 4' closet. Both, however, can be done and done well.

Darkroom Planning Checklist

Before beginning the preparation of the layouts and elevations, it is helpful to make a complete inventory of the materials and equipment that you have, or might eventually want to accommodate in the darkroom. It makes good sense to plan ahead and provide space for equipment that will be added during the life of the darkroom. This information is also helpful in planning the type of storage space, sink size, and other elements of the darkroom based on the actual equipment to be used.

Equipment	Model	Already Have	Will Build	May Add Later
Dry Side				
Enlarger, 35mm				
Enlarger, 4 x 5				
Enlarger, other				
Enlarger lenses				
Enlarger coldlight head				
Enlarger color head				
Polycontrast filters				
Color correcting filters				
Exposure meter				
Color analyzer				
Voltage regulator				
Easel, 11 x 14				
Easel, 16 x 20				
Easel 20 x 24				
Easel, other				
Focusing magnifier				
Negative proof printer				
Contact printer				
Paper safe				
Enlarging timer				
Footswitch				
Scale/balance				
Printing control devices				
Dust sprays/brushes				
Paper trimmer				
Scissors/film cutter				
Densitometer				
Film cassette opener				
Wet Side				
35mm/2 ¼ developing tanks				
Roll film washer				
Sheet film tanks				
Sheet film hangers				
Film squeegee				
Processing trays				
Mural processing tray/drum				
Color processing drum				
Color drum agitator				
Print tongs				
Immersion heaters				
Water chiller				
Recirculating heater				
Stabilization processor				
Thermometer				
Gloves				
Stirring rods				
Graduates				

Equipment	Model	Already Have	Will Build	May Add Later
Funnels				
Aprons				
Towels				
Timer				
Chemical storage containers				
Squeegee board				
Print squeegee				
Print washer				
Negative drying cabinet				
Workroom				
Film				
Paper				
Print dryer, electric				
Print dryer, screens				
Dry mounting press				
Tacking iron				
Mat board				
Mat cutters				
Spotting brushes				
Spotting dyes				
Negative storage system				
Print storage containers				
Safelight filters				
Unmixed chemicals				
Negative clips				
Copystand				
Built-in Equipment				
Counters				
Sink				
Enlarger base, adjustable				
Light box				
Towel rack				
Shelf over sink				
Shelf over enlarger				
Ventilator fan				
Air conditioner				
Light-proof louvers				
Dehumidifier				
Light-proof door				
Safelights				
Water temperature regulator				
Valve				
Water filters				
Footswitch for enlarger				
Supply cabinets				
Electrostatic air cleaner				
Print viewing light				

Planning Grids

Dry-Side Cutouts

Preparing Layouts: Things to Remember

When working on your layout there are certain things to keep in mind:

Enlarger. If you plan to make very large prints, the enlarger should be placed where it can be tilted horizontally to project the image on a facing wall. Enlargements of up to 20" x 24" can usually be made by making an adjustable enlarger base (see page 112) or by using a wide-angle enlarging lens.

Aisles. There should always be sufficient room in the aisle to allow for free movement but not so much that additional steps are necessary to move from the enlarger to the sink. The normal aisle width for a one-person darkroom is between 30" and 36".

Doors and Drawers. Be sure to allow for door and drawer openings. If an aisle is too narrow, cabinet doors and drawers may not open completely without hitting the opposite side. Be sure also to allow for print drying racks to pull out fully.

Wet and Dry Sides. Where space allows, the dry and wet sides of the darkroom should be on opposite sides of the room separated by a center aisle. This reduces the possibility of contamination. Ideally, the developer tray should be located directly opposite the enlarger to reduce the number of steps needed to go from one to the other. If space is not sufficient to separate them with an aisle, a partition of wood should be installed between them to eliminate any possibility of splashing.

Left Handed? It is recommended that if you are right-handed the room be laid out so that work proceeds from the left to the right (clockwise on the layout sheet), and if you are left-handed it should flow in the opposite direction (counter-clockwise).

Exits. All exits should open outward so in case of emergency you can leave the room with the least resistance. Exits should also be sufficiently large to allow for the movement of equipment into and out of the room without tearing down walls.

Size. The size of the darkroom depends, to a large extent, on the size of the prints you plan on making. If you are working primarily with 8" x 10" prints there is a strong likelihood that you will someday want to make larger prints, so accommodate that possibility when planning the room. It's easier to do it now than to have to rebuild the darkroom later. Darkrooms should not, however, be larger than necessary. A large room only makes you walk farther. The average darkroom will fit well into a space ranging from 6' x 7' to 10' x 12' regardless of print sizes being made.

Working Space. Always remember that most equipment also requires working space. For instance, a dry mount press without a place to have mat board, prints, and dry mount tissue nearby will be a constant irritation.

Enlargers

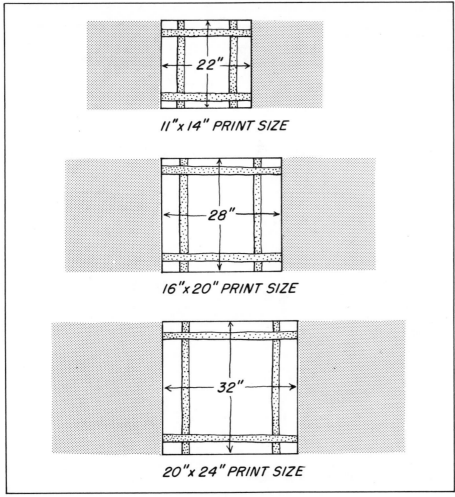

11"x14" PRINT SIZE

16"x20" PRINT SIZE

20"x24" PRINT SIZE

Enlargers. These enlarger cutouts are based on the maximum size of the prints to be made. Enlargers are relatively small compared to the size of the easel plus handling room required to make prints of a given size. The enlarger cutouts are also based on the longest dimension of the paper to be used so that both vertical and horizontal prints can be made. If you normally plan on making prints up to 11 x 14 but occasionally make larger ones, you can allow for the larger space with an adjustable easel base (see page 112).

When making an allowance for the enlarger you should also be generous with the working space on either side. There should be sufficient room for the maximum-sized paper you plan to use, with unexposed paper kept on one side and exposed on the other. The space required can be reduced by installing a light-proof drawer under the enlarger base, thereby eliminating the requirement for counter space to handle it. However, the light-proof drawer will conflict with the adjustable enlarger base unless it is offset to one side.

Paper Cutter

Stabilization Processor

Dry Mount Press

Light Table

Wet-Side Cutouts

Sinks

Processing prints requires a minimum of 3 trays: for developer, stop bath, and fixer. There should also be a fourth tray to be used as a holding-water bath for prints prior to placing them in the washer. Ideally the sink should allow for a fifth tray to hold fixer because two-bath fixing is more effective and more economical. The sinks shown here are designed to accommodate anywhere from 3 trays to 6 with an additional 30" space left for washing. If you plan on washing with an East Street Gallery washer or some other such space-saving equipment, the 30" space allowed can be greatly reduced. The sinks vary in size depending on whether you plan to align your trays in a horizontal or vertical position in the sink, and on the size and number of trays you plan to use. If you plan on building your own sink, and if space allows, you should build the largest size possible to accommodate expansion of your activities. The actual cost of the additional materials and the additional labor required are minimal.

If space in your darkroom is at a premium, you can save sink space by using tray racks to hold the trays one over the other.

Sinks for Processing Prints up to 11 x 14

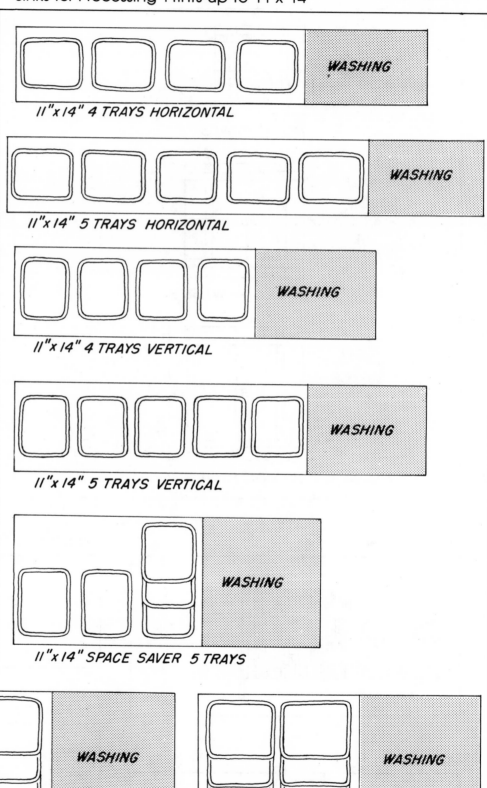

11"x 14" 4 TRAYS HORIZONTAL

11"x 14" 5 TRAYS HORIZONTAL

11"x 14" 4 TRAYS VERTICAL

11"x 14" 5 TRAYS VERTICAL

11"x 14" SPACE SAVER 5 TRAYS

11"x 14" SUPER SPACE SAVER 3 TRAYS

11"x 14" SUPER SPACE SAVER 6 TRAYS

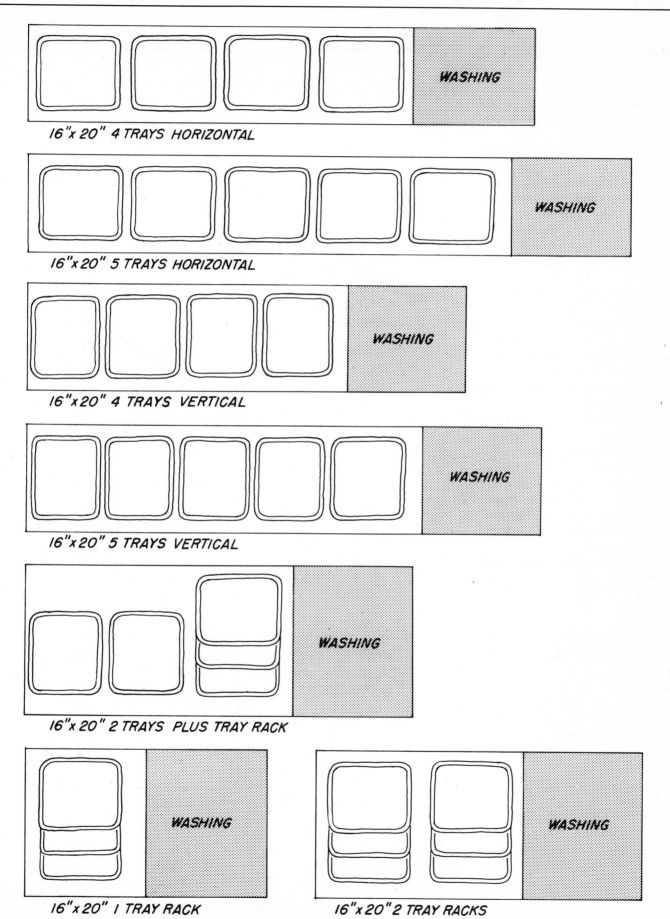

16"x 20" 4 TRAYS HORIZONTAL

16"x 20" 5 TRAYS HORIZONTAL

16"x 20" 4 TRAYS VERTICAL

16"x 20" 5 TRAYS VERTICAL

16"x 20" 2 TRAYS PLUS TRAY RACK

16"x 20" 1 TRAY RACK

16"x 20" 2 TRAY RACKS

WASHING

Light-Trap Cutouts

Light traps allow free access even when light-sensitive materials are exposed. Light traps are generally a combination of doors and curtains, or mazes that require no doors; the configuration of the walls is enough to prevent light from entering the room.

The inside of a maze or trap should always be painted a flat black to reduce reflections, and tests should be made to ensure that they are light-proof. Film is especially sensitive to light, even minor reflections, and mazes in particular should be watched so that no reflections enter the room to fog the film.

A white line should be painted on the inside walls of any light trap as a guide. All door handles should also be marked with phosphorescent paint. Entering a maze directly out of the bright sun can cause you to be quite blind until your eyes adjust. The white line will enable you to enter without waiting for a complete adjustment.

The accompanying mazes have been drawn to scale providing for 30" of shoulder room. The minimum would be about 28", so slightly smaller designs are possible. A separate equipment door can be constructed in the maze to allow the entry of larger equipment than the light trap will allow and it can also double as a panic door. As this door will not be opened regularly it need not be hinged. A panel attached loosely with small screws is quite effective and can be pushed out if a fast exit is required. Make sure all doors, including the equipment door, open outward for safety.

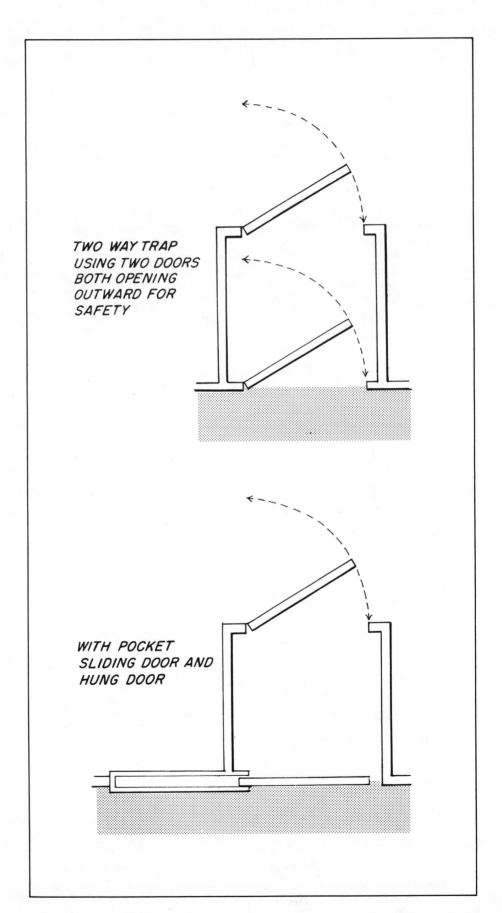

TWO WAY TRAP USING TWO DOORS BOTH OPENING OUTWARD FOR SAFETY

WITH POCKET SLIDING DOOR AND HUNG DOOR

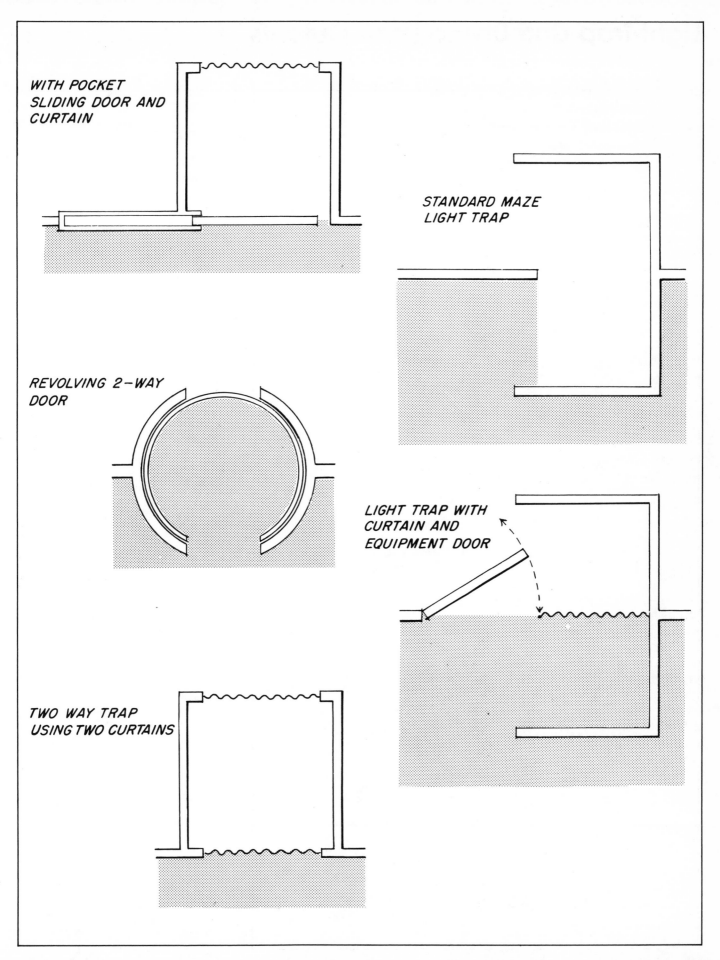

WITH POCKET
SLIDING DOOR AND
CURTAIN

STANDARD MAZE
LIGHT TRAP

REVOLVING 2-WAY
DOOR

LIGHT TRAP WITH
CURTAIN AND
EQUIPMENT DOOR

TWO WAY TRAP
USING TWO CURTAINS

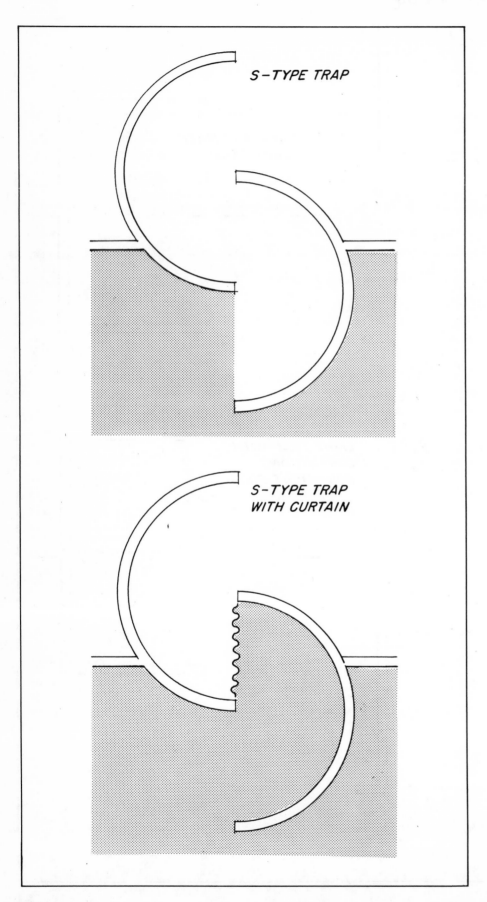

S-TYPE TRAP

S-TYPE TRAP
WITH CURTAIN

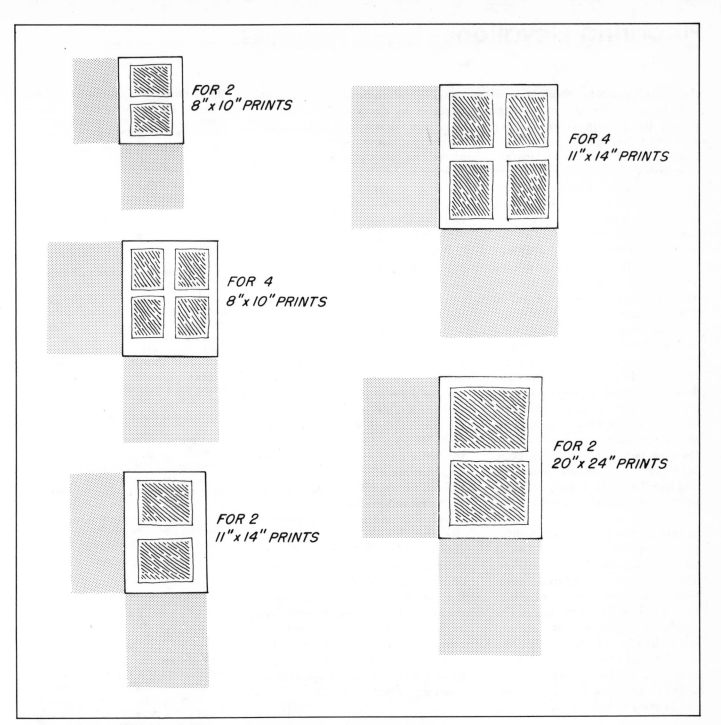

FOR 2
8"x 10" PRINTS

FOR 4
11"x 14" PRINTS

FOR 4
8"x 10" PRINTS

FOR 2
20"x 24" PRINTS

FOR 2
11"x 14" PRINTS

Drying Racks. The drying racks shown here are made with fiberglass screens and wood or metal frames (see page 106). Their capacity should be sufficient to hold prints from a normal printing session. The capacity of the drying rack depends on the horizontal dimensions shown as well as on the number of shelves allowed by the vertical height available to you. If you normally work in more than one size print you should build for the larger size. The shaded areas indicate the space needed to pull the rack out either horizontally or vertically. Once you have determined how a given rack will be positioned in your darkroom you can trim off the shaded area that will not be used.

Preparing Elevations

After the layouts for the darkroom have been completed, work can begin on the elevations for the dry and wet sides of the room. Elevations are similar to floorplans except they show the vertical surfaces of the room rather than the floor. To prepare elevations the first step is to measure each wall's length and height and outline them on a section of the grid paper using the scale of ½" to 1'. When this is completed you will have 4 rectangles (or squares) each of which represents a wall in the darkroom. Label one of them wet side and one dry side depending on how they relate to the floorplan. Now draw in all of the existing features of the room that affect the darkroom design, such as door openings, window openings, plumbing outlets, sinks, etc. These items should be drawn to scale and in their proper location in the room. Measure their size and placement and use the ½" to 1' scale to locate them on the drawings properly.

When the walls have been drawn to scale on the grid you can begin to plan what the counters and sinks will look like after they are installed. The next step in preparing elevations is to determine the height of the work surfaces in the room. The height of counters, sinks, and enlarger baseboards determines to a large extent how comfortable the darkroom will be to work in. If they are too high or too low, great strain can be put on the back and legs and

cut your visit to the darkroom short. Because this decision is so critical it pays to make it wisely. The normal height for work surfaces is 36" above the floor but this is only a starting point. Comfort while working depends not only on your height but also on the length of your arms and legs. Until all photographers are standardized darkrooms cannot be.

Begin with the 36" indicated height and make a temporary surface at this suggested height. You can do this by supporting a board with books. Now try to lean on it and move things about. See how comfortable the height is. Strain will show only after a number of minutes have passed, so spend some time to see what your reaction is. If your back is straight and your arms are comfortable, the height will be right for you. If not, raise or lower the board until a more comfortable height is found.

Transfer the ideal working height to the elevations by drawing a line on all wall surfaces to represent that height. Draw another line about 6" above the floor line to indicate the lowest level for the fronts of counters, sinks, drying racks, etc. If they go all the way to the floor there will not be room for your feet as you stand at the counter and cleaning the room will be much more difficult because you will not be able to reach under the sink to clean up spilled chemicals.

The Wet Side. The wet-side elevation should show the placement of the sink, shelves, water outlets, safelights, under-sink storage, and, if there is no other space available, the print drying racks.

The sink bottom should be located at a distance slightly below the ideal working height. The side walls raise about 6" above the bottom and if the sink is too high it is difficult to reach over the side walls to reach the trays in the bottom of the sink.

Water outlets: Ideally there will be a regulated outlet at one end of the sink and an unregulated one at the other. Both outlets should be at least 12" above the sink bottom (or above the duckboards if you plan to use them) so that large graduates can be placed under them to be filled. Even better is to have rubber hoses attached to faucets. When not being used, they lie on the bottom of the sink. In use they can fill graduates as high as the hose is long.

The storage under the sink can be used to hold processing trays, which can be separated by thin sheets of masonite or plywood. The bottom of this tray storage rack should slope toward the front to allow for drainage when wet trays are stored. Preferably, trays should be left tilted on end in the sink to drain completely prior to being stored.

(continued on next page)

The Dry Side. The dry-side elevation will show the counter, dry-side storage, and the enlarger mount and baseboard. If you plan on using kitchen-type cabinets they can be drawn in so that their counters are at the height of the line drawn on the elevation to indicate working height. Check to be sure the enlarger head can raise to its full limit, and use the chart on page 112 to determine if you can make the size prints you normally make at the counter-top height. Perhaps your enlarger head will hit the ceiling before the negative-to-easel distance is sufficient to give you the size prints you normally make. If this happens, you have three alternatives:

(continued on next page)

Print drying racks can be located under the sink if there is no room for them outside of the darkroom. Building instructions are shown on page 104.

Dowels can be mounted into the walls on the sides or back of the sink to provide a convenient place to hang graduates, funnels, tongs, and other small items for draining and storage. Be sure to place them where the dripping water will not contaminate processing trays. A small trough can be fashioned under the trays to funnel the water into the sink.

Exhaust vents or fans can be located over the sink to eliminate fumes and water vapor. Never locate a fan that blows air into the room over the sink since that will just distribute the dust and vapor more widely. The wet side should always be used to exhaust the air out of the darkroom.

Safelights should be indicated on the elevation and should be no closer than 4' from processing trays or the enlarger baseboard.

The shelves over the sink should be high enough that when trays are stood on end to drain in the sink they will not hit them.

The Wet Side

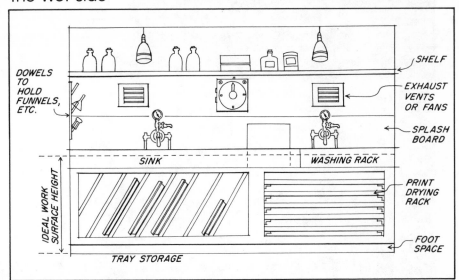

1. Cut a hole in the ceiling to allow the enlarger head to rise higher.
2. Lower the enlarger baseboard to increase the negative-to-easel distance.
3. Use a wide-angle enlarging lens.

Normally the enlarger can be mounted on the wall just above the counter top or it can be set directly on the counter. You may want to build an adjustable enlarger base to provide for larger prints (see page 112).

Determine the width of the enlarger area based on the maximum-sized easel you plan to use. Locate this area near the developing end of the sink, allowing for room on either side of it for unexposed and exposed paper.

The Dry Side

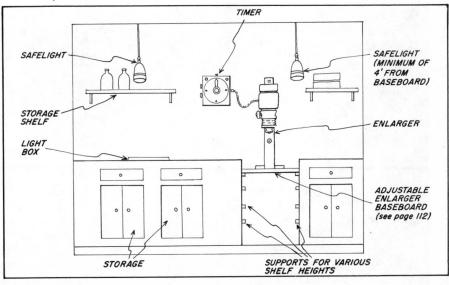

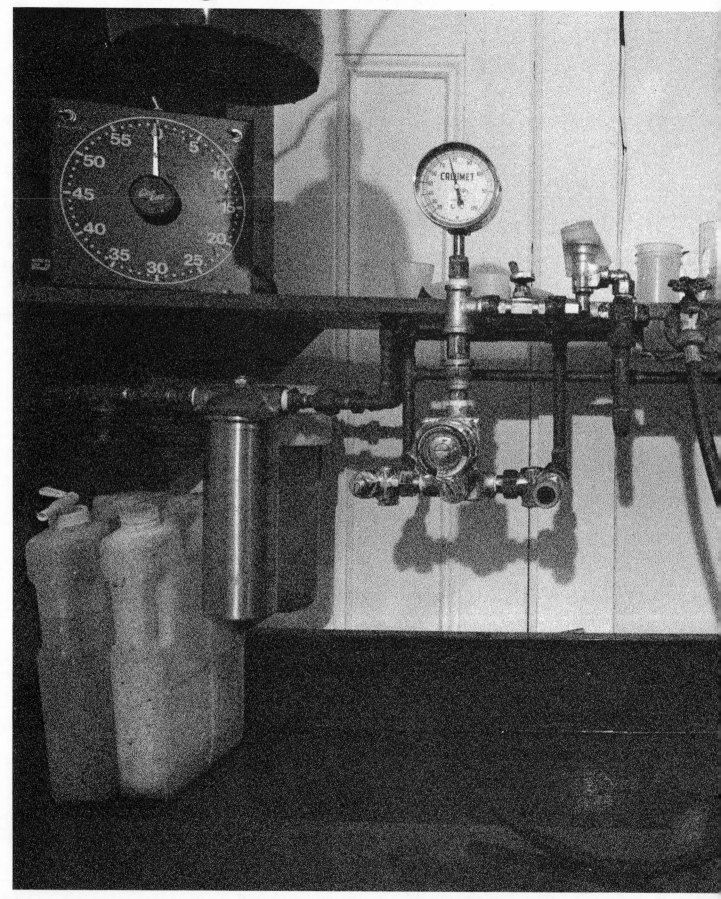

Contents

Tools ● **58**
Installing Partitions ● **60**
Hanging Doors ● **62**
Installing Sheetrock ● **64**
Getting to Know
Your Plumbing ● **66**
More About Your Plumbing ● **68**
Typical Darkroom Plumbing ● **70**
Roughing in the Plumbing ● **72**
Installing Supply Lines ● **74**
Installing the Drain ● **76**
The Easy Way Out
and Unique Solutions ● **78**
A Modular Plumbing System ● **80**
Introduction to Electricity ● **82**
Electricity in the Darkroom ● **84**
Tools and Materials
for Electrical Work ● **86**
Wiring the Circuits ● **88**
Modular Control Panel ● **90**

Most communities require a permit to do plumbing or electrical work and in many cases require that the work be performed or supervised by a licensed electrician or plumber. These legal requirements are designed to ensure that the work is done properly and safely. Failure to comply with local laws is not recommended and can have a significant impact on your legal liabilities should any personal or property damage result.

Tools

The tools required to build a darkroom are common ones that you may already own. If you had to buy all of the best available tools, the total expenditure would be less than $200.00, which is reasonable considering how much you would have to pay to have the room built for you. If you are converting an existing room and plan on adding only wiring or plumbing, the cost will be even less.

Take it from one who has learned the hard way: buy only the best tools. With reasonable care they will last a lifetime, whereas cheap tools probably won't last through the first job. The tools shown on these pages are the standard ones required to do carpentry, plumbing, and electrical work.

Tools are generally classed as hand tools (powered only by the human hand), power hand tools (operated by hand but powered by a motor) and power tools (bench mounted and powered by a motor). The tools demonstrated in this book are from the first two categories; large power tools are not necessary.

Hand Tools

Hand Saw. These come in two kinds: crosscut (used to cut across the grain of the wood) or rip (used to cut along the grain).

Plumb Bob. Suspended on a string, these are used to determine a perfect vertical line. When installing framing, paneling, etc., they will ensure that the verticals are accurate.

Pliers. Pliers can be used for holding, turning, bending, or crushing. The best kind are slip-joint pliers that adjust to handle either larger or smaller pieces.

Chalk Line. When the string is pulled out of the holder it is covered with chalk dust. If you hold both ends down and snap the taut string, it will snap against the floor or wall and leave a line of chalk. This is a simple way to lay out the floorplan on the basement floor or to indicate where pipes or counters are to be run along a wall. You can also use a piece of string and chalk, snapping it against the floor in the same manner, which works just as well although a bit messier.

Level. These are used to determine if something is level in either the vertical or horizontal directions. A curved fluid-filled tube with an air bubble in it indicates when the level (and whatever it happens to be held against) is level and, if not, what direction it is tilted.

Hammers. The best hammer for carpentry work is the curved claw model that enables you to drive a nail and then pull it out using the other end.

Combination Square. Combines the functions of a ruler, square, and level in one unit. Ideal for general purpose work and its small size makes it easy to work with.

Tape Measure. You can buy several different types of rulers, including the folding zig-zag ruler or the tape rule shown here. Most types will suffice for general construction work, but this one is slightly more convenient since it is small and comes in lengths ranging from 6' to many hundreds of feet.

Adjustable Wrench. Rather than buy a whole set of open-end wrenches, buy one of these. They come in various sizes and the one you select should be based on the maximum size of nut you expect to encounter. Because the largest nut is most likely to be in the plumbing, a wrench for working on plumbing fittings should have jaws that open at least 1½ inches.

Pipe Wrench. Used primarily to fasten and unfasten threaded steel pipe.

Chain Wrench. Used to twist large drain/waste/vent pipe in sewer systems.

Screwdrivers. These come in two types, slot headed and Phillips, for two different kinds of screw heads. They are easy to tell apart: the Phillips screw has crossed slots, and the other has a single straight slot running across the screw head. You should have a variety of sizes of screwdrivers. The head should fit snugly into the slot of the screw or you will damage the screw, making it difficult to remove.

Tubing Bender. Used to bend copper tubing so that the walls do not collapse and restrict the flow.

Flaring Tool. Used in flaring the ends of copper tubing to be used in plumbing and incoming water lines. Simplifies the installation and eliminates the need for using a torch and solder.

Hacksaw. This tool is very handy for cutting copper or plastic plumbing pipe. It can also be used to cut cast-iron pipe or ventilating duct.

Tubing Cutter. Designed to make even, smooth cuts in copper pipe or tubing. Makes working with pipe easy. As the tool is revolved around the tube, the blade gradually cuts deeper and deeper until the piece you want drops off.

Propane Torch. If you choose to use soldered joints in your plumbing system, you will need a torch to solder the joints.

Power Tools

Sabre/Bayonet Saw. If you plan on buying only one power tool, this should be it. It is by far the most versatile tool available for cutting wood, plastics, and metal. Many styles of blades are available, ranging from fine wood scroll blades, to blades that cut cardboard, to blades that cut sheet steel. The narrow blades allow you to drill a starter hole in a wall and then cut out an opening without using additional tools.

Drill. The power drill is usually a standard tool in the home workshop. Its basic function is to drill holes, but special attachments can be added to grind, polish, and sand. Slightly more expensive models have reversing motors and variable speed controls which are especially useful because they allow you to start a hole with a low speed thus giving you more control. For darkroom building, a hand brace and bit will suffice if you don't already have a power drill.

Sander. The power sander can save you hours of work, and is certainly a good investment.

Installing Partitions

Building the Room Itself

If you are planning to install the darkroom in a large space such as a basement or garage, the first step is usually to partition the darkroom off. If this is not done, it will be much more difficult to control both the cleanliness and the light-tightness of the space. It is relatively easy to make partitions; building door frames and hanging doors can be greatly simplified by buying set-up units.

There are two kinds of partitions, load-bearing and nonbearing. If you have to move an existing partition to accommodate the new ones for your darkroom, you should know which kind it is. A load-bearing wall supports part of the weight of the house and its removal can cause serious problems in upstairs floors and ceilings. A nonbearing wall can be removed without replacing the support, as you would have to do with a bearing wall; however, even nonbearing walls may contain pipes or electrical wiring which must be rerouted. Study

the wall carefully before deciding to move it. Wiring is fairly easy to reroute; plumbing is much more difficult. The detailed plans in this section deal with only the installation of new partitions that are nonbearing.

Wall partitions can be built with either 2 x 4 studs or 2 x 3s. The 2 x 4s are not significantly more expensive and do make a more stable wall, especially if cabinets and sinks will be mounted to it.

Always be sure to use well-seasoned lumber. If you use inexpensive green or wet lumber it will tend to twist and bend as it dries within the wall. This will crack the wall board and also make door frames and enlarger mounts move out of alignment. Specify "dry" lumber when ordering. For economy always use the lowest grade of lumber suitable for your project. For wall studs this would be "construction," "standard," or "utility" grades if your partitions are nonbearing and "stud" grade if they are either load-bearing or nonbearing.

When preparing plans, remem-

ber that the measurements of lumber refer to the lumber before final cutting by the lumber yard. Therefore, a 2 x 4 is actually 1½ x 3½ and a 2 x 6 is actually 1½ x 5½.

Marking the Layout on the Floor

The first step in building the room is to mark the floor to show where the various walls and doors are to be placed. Using a chalk line, transfer the measurements from your layout to the floor. To make long straight lines with the chalk line, either drive nails at both ends so that the string can be stretched between them, or ask two friends to hold the ends down. With the string held tautly against the floor, lift it an inch or so straight up by grasping it in the middle of the run and let it snap back against the floor. A faint chalk line shows where the wall should be installed. You can measure off door openings against this line and indicate the markings on the floor.

Door and Header Details

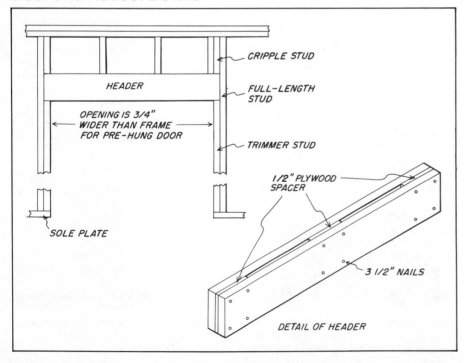

CRIPPLE STUD

HEADER

FULL-LENGTH STUD

OPENING IS 3/4" WIDER THAN FRAME FOR PRE-HUNG DOOR

TRIMMER STUD

SOLE PLATE

1/2" PLYWOOD SPACER

3 1/2" NAILS

DETAIL OF HEADER

Marking a Chalk Line

LIFT

Partition Parts

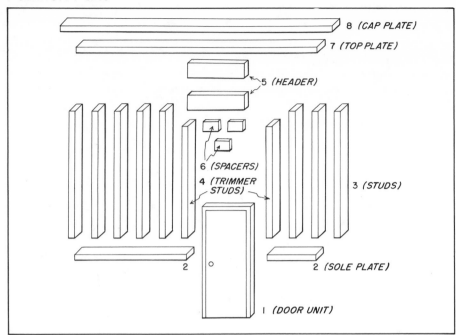

Assembled Partition

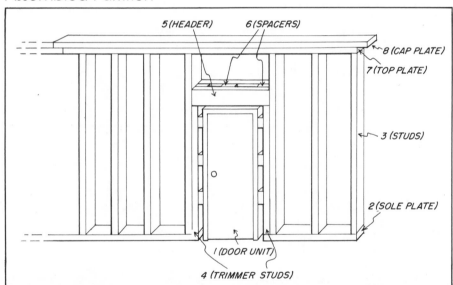

Joining Partitions

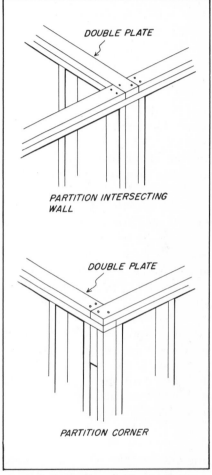

Partition Assembly. This two-part drawing shows a typical partition in both its assembled and unassembled state. If you are planning to build a light trap, the construction would be identical except the door and door frame would not be used. Instead, additional partitions would be built in the pattern selected for the light trap.

Begin the cutting and assembling by measuring off the sole plate (#2), cutting it to allow for a door opening if one is to be in that partition. The opening should be the width of the door frame plus an additional ¾" clearance needed for making adjustments when the frame is mounted into the wall.

Next cut the studs (#3) so that there are enough to be spaced every 16" along the sole plate. Cut a top plate

(#7) to the same length as the sole plate (including the door opening).

Cut trimmer studs (#4) used to support the header over the door frame opening. These should be cut long enough to go from the top of the sole plate to ¾" above the door frame.

Now cut two pieces of 2 x 6 (#5) for use as the header. Since they will be turned sideways to the other studs, their width will be too narrow unless spacing (#6) is used. If the wall is being constructed of 2 x 4s, an ideal "spacer" would be a piece of ½" plywood cut to size. Two pieces of 2 x 4 used sideways with a piece of this spacer in between equals the width of the 2 x 4 studs it will come in contact with. If your wall is being built of 2 x 6s to accommodate a sliding door, the header should be con-

structed of two pieces of 2 x 4 with spacers cut from another piece of 2 x 4 so that they are 2¼" wide.

After you cut and lay out all of the pieces on the floor, you can begin assembling the wall. Start by connecting the top and sole plates at either end to the full-length studs. Now put the door frame in place and nail in the trimmers and full-length studs, remembering to leave ¾" clearance on top and sides. Now nail the header into place over the trimmers. Install the remaining studs, raise into place, and nail into the adjoining wall. Assemble the second and third walls in the same manner. Once they are raised into place, all of the walls should be connected with a cap plate (#8) as detailed in the figure.

Hanging Doors

Installing Prehung Door Frame

When the walls have been raised into position and plumbed to ensure they are vertical, the door frame can be installed. Prehung (set-up) doors are available from most lumber yards, and since the door is already mounted to a frame you do not have to install hinges, handles, lock sets, etc. It is by far the easiest unit to use.

The first step is to cut five blocks half the width of the clearance left when the rough frame was assembled (⅜"). Nail one block to the top and one to the bottom of the rough opening on the side where the hinges are to be placed. Using a level, make sure they are exactly vertical. If they are not, you will have to plane the top or bottom one to make them so. Now install two blocks at the exact height of the door hinges to provide them with support, and place the remaining block halfway between them. Using the plumb bob, make sure that they are in line with the first two installed. Install the door frame and nail it to these blocks using 3" nails. Once the hinge side of the door is nailed into place, the door can be closed and the other side of the frame shimmed into place using old shingles that are wedge shaped between the door frame and trimmer stud. Lightly tap them into place so the frame comes within ⅛" to ¼" of the door itself. Be sure not to use too much pressure when inserting the shingles; that can cause the door frame to bow out, making the door stick. Use a level to ensure that the door frame is level on all sides. Open and close the door to make sure it is properly installed.

After the wall board has been installed, the door frame and the gap between it and the trimmer studs can be covered by casing as shown in the figure.

Door Frame in Place

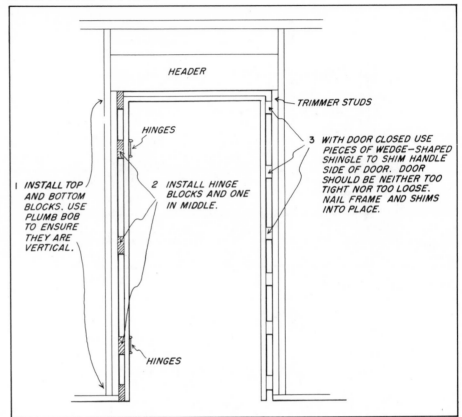

- HEADER
- TRIMMER STUDS
- HINGES
- 1 INSTALL TOP AND BOTTOM BLOCKS. USE PLUMB BOB TO ENSURE THEY ARE VERTICAL.
- 2 INSTALL HINGE BLOCKS AND ONE IN MIDDLE.
- 3 WITH DOOR CLOSED USE PIECES OF WEDGE-SHAPED SHINGLE TO SHIM HANDLE SIDE OF DOOR. DOOR SHOULD BE NEITHER TOO TIGHT NOR TOO LOOSE. NAIL FRAME AND SHIMS INTO PLACE.
- HINGES

Casing

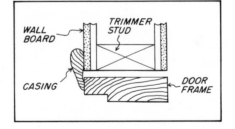

- WALL BOARD
- TRIMMER STUD
- CASING
- DOOR FRAME

Sliding Door

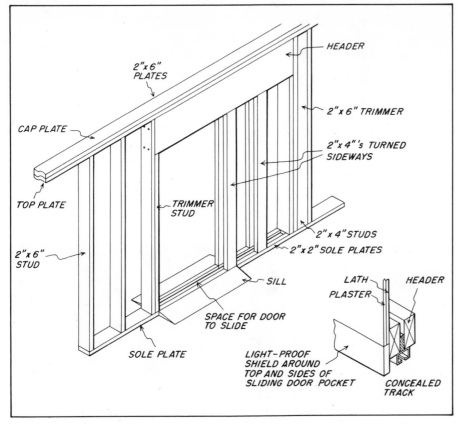

2"x 6" PLATES

CAP PLATE

TOP PLATE

2"x 6" STUD

HEADER

2"x 6" TRIMMER

2"x 4"'s TURNED SIDEWAYS

TRIMMER STUD

2"x 4" STUDS

2"x 2" SOLE PLATES

SILL

SPACE FOR DOOR TO SLIDE

SOLE PLATE

LIGHT-PROOF SHIELD AROUND TOP AND SIDES OF SLIDING DOOR POCKET

LATH

PLASTER

HEADER

CONCEALED TRACK

Pocket Sliding Door. If you are going to install a sliding door, the construction details are slightly different from those of a regular hung door. The wall must be thick enough to accommodate the door and its track within the partition itself and there must be a space left in the door frame for the door to enter the partition when it is opened. The figure shows how the track and wall should be constructed. All steps are the same as for the regular wall except the header is twice the width of the door and the space between the 2 x 2 sole plates must be wide enough to accommodate the door track. The door and track should be bought before assembling the wall because track widths vary and you should be sure the opening you leave is wide enough.

In light-proofing the door, it is necessary to bring the 2 x 2 sole plates across the opening, which can create a hazard when entering or leaving the room. This hazard can be eliminated by cutting two wedge-shaped sills to be placed on either side of the sole plate.

Installing Backing

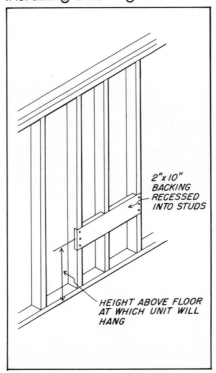

2"x 10" BACKING RECESSED INTO STUDS

HEIGHT ABOVE FLOOR AT WHICH UNIT WILL HANG

Backing. In some places you will need support for heavy objects such as sinks, enlarger mounts, cabinets, and phones. Special reinforcement, called backing, should be installed at these locations. Use 2" x 10" board and notch the studs to accommodate it. The backing should be securely nailed to the studs and can span any distance ranging from the distance between two studs to an entire length of wall. Its location should be indicated on your elevations because it will be covered by wall board before the sinks and other pieces of equipment are attached to it. If you don't remember where the backing is you could have a problem locating it.

Installing Sheetrock®

Finishing and Painting

This step takes place after the plumbing and wiring have been installed. It is the final step in finishing the room and helps to make it more attractive and easy to keep clean. The materials used help to determine the quietness of the room, the ability to maintain a stable temperature inside it, and its degree of light-proofness and light-reflecting qualities.

Most rooms today are finished in drywall, which is a gypsum board consisting of a noncombustible core with a paper surface on front, back, and edges. It is easy to cut and install. Panels come in standard 4' widths and if you put your studs on 16" centers one panel will cover four studs, from the middle of the first stud to the fourth. Some boards have beveled edges where sheets meet each other, allowing for easy filling of the cracks. If your panels have these bevels, they should be facing out. It is recommended that you use panels of either ⅜" or ½" thickness. The floor-to-ceiling height should be measured and the panels cut to fit and installed with nails made specifically for wall board installation.

1. Scoring. Place panel with ivory-colored side face up. Measure and mark panel size at opposite edges of panel. Line up straightedge with the marks. Hold straightedge firmly against the panel while scoring down through paper and part of panel core. Hold knife at slight angle away from straightedge to prevent cutting into straightedge.

2. Cutting. Break core of Sheetrock panel by snapping away from the scored face paper. Complete cutting by running knife through back paper.

3. Sanding Edges. Smooth all cut edges of panels with coarse sandpaper wrapped around a hand-size block of wood. Keep panel edges as square as possible.

4. Nail Attachment. For ¼", ⅜", and ½" thick panels use 1¼" GWB-54 annular-ring nails. For ⅝" panels, use 1⅜" annular-ring rails. Space nails max. of 7" apart on ceilings, 8" on walls and at least ⅜" from ends and edges of panels. Hold panel tight against framing and nail center of panel first, perimeter last. Leave small dimple at nailhead for filling with joint compound. Do not overdrive or counter-sink nails. This results in breaking the face paper or fracturing core of panel.

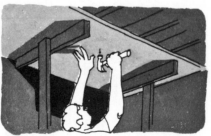

5. Ceilings. Apply ceilings first, with two people handling panels if possible. If you're doing job alone, make simple T-braces consisting of 2' lengths of 1 x 4s nailed to 2 x 4 uprights that are ½" longer than floor-to-ceiling height. Wedge T-braces between floor and panel to support panel while nailing and assure firm contact with joists.

6. Walls. Carefully measure locations and sizes of all openings in panels for fixtures. Cut with keyhole saw. Fixture plate must cover cutout completely. For horizontal application, apply top panel first, tight against ceiling panels. Stagger end-joints in adjacent rows. Use vertical application when ceiling height is over 8'-2" or if this results in fewer joints, less waste. Cut panels accurately so that they do not have to be forced into place.

Courtesy United States Gypsum Company

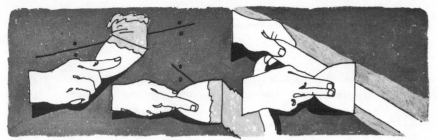

7. Taping. Apply a large daub of joint compound across joint. Level with surface of channel formed by tapered (wrapped) edges of board by drawing knife in direction of joint. Do not leave bare spots. Immediately apply Perf-a-Tape Reinforcing Tape. Center tape over depression and firmly press into compound with joint-finishing knife. Remove excess compound but leave sufficient amount under tape for strong bond. Embed tape with thin layer of compound to fill taper flush with panel surface. Allow to dry.

To finish end joints (not paper wrapped), apply compound and center tape directly over joint. Do not overlap tape applied at tapered joints.

8. First Coat, Nails. Draw bare joint-finishing knife over nails. If metallic ring occurs, drive nail below surface. Fill all depressions with compound, level with surface. Apply compound with sweep of knife in one direction; wipe off excess compound in opposite direction, level with panel surface.

9. Second Coat. After taping coat has dried (at least 24 hrs.), smooth lightly with sandpaper to level surface. Apply compound, using larger knife, with compound extending 2" beyond taping coat. Feather both edges of compound flush with face of panel by applying pressure to the edge of knife riding the panel. Allow to dry. Finishing end (butt) joints is same as for tapered-edge joints except that compound should cover a width of about 7".

Apply second coat to nailheads.

10. Inside Corners. Use a joint-finishing knife to butter joint compound on both sides of corner. Extend compound slightly beyond area to be covered by tape.

11. Inside Corners, Continued. Fold tape along center crease and lightly press into position. Firmly press both edges of tape into compound with finishing knife, removing excess compound. Leave enough compound under tape for strong bond.

12. Inside Corners, Second Coat. After joint compound has dried (at least 24 hrs.), apply second coat. Cover one side at a time, allowing first side to dry before applying compound to second side. Feather out onto face of panels beyond first coat.

13. Third Coat. Same procedure as No. 9 but feather about 2" beyond second coat. Apply third coat to nailheads. Allow to dry and sand lightly. Remove sanding dust from surface by wiping with a damp cloth.

14. Sanding Joints. Use a fine-grade, open-coat sandpaper wrapped around sanding block. After drying, lightly sand imperfections in finished joints, corners, and over nailheads. Do not rough up face paper. Do not use power sander. Remove sanding dust.

For Painting. After drywall surfaces have thoroughly dried, seal with Sheetrock Sealer, Grand Prize Primer-Sealer or TAL Enamel Undercoat. Finish with Grand Prize Latex Paint or Eggshell Finish, TAL Alkyd Flat Paint, TAL Super Ceiling White, or Grand Prize Latex Semi-Gloss or Durabond Lustre Enamel.

Getting to Know Your Plumbing

Nothing is quite so intimidating to the prospective darkroom builder as the thought of installing new plumbing. There is something awesome about cutting into the pipes of one's home when you are not totally confident that the job can actually be successfully completed. It is this fear of the unknown that makes plumbing a forbidding prospect. This fear can be overcome so you don't have to give up in advance and pay a plumber to do the entire job. Perhaps the job required is relatively simple and requires no major work at all. If not, you can study the basic theory of plumbing. This section will be a good start, but other references should be searched out in the local library, especially if your home is plumbed in materials not covered in this book.

You should tackle difficult jobs only if the water system can be shut off for a day or so in case something serious does happen and you cannot get professional help to correct it or complete the job yourself. The recommended method is to find a plumber who will do the planning and guide you through the intricacies of the job, but allow you to do all of the routine work. This results in a lower cost to you and it also ensures that the job will meet the local building codes and pass inspection. Also, if something does go wrong, there is someone to call on for help. There are four major steps involved in installing a plumbing system:

1. Locate and identify the existing plumbing and select a point at which the new system can tap into the old.

2. Draw plans for how the lines will run and where the connections will be made to the hot and cold supply lines, the drain, and the vent system.

3. Measure the runs and draw up the specifications for the materials needed, including pipe or tubing, fittings, pipe hangers or supports, and tools.

4. Install the system and check it out to see that it works properly. Invite the building inspector from your local office over to inspect it and give it a passing or failing grade. It usually helps to have touched base with the building inspector first. You'd be surprised at the kind of free advice you can receive before the job is begun.

How to Locate a Place to Tap into the System

When deciding where to put a darkroom in a house or apartment, you must consider the ready availability of hot and cold water and access to a drainage system. Before making the final decision on the darkroom placement you should find the possible points to tie into the plumbing system.

Plumbing will be either exposed or concealed. If it is exposed, you should have no problem identifying the various elements by tracing the supply lines from the meter and the drain lines from the sewer connection. If the plumbing is concealed, however, as it will be in most houses and apartments, you will have to involve yourself in some sleuthing. Here are clues that you should look for:

1. In bathrooms, kitchens, or utility rooms the plumbing will usually be exposed under a sink. That will make a natural tie-in point for both the supply and the drain and connecting at this point will eliminate any worries about having to install a venting system since one already exists for the sink.

2. If you are converting a spare room, the wall it shares with either a kitchen or bathroom (provided that the wall in the other room has the sink or toilet against it) is the one most likely to have plumbing. If you have to break through a wall to find the plumbing, first remove any molding and see if the plumbing can be located through the exposed opening. Otherwise, careful measurements in the one room can be transferred into the other to give an accurate location. It is also sometimes possible to hear the water in the pipes, especially if someone turns the water on and off in a nearby sink while you listen.

3. If you are converting a spare room that is either over or under an existing system, it is relatively easy to tap into it vertically by running pipes between the wall studs. This will allow you at least to utilize the existing drain and venting system.

4. If you are converting an attic, garage, or loft, there may be no existing plumbing readily available and a major installation could be required.

Typical Plumbing System

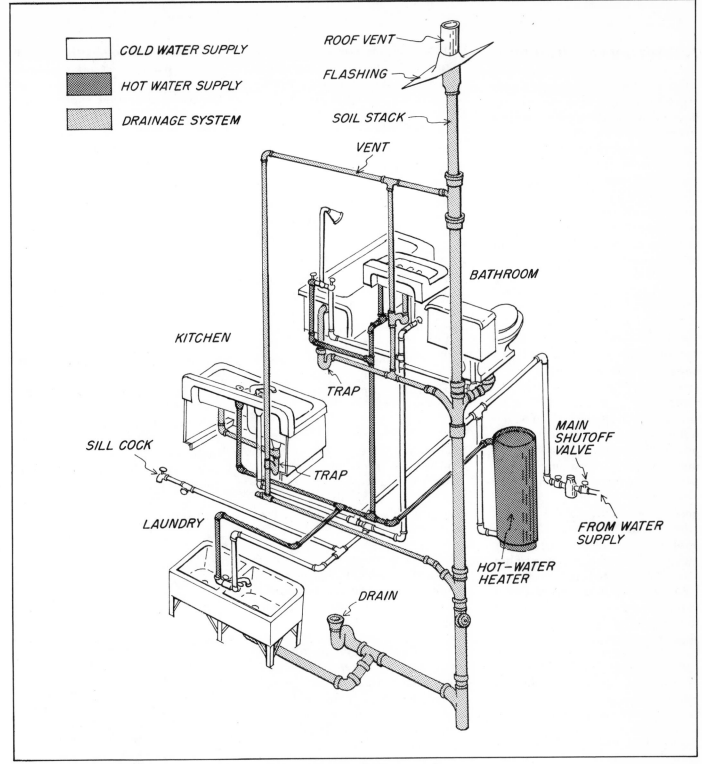

COLD WATER SUPPLY

HOT WATER SUPPLY

DRAINAGE SYSTEM

ROOF VENT

FLASHING

SOIL STACK

VENT

BATHROOM

KITCHEN

TRAP

MAIN SHUTOFF VALVE

SILL COCK

TRAP

FROM WATER SUPPLY

LAUNDRY

HOT—WATER HEATER

DRAIN

Typical Plumbing System. The plumbing system in a typical home or apartment will look something like the figure shown here. It is composed of three main subsystems:

Supply. Both the cold water (coming directly from the meter) and the hot water (coming from the meter through the hot water heater) that feed the faucets throughout the house.

Drain. The system that removes the waste water from the home. Since this system is not under pressure, all drain pipes must be sloped toward their eventual outlet.

Vent. This system equalizes the pressure in the drain system so that a quick rush of water does not create a vacuum which will empty the traps and allow gases from the city sewer lines or septic systems to enter the home.

More About Your Plumbing

Analyzing the Plumbing

After locating the pipes and deciding where to tap into the existing lines, you should identify exactly the materials and the sizes of the pipes so you can join the existing system properly to any new plumbing. The sections in this book dealing with the installation of the supply lines and drain systems will assume that the new supply lines will be run in copper and the new drain lines in plastic.

Identifying the Pipes

Hot Water Supply Lines. Both the hot and cold supply lines will usually be the smaller pipes in the system. In very few cases will they be more than 1″ in diameter. To be sure of which is which, turn on the hot water faucet in the nearest sink or tub and let it run for a few minutes. The hot water running through the pipes will gradually make one warmer than the other. If neither gets hot, you either have the wrong pipes or the wrong sink, so try another sink before looking for more pipes. If the line is very hot (or if the furnace is not on and the pipe isn't hot even with a faucet running) it may be a line for hot water to radiators, which you should not cut into.

Cold Water Supply Lines. These will usually look identical to the hot water supply in material and size and normally run parallel to it.

Drain. This will usually be larger than the supply lines, with a diameter of 1½″ to 2″ (the main stack will run straight up and down and is 6″ to 8″ in diameter). Because the drain pipe is not under pressure, it must slope downward from the sink or tub outlet. Use a level to see that it is sloping down. The slope should average about ¼″ per horizontal foot.

Vent. This line will normally tap into a drain line downstream from a trap. It will tend to run upwards because it acts as a gas outlet.

Determining the Materials

Once you know which pipes are which, the next step is to determine what they are made of. There are generally four kinds:

Copper. This comes in rigid and flexible kinds. You can tell one from the other by the number of bends in it. Because flexible copper tubing is normally sold in rolls it will have small bends and bumps after it has been unrolled and installed. Rigid piping, however, runs straight.

Galvanized Steel Pipe. This is hard and straight pipe. If you scratch it you will see the shine of steel. It often has a dark color from tarnish and a galvanized surface pattern you probably have seen on galvanized garbage cans.

Plastic. A good way to identify plastic is to shave it slightly with a knife. The plastic can be shaved away whereas any other material will just be scratched.

Hubless Cast Iron. If you find this material you have probably encountered a drain or vent. It will usually be larger than supply pipe and is joined with either leaded joints or special connections.

Darkroom Planning and Shopping

Before buying the materials you need, you should first think through the basic requirements of your darkroom.

What is the quality of the incoming water? Is it too hard? Is it full of suspended particles that will end up as white spots on good prints, requiring more time spotting and less time taking pictures? Is there sufficient hot water in the water tank to meet your needs as you foresee them? Is the temperature of the incoming water such that it would be convenient to have a water temperature regulator?

Water Too Hard. Hard water can make chemical mixing more difficult. The problem can be alleviated with a water softener or chemical additives.

Suspended Particles in Water. Often an accumulation of particles either in the city pipes leading to your house or in the house plumbing itself becomes dislodged and comes out of the water faucet whereupon the particles attach themselves to the finest negative you ever made. One way to prevent this is to use water filters (see pages 124-125 for examples of available equipment).

Temperature Regulation. If you have done much darkroom work you will have discovered long ago that there are two main problems with temperature regulation either when mixing chemicals or when washing prints and negatives. The first is caused by your sink having two separate nozzles, rather than one, with hot water coming out of one and cold out of the other. The only solution is to make connections to each faucet with a threaded coupling and have the two streams merge through an attachment. However, you will still be left with the second problem that is intrinsic to all systems: keeping the water temperature steady at the temperature you require. To make sure that the water flows evenly at 68°F (20°C), buy a water temperature regulator (see pages 126-129

for available units). The installation of this device ensures that once the temperature is set the water will remain at that temperature plus or minus the manufacturer's specifications (usually ½°F).

Number of Faucets. In addition to the water quality, you should also consider the number and types of outlets available on the sink. The major ones are:

Regulated Output. This type is connected through the temperature regulator and used primarily for mixing chemicals, washing prints and negatives, and providing a water bath for development.

An Unregulated but Mixed Hot and Cold Outlet. This unit can be used separately to clean equipment or as a unit to mix chemicals when the other outlet is being used to wash prints.

A Spray Nozzle. Normally found on kitchen sinks. Attached to a long hose it can be used for such jobs as cleaning of equipment and the sink itself. This nozzle should always be connected to the system with a high-pressure rubber hose and a shut-off valve. Both devices will prevent the hose from breaking while you are away from home.

It is helpful if all outlet faucets swivel and are high enough in their clearance to allow placing tall mixing graduates under them. Normally there should be a minimum of 15" clearance from the bottom of the sink (or the top of the duckboards if you use them) to the bottom of the faucet.

Later in this section we will describe how to build a modular unit containing all of these devices. The unit is designed to be detachable and can move with you from darkroom to darkroom.

Required Materials and Tools

To install a plumbing system, special tools are required as are certain materials such as pipes and fittings.

This section will discuss the most commonly available.

Materials. Household plumbing comes in a wide variety of materials with the most commonly used being copper, galvanized steel, cast iron, and plastic. Copper is frequently used for supply lines because it satisfies the widest number of municipal codes. Drain lines are often installed in plastic because it is acceptable in a wide variety of locations and is much easier to work with than other materials.

Supply Lines. Copper supply lines come in two major kinds, rigid and flexible. Both have their advantages and disadvantages, and you should make your selection based on your particular needs. Rigid pipe is easier to connect to fittings because its rigidity makes it easier to cut evenly and keep straight. Flexible pipe or tubing is easier to install on long runs, especially those that have occasional obstacles preventing running it in a straight line. Each time the rigid variety turns a corner even slightly, a fitting is required; the flexible kind can be bent as required and less joining is needed.

Copper pipe and tubing comes in three main types based on the thickness of its walls. This thickness determines the amount of pressure the line can safely handle:

Type K—Thick Walled
Type L—Medium Walled
Type M—Thin Walled

Flexible tubing comes in only Type K and Type L. Type L, either in rigid or flexible varieties, is the most commonly used interior pipe and is suitable for the darkroom. In most cases you will require adaptors to tap into the existing lines in your house. You will normally tap into either a ⅜", ½", or ¾" supply line. The size of the line to be tapped can be determined by referring to pages 66-67. The reduction from a larger pipe to the ⅜" or ½" pipe you will be using for the new plumbing is done with a reducing T. The kind of T you require is determined by the kind of pipe you are tapping

into. The fitting required to tap into a galvanized pipe is different from that required to tap into a copper pipe.

Drain Lines. Plastic pipe is a relative newcomer in the plumbing world and as a result its ability to satisfy building codes is not yet uniformly established across the country. You should check with your building department to see if this material will meet the local requirements. The big advantage of plastic and the reason it is being recommended in this book is that it is by far the easiest material to work with. Drain pipe made of galvanized steel or cast iron in the large sizes needed can be very heavy when installed in long runs and is therefore very difficult to work with. Plastic pipe, on the other hand, is no more difficult than building a model airplane and the only tools required are a saw and glue. An additional advantage is that it is not corroded by darkroom chemicals and will last indefinitely without any problems. To install the drain, you will need selected fittings and an adaptor to the existing drain in addition to the pipe itself.

Three main types of plastic pipe are on the market and their intended uses are somewhat different. The major types are:

PVC—Polyvinyl chloride
CPVC—Chlorinated polyvinyl chloride
ABS—Acrylonitrile butadiene styrene

All three can be used in cold water supply lines, but only CPVC can be used in hot water lines or a drain system. CPVC has been designed to withstand higher temperature without failure.

Typical Darkroom Plumbing

The typical darkroom plumbing requirements are relatively simple. This section shows most of the elements that will be encountered in the existing system and illustrates most of the materials needed for the new plumbing. It is an idealized plan but by using it as a guide you should be able to design and specify the materials you need for your own system.

Shopping List for Plumbing Installation.
This general plan for darkroom plumbing illustrates and identifies all of the parts required. The numbers are keyed to the shopping list and to the photographs on the opposite page.

Shopping List

General Plumbing—Supply
(7) Copper pipe (rigid)
(7) Copper tubing (flexible)
(11) Saddle T adaptors
(11) T adaptors
(17) 90° elbows
(12) Hose bibs
(11) Reducing Ts
 Caps
(18) Adaptors to existing pipes
(14) Couplings

*Faucets if not using filters
and temperature regulators*
(8) Long-necked swivel mixing
 faucet
 Spray hose attachment
 Plumbers putty

Materials needed to build modular plumbing unit with both filtration and temperature regulation (described on pages 80-81)
(5) Hot line filter
(5) Cold line filter
(9) Temperature regulator
(17) Elbows
(11) Ts
(7) Pipe
(9) Faucet
(8) Long-necked swivel mixing
 faucet (for unregulated outlet)
(13) Hose
(6) Hose connection

Drain
(3) Plastic drain pipe
(4) Adaptor
(19) Elbows
(2) Trap
(1) Sink strainer/drain

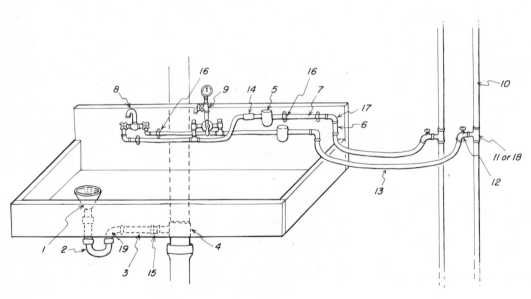

1	SINK DRAIN UNIT	*7*	COPPER PIPE	*13*	HIGH PRESSURE WASHING MACHINE HOSE
2	P–TRAP (PVC)	*8*	UNREGULATED WATER MIXING VALVE	*14*	COUPLINGS
3	PVC PIPE	*9*	TEMPERATURE REGULATED WATER MIXING VALVE	*15*	PVC COUPLINGS
4	ADAPTOR TO SOIL STACK	*10*	EXISTING SUPPLY LINES (HOT AND COLD)	*16*	PIPE HANGERS
5	WATER FILTERS	*11*	T's TO ADAPT FROM OLD SYSTEM TO NEW	*17*	ELBOWS
6	HOSE CONNECTIONS	*12*	HOSE BIB WITH SHUT OFF VALVE	*18*	ADAPTOR FROM THREADED PIPE
				19	PVC ELBOW

1. Sink Strainer/Drain

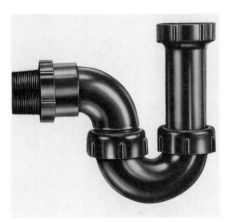

2. Trap

3. Plastic Drain Pipe

5. Hot and Cold Line Filters

6. Hose Connection

8. Long-Necked Swivel Mixing Faucet

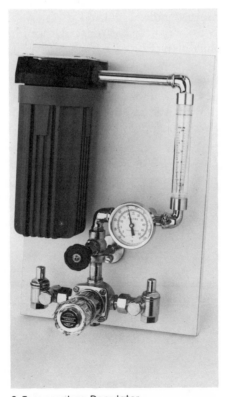

9. Temperature Regulator

11. Reducing T

12. Hose Bib

14. Coupling

15. Pipe Coupling

16. Pipe Hanger

17. Elbow

18. Adaptor

Roughing in the Plumbing

Installation

If you have to do major work to install the system, begin by roughing in the plumbing. Plumbing is installed in new construction after the room has been framed but before the finishing wall board has been put up. If you are not doing new construction, the plumbing can be hidden behind cabinets, covered by a false wall, or left exposed, although that can become a dust collector.

If you are installing the plumbing in a newly framed (or exposed) wall you should consider recessing the pipes into either the studs (the 2 x 4s holding up the walls) or the joists (the beams holding up the ceiling). When doing this there are a few things to remember:

1. All holes in joists should be centered in the vertical direction and the hole diameters should be no greater than one-quarter of the depth of the joist.

2. A notch can be cut in a joist as long as it does not fall in the middle and is as close to a support as possible. The notch should be no more than one-sixth the depth of the joist and should be reinforced with 2 x 4s nailed under it (if it's on top of the joist) or reinforced with a steel brace if the notch is on the bottom.

3. When notching studs, a notch cut into the top half should be no deeper than two-thirds of the stud's depth but on the bottom no deeper than one-third. The notch should then be reinforced with a reinforcing plate.

Adapting off the Main Supply Lines

The next step after roughing in the plumbing is to make the connection between the new system and existing pipes. This is normally done with adaptors that serve three functions. The first is to provide an outlet from an existing pipe; by inserting a T fitting into an existing pipe run you add a new outlet to which your supply lines can be attached. The second function is to marry together pipes of different materials. Special Ts exist to connect copper pipe to copper, galvanized, or plastic supply pipe. The third function is to reduce the main line pipe size to the size pipe you plan on using. If you are connecting ⅜" copper tubing to a ⅜" copper supply line all you require is a ⅜" T. However, you may require a T that will reduce a 1" supply in galvanized steel to a ⅜" copper pipe connected to your sink. See the description of a saddle T on page 70 before committing yourself to any more complex method of tapping your existing system. Although the illustration on page 70 shows it being connected to a hose bib so that the sink can be connected through rubber hoses, saddle Ts can be used to connect galvanized pipe to copper, etc. It is a time-saving device that eliminates having to cut and thread steel pipe.

How to Support the Pipes

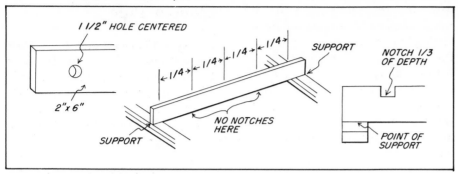

How to Support the Pipes. All pipes should be supported with brackets or hangers at regular intervals. With plastic pipe or long runs of copper, leave the hangers loose enough to allow for expansion and contraction of the pipes.

How to Make a Notch

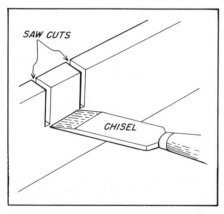

How to Make a Notch. Using a crosscut saw make two parallel cuts into the stud or joist as far apart as the pipe to be inserted is wide. Cut them to the necessary depth and then, using a wood chisel, knock out the piece of wood between the cuts.

Cross Pieces

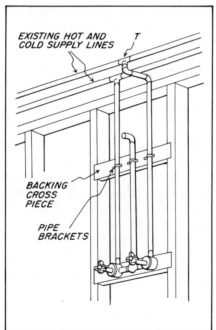

Cross Pieces. In those cases where the plumbing is running parallel to the existing supports, cross pieces can be inserted against which the plumbing can be attached. Be sure the plumbing is recessed sufficiently so that the pipes are hidden but the fixtures will protrude the correct distance after the finish wall board or paneling has been installed.

The advantages of using copper for supply lines are its quality, its ease of installation, and its ability to meet most codes.

Measuring Pipe and Tubing

How to Determine the Diameter Needed. Most of the plumbing you install for the darkroom will be ⅜" or ½" in diameter on the supply side and 1¼" or 2" on the drain side. It is important to determine the size of the existing system into which you will tap to know what size adaptors to buy. The outside diameter is not a completely accurate guide because the diameter in which pipe is sold is determined by the size of the hole running through it. The pipe you normally encounter in the wall has all its holes covered (otherwise it leaks) so you have to make a determination based on the kind of material and the outside circumference. The table below will give a good indication of the size of the existing pipe. Run a string around the pipe and mark where it crosses. The distance between the two points is the circumference of the pipe.

If the length of the string is:	2¾"	3¼"	3½"	4"	4⅜"	5"
The size of the pipe is:						
and the pipe is galvanized:		¾"		1"		1¼"
or copper:	¾"		1"		1¼"	

Measuring the Length of Pipe Needed

When measuring the length of pipe required, take into account the fittings into which the pipe is eventually going to be inserted. The easiest way to do this is first to measure the distance from the end of the fit-ting to where the pipe will be stopped when inserted. Now place the fit-tings exactly where they will be in-stalled in the system and measure the distance from one face of the fitting (the end) to the other. Add this measurement to the distance determined above (add it twice as there are usually two fittings, one at each end) for the total length of pipe required.

Measuring Pipe

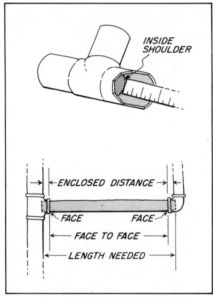

If you plan to work with thread-ed pipe you can use the following table to indicate how far you can expect the threaded pipe to go into the fitting. Again, remember that there will be two fittings so the dis-tance that the pipe goes into the fit-ting should be doubled before add-ing it to the face-to-face measure-ment.

Distance Threaded Pipe Extends into a Fitting

Size of pipe	Distance into fitting
½"	½"
¾"	½"
1"	9/16"
1¼"	⅝"
1½"	⅝"
2"	1-1/16"

Working with Copper Pipe

Cutting. There are two ways to cut copper pipe. The first is to use a hacksaw to make the cut and a file to smooth off the burrs. An easier method is to use a tube cutter en-suring a square and smooth cut in the pipe or tubing.

Connecting Copper Pipe or Tube to Its Fittings. There are four types of con-nections that can be made with copper tubing or pipe: soldered (used for either rigid or flexible pipe), threaded (rigid only), flared (flexible only), and compression (flexible only). Compression fit-tings are the easiest to use and re-quire no tools other than a pair of wrenches.

Using a Mitre Box

When cutting with a hacksaw, it helps to use a mitre box to ensure a square cut in the pipe.

Filing Off Burrs

After cutting the pipe, be sure to file off the burrs left by the saw blade.

Cutting Pipe

The tube cutter works by revolving it around the tube and gradually tightening the screw handle so the rotary blade cuts deeper and deeper into the wall of the pipe. If you turn the handle too fast it can flatten the pipe and make a connection difficult when it comes time to connect it to a fitting.

Using Reamer

All you have to do after cutting with the tube cutter is to rotate the reamer in the opening until the sharp edge is removed and a smooth end is made.

Cleaning End of Pipe

All surfaces should be cleaned and free of grease or dirt to ensure a strong joint. Use steel wool, emery cloth, or a wire brush.

Applying Flux

Flux keeps the tube form oxidizing when you apply the torch, making the solder stick better to the tube and fitting. Coat both the outside of the pipe and the inside of the fitting.

Applying Solder

The hottest part of the torch flame is where the blue flame meets at a point. Apply this portion of the flame to the fitting (not the pipe). Keep touching the solder to the pipe and fitting where they come together. When solder begins to melt, fill the joint evenly (the solder will automatically be pulled into the joint by capillary action) until it is full. Do not move the fitting or the pipe until the solder has hardened; otherwise you may eventually have leaks.

Wiping Joint

Before it hardens remove excess solder with a small brush or wiping cloth.

*The above illustrations are taken from "The Theory and Technique of Soldering and Brazing of Piping Systems," a copyrighted book by H. A. Soskin. For information on obtaining the text for use in classroom instruction, write to NIBCO, Inc., Elkhart, Indiana.

Bending Pipe

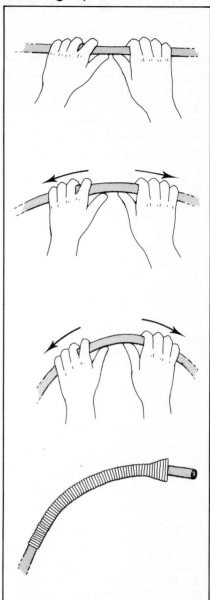

Bending. Copper pipe should not be bent because it is too rigid. Bending copper tube can be a problem because if the tube is bent too fast or too sharply the walls can collapse. This is fine when you're trying to impress someone by bending a Coors can in one hand but the plumbing inspector frowns on it in your plumbing system. There are two ways to prevent this. The first is simple: bend it slowly from the center of the bend outward while supporting the side toward which it's being bent with the thumbs of each hand. Gradually work your hands out as you continue the bending action. Make a few passes along the pipe to complete the bend rather than doing it all at once.

The second and simpler method is to use a bending spring that distributes the force of the bending evenly along the tube and supports the tube so the walls do not collapse.

Installing the Drain

If your building code permits the use of PVC plastic pipe for drains you are in good shape. To install this material you basically need only a saw and some glue. Additional tools may be required where you tie into the existing system. The installation of a drain pipe encompasses three steps:

1. Installing the drain outlet in the sink.
2. Connecting a trap to the sink.
3. Running the drain pipe and connecting it to the existing DWV (drain-waste-vent) system.

Drain Assembly

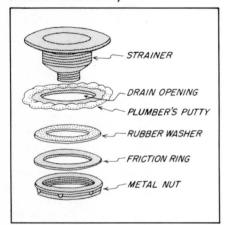

Drain Assembly. Buy a sink outlet unit that matches the drain pipe you intend to install (usually 1½"). Drill a hole in the bottom of the sink at its lowest point and install the unit following the instructions that came with it. Or use the illustration below as a guide.

Fitting Drain in Wooden Sink

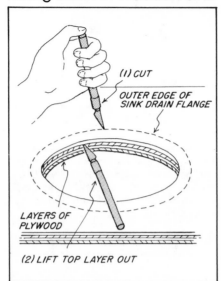

Fitting Drain in Wooden Sink. If your sink drain is being installed in a wooden sink you should first drill, or saw, the hole to hold the unit. The next step is to recess the flange that keeps the drain from falling through the hole. If it is not recessed, water will build up in the sink to the top of the flange. The best way to do this is to insert the unit in the drain, draw a circle around the outer part of the flange, and remove the unit. At this point, carefully cut the circle out to the depth of the flange. If the sink bottom is made of plywood, one of the levels of laminate will be approximately the same height as the flange. After the circle is cut, use the knife to separate the top layer of plywood and remove it.

Assembling the Trap

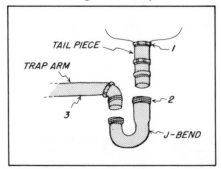

Assembling the Trap. Install a "P" trap consisting of three parts (usually available as a unit): (1) a tail piece coming from the sink drain; (2) a "J" bend; and (3) a trap arm.

Installing the Run to Existing Drain Pipe

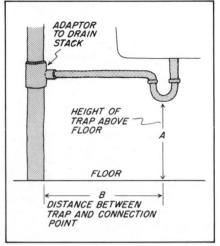

Installing Run to Existing Drain Pipe. The P trap should now be connected to the existing drain system. All drain pipe must slope toward its outlet at the rate of ¼" per linear foot. To determine this, measure the height of the bottom of the trap outlet you have installed and the horizontal distance between it and the pipe to which you will connect the drain. Multiply the ¼" drop times the number of horizontal feet and that will tell you how far to drop the pipe over the entire run. Subtract that from the height the bottom of the trap outlet is above the floor to determine how far up the existing drain you should make your connection. Most building codes require, and common sense dictates, that no part of the drain pipe can be below the top part of the U bend in the trap. This is to prevent the pipe from acting as a siphon and emptying the trap, which would allow sewer gas to enter the darkroom. This requirement, when related to the need for the pipe to drop ¼" for each foot that it runs, means that a sink outlet can be no farther than 4¼' from the stack if the drain pipe you are using is 1¼" in diameter, or 5' if the pipe is 3". This measurement can influence the location of the darkroom and also the sink and the sink's drain. Everything should be done to ensure that the outlet meets these requirements because installing a new DWV stack can be very expensive.

Cutting Drain Pipe

Cutting the Drain Pipe. Working with plastic pipe is easy. First, measure the pipe run needed, as demonstrated on pages 74-75. Then, make the necessary cuts using either a hacksaw or special plastic pipe cutter similar to the one illustrated. When cutting with a hacksaw, use a mitre box to ensure straight, square cuts.

Removing Burrs

After cutting, all burrs should be removed with a burring tool and the end of the pipe cleaned of all dirt and grease.

Aligning Joint

Working with the Pipe. Insert the pipe into the fitting to make sure it fits. Align the fitting on the pipe in the direction it will actually point. Mark the location with a pencil.

Applying Solvent Cement

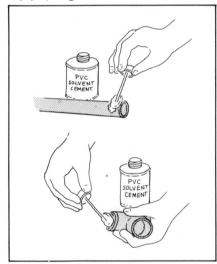

Remove the fitting and apply PVC solvent cement to the outside of the pipe up to the point where it will extend out of the fitting. Also coat the outside of the fittings. Quickly place the fitting over the pipe and align the pencil marks. Because of the speed with which the cement dries this should be done within one minute.

Adapting to the Stack

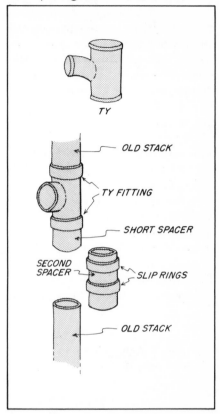

Connecting to the DWV Stack. Connecting the sink to the existing stack requires that the stack be cut and a TY inserted. Hold the TY against the stack with the outlet centered where you have marked the center of the drain to be. Mark the stack to indicate where the top and bottom of the TY are to be.

If the Stack is Hubless Cast Iron. If the stack is hubless cast iron, the stack should be cut with a pipe cutter (which can usually be rented). The TY is then inserted in the line and connected with rubber sleeves and clamps available at your plumbing supply store.

If the Stack is Copper or Plastic. If the stack is copper or plastic the lower cut into the existing stack should be about 8" below the center line of the TY inlet. This allows room for a spacer to be inserted in the line to adapt the TY to the existing stack. First, make the connection to the top cut with either solder or cement (for plastic) and then cement or solder a short spacer into the bottom of the inserted TY. Then cut a spacer to fill the remaining gap and seal it to the spacer above and the existing drain below with slip fittings at both ends. These fittings should also be soldered or cemented in place.

Unique Solution

If you are lucky your entire plumbing connection can be made between the sink assembly and the existing water supply in a matter of minutes. All you need is a "saddle T." You can bolt this device onto the existing pipe and then drill through to tap the water line (the water should be turned off and the drill grounded). Screw a hose bib into the saddle T fitting and connect the sink to the water supply with high-pressure water hose used for washing machines. Either tap the drain into the existing drain or run a rubber hose from the sink drain into the existing sink, bath, or shower to provide drainage.

Shower Diverter. If you build your darkroom in a bathroom, you can purchase a shower diverter that allows you to use the shower and at the same time provide a convenient connection for a hose which can run to the print washer or to the sink. The diverter is easy to install; remove the shower head, screw on the diverter, replace the shower head, and connect the darkroom hose. These diverters by Alsons are available in most hardware stores.

Saddle T Assembly

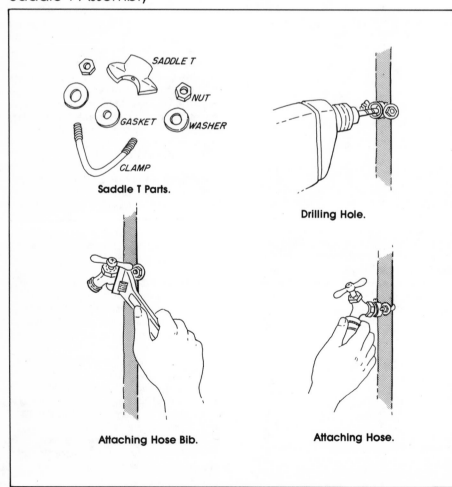

Saddle T Parts.

Drilling Hole.

Attaching Hose Bib.

Attaching Hose.

Making Flared Joints

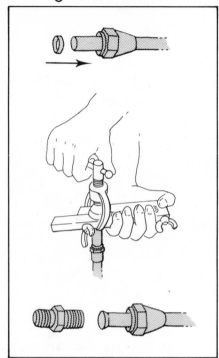

Making Flared Joints. Fit the threaded portion of the fitting onto the tube before beginning the flaring operation. Then slide on the metal gasket.

Insert the tube into the flaring block so its end protrudes just slightly. Screw the tapered head of flaring tool into the tube, making it flare into a funnel shape.

Screw the male-threaded fitting into the fitting first put on the tube. Tighten it down with reasonable pressure.

Making Compression Joints

Making Compression Joints. Slip female fitting over the tube followed by the metal gasket.

Insert the male fitting and, using wrenches, tighten the joint.

Draining Uphill

You may find that your darkroom does not have a drain to connect with that is lower than the sink outlet you plan to install. To get the waste water out of the sink and up to the drain you will have to install a pumping system. First, determine the rate of flow of your pump. Your plumbing store or plumber can help you with this. Usually, installation instructions will be included with the pump. If they are not, you can follow the basic instructions covered on pages 76-77 on installing drains.

Pumping water uphill to an existing drain line was the least expensive solution when Rick Ashley installed his darkroom in the basement of an older Marblehead home. The unit consists of a holding tank with float valve, a pump, and a check valve. The water from the sink flows into the tank and its level is measured by the float which automatically turns the pump on and off as needed. The check valve prevents water from flowing backward in the system.

Pfefer Phittings. The Pfefer Company distributes a complete line of plumbing connecters for darkroom use. The ones shown below are typical of the wide range available.

Swivel Hose Connecter. Has female garden hose swivel. Models are available to connect to ¼", ⅜", and ½" i.d. (inner diameter) tubing.

Barbed Hose Connecter. Designed for use when connecting a hose to any tank or tray. Models are available to connect to ¼", ⅜", and ½" i.d. hose or tubing.

Adaptor. Models are available to connect garden hose to ½" or ¾" male pipe threads.

Clamp-on Hose Adaptor. Connects garden hose to threadless faucets. Similar model has snap fitting to connect to snap nipple.

Y Adaptor. Designed to give two outlets from one water source; each with separate shut-off valve. All fittings connect with garden hose threads.

Thermometer Well. Can be inserted in-line to hold thermometer in water flow. Allows constant monitoring of the incoming water temperature.

Snap Coupler. With all hoses and fittings connected with snap couplers, lines can be changed around quickly without having to unscrew threaded fittings. Makes connections quick and easy.

Drain Alignment Mistakes. Installing a drain can be like digging a tunnel from two sides of a mountain: if they don't meet in the middle they don't do much good. If you find that your drain and sink don't meet where you had planned, this flexible connecter by Webstone can be used to cover this mistake.

A Modular Plumbing System

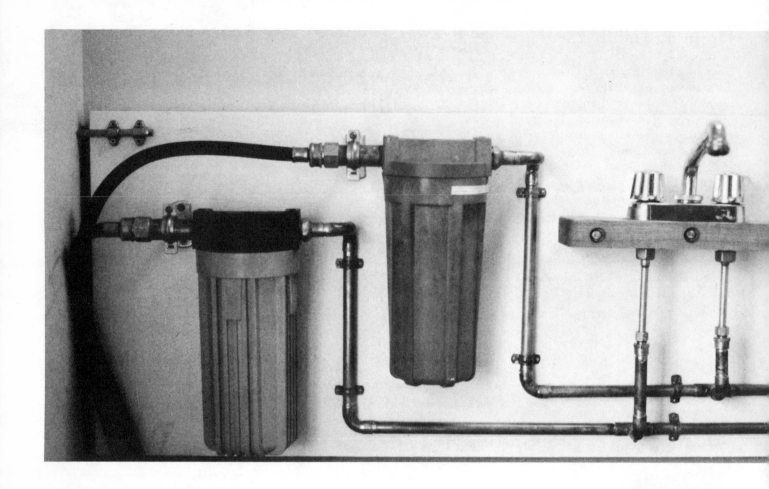

The Components

This modular unit consists of a temperature regulating valve by Meynall, two in-line water filters by Arkay, and an unregulated mixing valve.

Laying Out the Units. Cut a plywood panel (½" or ¾") the length of your sink and at least 2' high. Assemble the basic components on the boards in the rough positions they will occupy.

- Filters have an input and an output side so align them as indicated in the directions that come with them.

- Determine the correct mount for the unregulated outlet. Since most faucets are designed to be connected from either the rear of

the unit or from the bottom your mount may vary somewhat from the one illustrated. If possible, use the type that is plumbed from the bottom and cut a 2"-thick piece of wood large enough to hold it. This can later be mounted to the plywood panel with long bolts.

- Mount the regulator valve on the back panel.

- Using a black pencil draw lines connecting the cold water lines from the outlet side of the filter to both the regulated and unregulated valves. Make sure that they are fed on the correct side. Both units will be marked as to which side is hot and which is cold.

- Using a red pencil trace the hot water supply lines from the outlet on the hot water filter to the regulated and unregulated valves.

Assembling the Unit. The unit should be assembled using ½" copper pipe with soldered joints.

- Determine the exact fittings required for the assembly. Each right-angle turn will require an elbow; each fitting will require a matching fitting that fits into or on it; each connection from the main line to a branching line will require a "T."

- With this list of components in hand visit your local plumbing supply store. A plumbing supply store will probably be more useful than a hardware store: the line of parts is usually larger and the people are more knowledgeable about your needs.

- If you are unsure about fittings for certain parts, take the parts with you so that the salesperson can determine the right fittings.

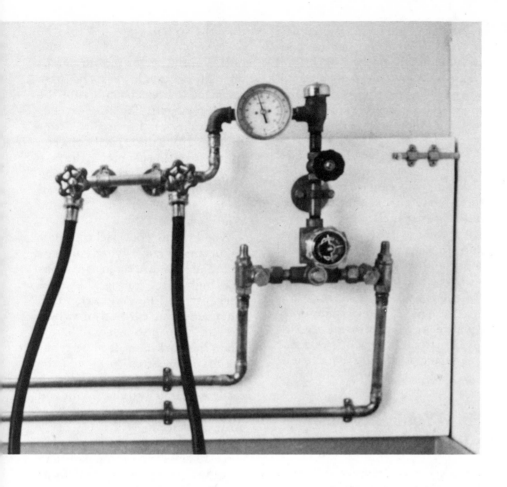

The plumbing system shown here is mounted on a large panel over the darkroom sink. It is connected to the house plumbing supply with high-pressure rubber washing machine hoses. This modular design allows the sink and plumbing system to be moved into a new darkroom. You can assemble the unit at a workbench, which is usually easier than assembling a unit permanently on the wall.

- Begin the assembly by laying the fittings on the board in the places indicated by the sketch you drew earlier while doing the layout.

- Measure the lengths of pipe needed to connect these fittings. Be sure to include the portion of the pipe that will fit into the fitting.

- Cut the lengths of pipe needed and assemble the entire unit to be sure that everything lines up and fits correctly.

- Remove the copper pipe and fitting and solder all of the joints. Where fittings are to be set at various angles be sure to mark the proper alignment (scratch the pipe and fitting with a knife) so that they can be reassembled in the correct alignment.

- Reassemble the soldered units on the panel and connect the fittings to the filters, and faucets with the threaded fittings. Be sure that all threaded fittings are tightened securely and sealed with pipe joint cement.

- Connect the unit to its supply by attaching the high-pressure washing machine hoses (regular hose will break and flood your darkroom). They can be connected to the existing supply lines with a "saddle T" adaptor (see page 79).

- Turn on the water and check for leaks.

Introduction to Electricity

If plumbing is intimidating to the average person, electrical wiring can be downright terrifying. Very few photographers have drowned while installing plumbing, but you can bet there have been a few shocks for those installing their own wiring. Electricity can be fatal and this is especially true in a darkroom where the presence of moisture contributes to electrical conductivity. Wiring should be attempted only by knowledgeable people and even then it should be inspected by a licensed electrician to be sure there are no hidden flaws. Wiring over sinks, faulty grounding, or cables in moisture-laden places all contribute to serious problems. If you are not experienced enough to take on this job yourself and yet don't want to spend a great deal of money, find an electrician who will do the heavy wiring (service entrance wiring, fuse panels, etc.) but will allow you to do the installation of cable runs, light switches, power outlets, etc., and inspect the job upon completion. This method will save money but also guarantee that the job has been done correctly.

In this section it is assumed that you are confronted with one of two common situations.

Utilizing an Existing Outlet. If your darkroom has walls that have been finished and you don't want to get involved in any heavy construction work, you can build an electrical control panel that plugs into an existing outlet. The only requirement is that the circuit into which you are plugging can carry the expected load. To make these calculations use the information on pages 84-85. This method has several advantages. Primarily, it requires no damage to the existing room, so it can be reconverted to its original purpose without any extensive work. It's easier and less expensive than redoing the entire room wir-

ing and is equally functional and effective. The unit can be constructed on a kitchen table and when you move it can go with you and be plugged into the next darkroom. Instructions on how to build this unit follow later in this section.

Rewiring from the Service Entrance. When you want a permanent installation you can wire the darkroom circuits from the service entrance (fuse panel) to the darkroom outlets and switches. Before beginning this installation, you should check with your local building department and become familiar with the relevant codes. Failure to follow the laws of your community could make your insurance policy invalid should injury or fire occur as a result of a faulty installation.

How Your Electrical Circuits Work

The electric current for your residence enters from the street through heavy-duty cables. The first connection after they enter the house is to a fuse panel. This panel (called a service entrance) performs two functions. The first function is to take the incoming current and distribute it to a number of smaller circuits. This allows the house wiring and equipment to be of a smaller size than it would be if all of the house current went through one large circuit. In this respect it's like an eight-lane expressway coming into the panel with a large number of one-lane exits leaving to various parts of the house. The second function of the fuse panel is to prevent the wiring from catching fire or melting should it become overloaded. This is accomplished with fuses or circuit breakers. When current flows through a wire it generates heat. If there were no fuses, and you drew more current

than the system was rated for, the wires would become hotter and hotter until they or the surrounding material caught fire. The fuses are made to break or interrupt the circuit if current flow ever exceeds the capacity of the circuit. Never try to increase the capacity of a circuit by inserting pennies in the fuse holder or by increasing the rating of the fuse you install. Either of these solutions creates fire and safety hazards.

When wiring your darkroom it is important to know what your circuits and fuses are rated at in amps (the higher the rating the more current the line can carry) and what outlets are currently on which circuits. You also need to know what the darkroom load on your circuits is expected to be and the load on other outlets that may already be wired into the circuit you plan to use. If you calculate that your darkroom will require 12 amps and your circuits are rated to carry 15 amps, you can wire off an existing circuit provided other outlets already wired into the circuit are using no more than 3 amps. If they are using more or if your circuits are rated at less than you need, you will either have to install an entirely new circuit or split your darkroom load between two existing circuits.

Fuse Panel

How to Tell What Outlets Are on What Circuits

If you plan to run the wiring off of an existing circuit you should first figure out what outlets and current demands are already on that circuit. These other outlets and their loads must be taken into consideration when determining if the circuit can handle the load your darkroom will add to it.

The wall outlets and t'.e lighting fixtures in a home or apartment are generally installed and wireᴅ before the final wall panels are installed. This means that the initial wiring is located for reasons of convenience and economics. All outlets in all rooms are usually not on the same circuit. So be sure to check the entire house when trying to decide what outlets are on which circuits.

1. Draw the fuse panel (or circuit breakers) showing their arrangement in the box.

2. Turn off the master power switch or pull the master fuse. This will kill all of the electricity in the house and make it safe to pull one of the circuit fuses. If your house is on circuit breakers they are safe to switch without turning off the master switch.

3. Remove one fuse or turn one circuit breaker off.

4. Turn the main power switch back on. This will restore all electrical power with the exception of the circuit from which you removed the fuse or turned off the circuit breaker.

5. Using a voltage tester (see tools, page 86) or by plugging in a small lamp, check all of the outlets in the house to see which ones don't work. These are all on the circuit from which you removed the fuse. Also check all light switches to see which lights are on the circuit; don't forget to check such heavy appliances as the refrigerator, washing machine, etc. Any appliance outlet or switch on each circuit should be noted on your drawing.

6. Turn the master switch off, turn the circuit breaker back on or replace the fuse. Take out another fuse and repeat the same process. If working with a fuse panel, always turn off the main power before removing or installing a fuse just to be safe.

When you have completed this chart, you should know what is already on the circuit to which you want to make your connection. If any heavy appliances such as washing machines or space heaters are on the same circuit, you should change your plans because their load is guaranteed to be too high. It may also be against your building codes to connect into those circuits. In any event whatever is already on the circuit should be used in making the power calculations on page 84.

Electricity in the Darkroom

How to Calculate Power Requirements

When you are working in your darkroom, you are drawing current from the house electrical system. Because house wiring is designed to carry a specific load and no more, it is important to be sure you will be within those limits. If you are not, you will be cursed with blown fuses or tripped circuit breakers. The easiest solution is to prevent problems initially. This section will help you calculate the expected load so that corrective action can be taken before you have problems.

Computing the energy requirements in your darkroom and then comparing those with what the wiring will allow is really very easy. There are three units of measurement involved:

Volt. A unit of measurement of the electrical pressure in a circuit. It is similar in this respect to measuring air pressure in pounds.

Amp. A unit of measurement for flow in the circuit. Similar to measuring water flow in gallons per minute.

Watt. A unit of measurement representing power consumption.

Most of the appliances you deal with consume a fixed amount of power when they are operating. This amount is almost always expressed in watts. Unfortunately your house circuits are rated in amps. To find out what power you need (in amps) you must add all of the devices expected to be on the circuit you plan to use so you know the total number of watts. Then convert this figure to amps to see if your circuit can accommodate the load. To do this, you can use the following table:

Calculating Power Requirements

A. Equipment	B. Watts	C. Number in Use	D. Total Watts
Enlarger			
Printing Safelights			
Red Safelights			
Timers			
White Lights			
Light Table			
Exhaust Fan			
Air Conditioner			
Dehumidifier			
Radio			
Exposure Analyzers			
Print Dryers*			
Dry Mount Press*			
Space Heaters*			
Other (including other outlets on the same circuit)			
Other**			
Other			
Other			
Other			
Other			
Other			
Total Darkroom Requirements in Watts			

* These items are unusually large users of power and should be placed on separate circuits if at all possible, or not used at the same time as the darkroom if they have to be on the same circuit.

**Under "other" you should also refer to the chart showing what other outlets are on this same circuit and add those in this space.

How to Use This Table

A. Column A lists the most commonly used darkroom equipment. It is essentially a checklist of what you have now or might have in the future. Under "Other," list anything additional you plan on having.

B. In this space list the power requirements for the equipment in watts. If you already have the equipment you can usually find its rating in watts on a plate which also lists additional information such as manufacturer's name, serial number, etc. If you do not have the equipment use the following table of normal (or average) ratings:

Safelights	15-40
Enlargers	75
White lights	40-100
Timers	25
Exhaust fans	75
Air conditioner	800-3000
Dehumidifier	550
Radio (solid state)	25
White light (fluorescent)	100

C. List here the number of similar pieces of equipment you will have. For instance, you will probably have more than one incandescent light bulb in the room.

D. Multiply the number in Column B times the number of units in Column C and enter the figure here.

E. Add all of the numbers in Column D to give you a grand total for the darkroom. You now know what your energy requirements are; now convert the watts to amps to see if your circuit will carry the load.

Converting from Watts to Amps

To convert from watts to amps, use the formula:

$$AMPS = \frac{WATTS}{VOLTS}$$

If you live in the United States, divide the results from Column E of the previous table by 115 (the standard American voltage) and you will know how many amps are required. In England or Europe you would divide by 220 for the same result.

You can also use the following table:

If you are using wattage between	and you live in the U.S. (115 volts) your circuit must be capable of carrying	Europe 220 volts
0-100	0.9 amps	0.5
100-200	1.8 amps	0.9
200-300	2.6 amps	1.4
300-400	3.5 amps	1.8
400-500	4.4 amps	2.3
500-600	5.2 amps	2.7
600-700	6.1 amps	3.2
700-800	7.0 amps	3.6
800-900	8.0 amps	4.1
900-1000	9.0 amps	4.6
1000-1100	10.0 amps	5.0
1100-1200	10.5 amps	5.5
1200-1300	11.5 amps	5.9
1300-1400	12.5 amps	6.4

Do You Have Enough Amps in Your Circuit?

In most modern American homes, the circuits are wired up to handle a load of 15 amps. Older homes vary and you should check carefully to determine what their rated capacity is. If your answer to the previous calculation is less than the rated capacity of your house, you will have no problem using the circuit you planned. If your answer was more, there are a few solutions:

1. Eliminate some of the equipment.

Typical Darkroom Circuits

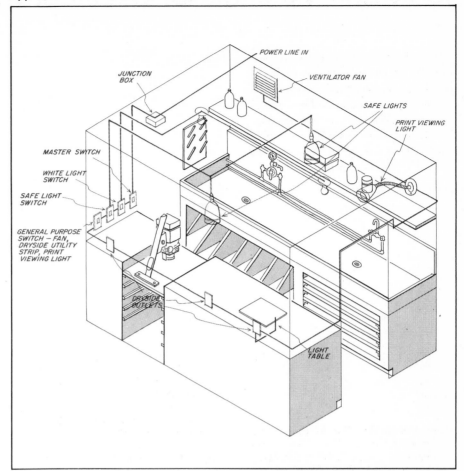

Placement of Electrical Circuits in the Darkroom. This illustration shows the typical arrangement of required electrical fixtures, outlets, and switches. The drawing shows three separate circuits for white lights, safelights, and outlets. There is also a master switch controlling all power to the darkroom.

- All switches should be located near the enlarger as a matter of convenience.
- All safelights should be located at least 4' from where light-sensitive materials will be used, i.e., enlarger easel and processing trays.
- The switch controlling the white light circuit should be separated from the other switches to prevent accidentally turning the lights on when materials are exposed.
- All electrical outlets should be mounted at least 3' above the floor to eliminate the hazard of walking on wires plugged into them.

2. Put some of the equipment on a separate circuit. Use your drawing to determine the closest convenient one that is truly a separate circuit and not just a different outlet on the same circuit.

3. Do not use all of the equipment at the same time. You can easily change your work habits so that you are not drying prints when the enlarger is on, or vice versa.

4. Add a new circuit coming from the fuse panel rated at the capacity you need.

Solutions not to use:

1. NEVER put pennies in fuse boxes.

2. NEVER put higher rated fuses in the box. You cannot do this safely without changing the wiring.

Tools and Materials for Electrical Work _____

All of the materials needed to wire darkroom circuits are available at local hardware stores. Make a list of all the parts you need before you go, because once you are working on electricity in the house, it will be difficult to safely turn it back on until the job is completed.

Tools

Voltage Tester (1). This device is used to determine if a circuit is live. It will light up if there is voltage in the circuit. Also used to determine what outlets are on which circuits and to make sure that the circuit is not live before working on it.

Pliers (2). These are used to twist together the ground wires which are usually too heavy to twist by hand.

Wire Strippers (3). Wire can be stripped with a knife but wire strippers are better. The surface of the wire should not be damaged when stripping; such damage could cause a short circuit.

Equipment

Fuse Panel (4). A modern fuse panel with circuit breakers will be located near the source of the incoming electrical lines.

Fuses (5 and 8). Fuses in older panels will look like the illustrations shown here. One screws into place and the other snaps into holding clips.

Wall Switch (6). Used to control power to circuits and outlets in the darkroom.

Outlets (7). Used to plug in darkroom equipment. Always buy the type that accepts grounded plugs.

Switch with Pilot Light (9). This switch can be used to control all outlets in the darkroom. The light will indicate if the circuits are on or off.

Switch Outlet (10). You can use these outlets in place of regular outlets if you want to be able to turn individual outlets on or off at the outlet itself.

Cable (11). Most wiring today is done with what is called NM (nonmetallic) cable, which replaces armor cable found in older homes. Be sure to buy it with two wires and ground. Also be sure to buy it with large enough wires to carry your load. In most cases, you can use a #12 wire, but after determining the load you expect to put on the darkroom, check your building code to see if this is sufficient.

Junction Boxes (12). These are used as a point to connect two or more cables; they are the only place where cables should be spliced or connected to each other.

Switch Boxes (13). These are similar to junction boxes, but somewhat smaller in size, and are used wherever a switch or outlet is to be connected. They are mounted to a stud so that the front of the box will be flush with the eventual wall surface. The switch or outlet is wired into them and then covered with a face plate.

Light Fixture (14). These are inexpensive ceramic fixtures that attach to switch boxes recessed in the wall. They are ideal to use to screw in bulbs or safelights and are a great deal cheaper than more elaborate fixtures.

Grounded Plug (15). All cords in the darkroom should have grounded plugs similar to the one shown. This ensures that the equipment ground will connect with the grounded circuits in the house wiring.

Wire Nuts (16). When connecting cable, the wires are stripped about ⅜" back from the end and then two or more can be held together by one of these "nuts." The nuts eliminate the need for soldering and are available in different sizes, depending on size or number of wires to be connected.

Junction Box Cover (17). Once the wires have been installed in a junction box (13) a protecting cover should be screwed in place to close the box.

Wall Plates (18 and 19). After switches or outlets are installed they are finished off by installing a plate over the box in which they are mounted.

Connecter (20). These are used to attach the cable when it enters the junction box or switch. They should always be used because they protect the cable from stress and abrasion.

Fasteners (21 and 22). When installing equipment against wall board these fasteners can be used to mount where there is no backing into which screws can be fastened.

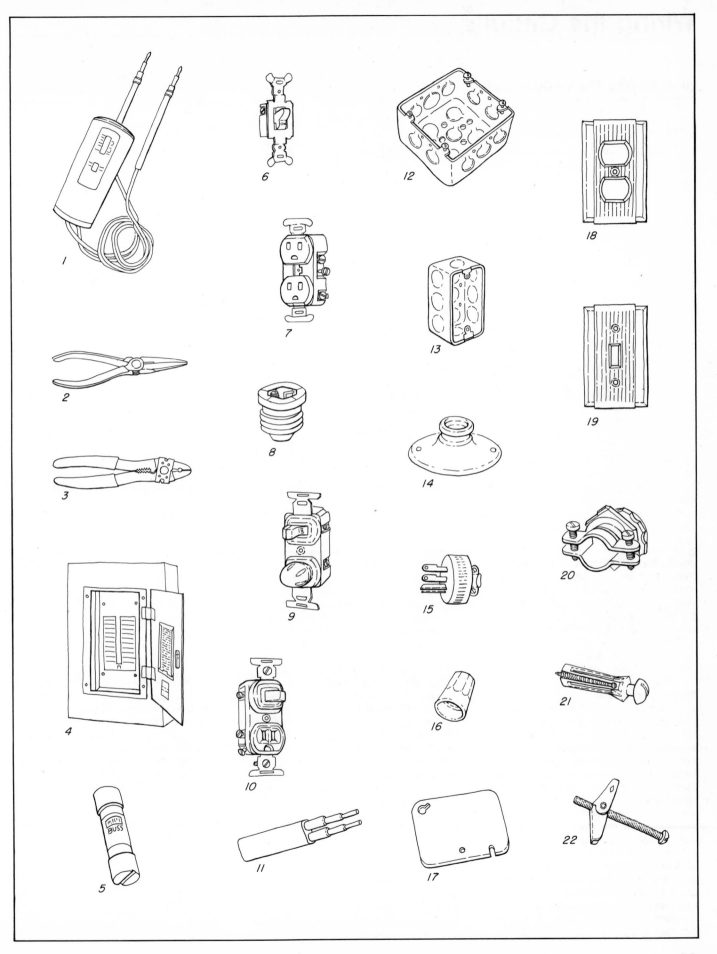

1

6

12

18

7

13

2

8

19

3

14

4

9

15

20

16

21

10

5

11

17

22

Wiring the Circuits

How to Wire the Circuits

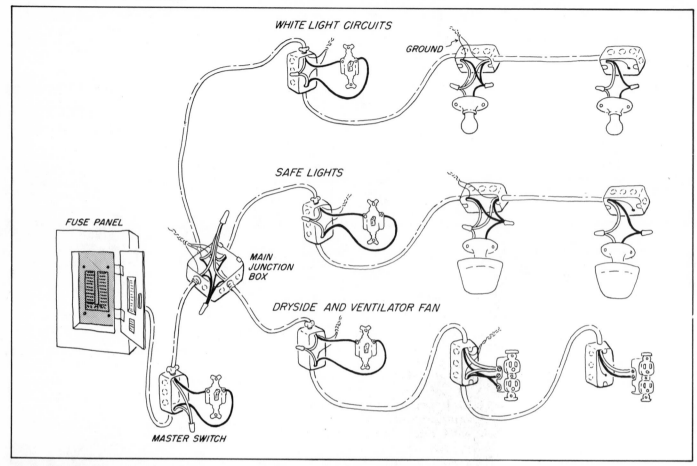

WHITE LIGHT CIRCUITS

GROUND

SAFE LIGHTS

FUSE PANEL

MAIN JUNCTION BOX

DRYSIDE AND VENTILATOR FAN

MASTER SWITCH

How to Wire the Circuits. This drawing shows a typical darkroom circuit with a master switch controlling separate circuits for white lights, safelights, and a general circuit for the dry side. Wiring can be run directly from the fuse box, or it can begin from an available junction box provided the load is within the limits of the circuit being tapped.

Things to Remember.

1. Before working on any circuit be sure you pull the fuse or interrupt the circuit breaker in the service panel. To be safe shut down the master power switch and ALSO remove the fuse for the circuit you are working on. Use a voltage tester or plug in a lamp to be sure the circuit is not hot. Do not be careless, since you can be fatally injured by failing to follow this step.

2. Always use grounded cable for all circuits. Grounded cable consists of a white wire, a black wire, and a bare copper wire. The bare copper wire is the ground and should always be twisted together with all other ground wires in the same box and then fastened to the box itself. This will ensure that all circuits

and boxes are at the same electrical potential as the earth and if there is a short, the current will go through the ground wire and not you.

3. Always buy outlets that will accept the 3-pronged grounded plugs. If you don't, then the equipment itself will not be grounded even though the circuit is and you will be in danger and have wasted your time grounding the circuits.

4. The white wire in the cable is the neutral wire (this does not mean you can touch it with the power on) and should always be connected to the silver terminal in outlets. When wiring a switch, the white wire is connected straight through to the other white wires and should never be connected to the switch terminals.

5. The black wire is the hot wire and should always be connected to the brass terminals on switches and outlets. When wiring switches it is the black wire that is connected to the switch.

6. Always use connectors when running cable into a junction or switch box. These connectors protect the cable from being cut by the rough edges of the box and also from being pulled loose.

DANGER! No wiring should be attempted without having it inspected. Failure to do so can be extremely dangerous and in violation of local laws. The material in this section is for descriptive purposes so you can discuss it with a licensed expert. Do not use these drawings and captions as a guide to wiring.

Wiring In a Junction Box

Wiring In a Junction Box. Run the cable into the junction box leaving 6" of cable past the point where the connector will fasten it to the box. Mark the point where the cable is flush with the inside of the connector.

Remove the outer sheath of the cable at the place marked, being sure not to cut into the insulation of the wires inside. A small knife blade can be used to cut outward through the plastic sheath ensuring that the wires are not cut.

Attach the connector to the box using the nut that comes with it.

Run the cable through the connector so that the end of the sheath comes flush with the inside of the connector.

Carefully remove the insulation from the last ⅜" or so of the wires.

WRONG WAY

RIGHT WAY

Hold the exposed wires together and screw the correct sized wire nut over the ends to hold them together. If too much insulation has been removed you will see bare wire when the nut is screwed tightly into place. This should be cor-

rected by removing the wire nut and trimming the end off the wire so that when it is rescrewed into place, no bare wire is exposed.

Twist the ground wires together tightly. In some junction boxes the ground wire can be attached with a clip to the side of the box.

The completed wiring in the junction box will look like the one in this illustration with all of the wires tightly connected by wire nuts. Now, carefully fold up the wires and place them in the junction box and screw the cover into place.

Connecting Wires to Switches

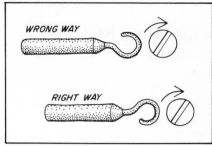

Connecting Wires to Switches. Those wires that are to be connected to terminal screws on switches or outlets should be twisted together and bent to fit around the screw head on the switch. They should be installed with the wires pointed in the same direction that the screw will be turned to tighten it, i.e., clockwise, so that they will not be pushed out by the screw as it is tightened.

Wiring on the Surface

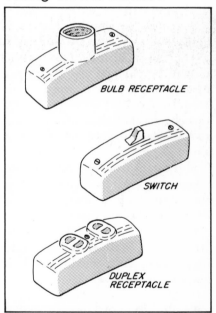

Wiring on the Surface. If you are converting a room that is already panelled or made of some material such as concrete block that you cannot run wires through, you can choose to run all of the darkroom wiring on the surface rather than behind the wall. To do this, you will need special fixtures made especially for this purpose. Junction boxes can be surface mounted and then the three items illustrated replace the usual bulb receptacles, outlets, and switches. The cable can be stapled into place or hidden inside conduit.

Modular Control Panel

Building a Master Electric Control Unit

When installing a darkroom in an apartment or in a finished room that may eventually be converted back to its original use, it is wise to do as little interior conversion as possible. This section shows you how to build an electric control panel that will put all of the electrical controls at your fingertips. All that's required once it's built is to plug it in. It has the following advantages over rewiring the room:

1. It can be built in your shop, on your kitchen table, or by a friend, and then installed in the room just by plugging it in.

2. It can be taken with you if you move. All you have to do is plug it in the next apartment or house.

3. It has two outlets for safelights, each on separate switches.

4. It can be adapted to allow the unit to be plugged into two separate outlets (provided they are on separate circuits; see pages 82-83) thereby dividing the darkroom load so it does not exceed the limits of a single circuit.

5. It can be used to feed a remote power strip installed elsewhere in the room as a power supply. If the control unit is mounted on the dry side near the enlarger, the remote strip would be near the wet side (never close enough to the sink to get wet) or vice versa.

This unit is based on the actual switches listed. If you use different switches the wiring will be different. Wiring diagrams usually accompany electrical parts and can be used as a guide.

Building the Case

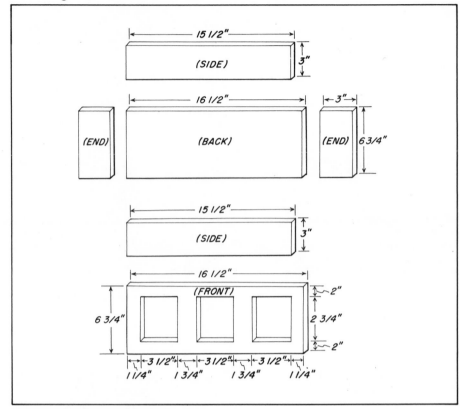

Building the Case. The first step in assembling the control panel is to build a case to hold the switches and outlets. This case can be cut to the dimensions indicated from ½" plywood. The back, sides, and ends are glued and then nailed together. The front panel is attached to the case with wood screws so that it can be removed if necessary to repair wiring.

DANGER! No wiring should be attempted without having it inspected. Failure to do so can be extremely dangerous and in violation of local laws. The material in this section is for descriptive purposes so you can discuss it with a licensed expert. Do not use these drawings and captions as a guide to wiring.

Wiring Diagram

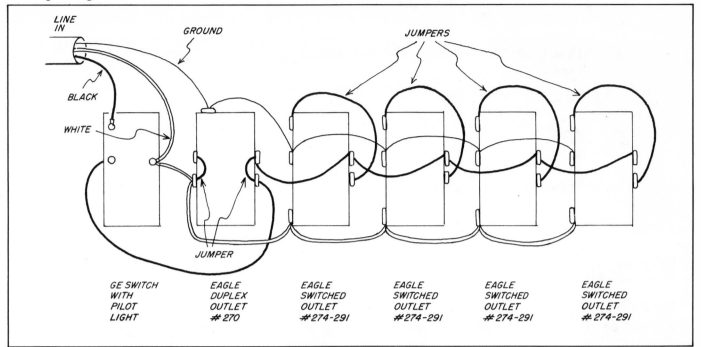

LINE IN

GROUND

JUMPERS

BLACK

WHITE

JUMPER

| GE SWITCH WITH PILOT LIGHT | EAGLE DUPLEX OUTLET # 270 | EAGLE SWITCHED OUTLET #274-291 | EAGLE SWITCHED OUTLET #274-291 | EAGLE SWITCHED OUTLET #274-291 | EAGLE SWITCHED OUTLET #274-291 |

Wiring Diagram. This wiring diagram is for a series of switches and outlets identical to the ones listed. As all switches vary in their design, switches other than those indicated will require slightly different wiring.

This view is from the back of the switches. The best approach is to mount the switches to the front panel of the case before attempting to wire them. This will keep them from shifting about and lessens the chance of an inadvertent short circuit.

Never work on the panel with power supplied to the circuits. Also, have the wiring checked by a licensed electrician prior to using it. All wiring is potentially dangerous and it pays to be sure that it has been done correctly.

This switch panel should be kept well away from sources of water and all switches should be grounded to ensure that shorts will not be dangerous.

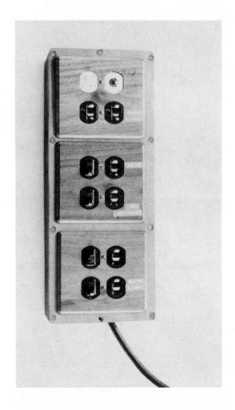

The Assembled Unit. This photograph shows a completely assembled unit built from the plans given on these pages. The top switch (white) is the master power switch that controls all other circuits. At the end of the session in the darkroom, turning off the master switch shuts down all darkroom circuits.

There are two outlets controlled only by the master switch and four outlets controlled both by the master switch and by their own switches.

5 Building the Inside

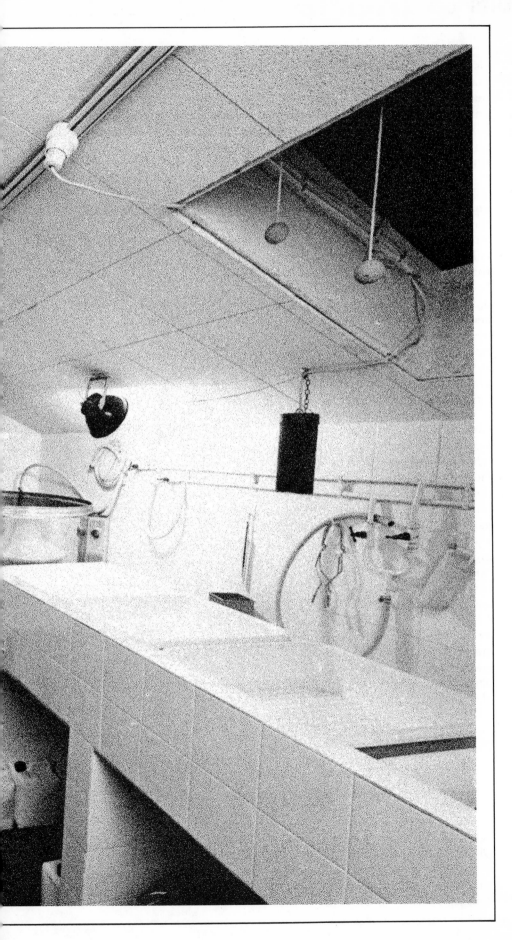

Contents

The Lighting Circuits ● 94
Lighting Equipment ● 96
Building a Darkroom Sink ● 98
Building a Sink Stand ● 100
Installing Counters ● 102
Building a Print
Drying Rack ● 104
Making the Drying Frames ● 106
Building a Lightbox ● 108
Mounting the Enlarger ● 110
Building an Adjustable
Enlarger Base ● 112
Air Quality ● 114
Light Proofing ● 116
Those Added Comforts ● 118

The Lighting Circuits

Lighting the Darkroom

Lighting a darkroom has similar considerations to taking pictures: eliminating unwanted light and controlling the light you do want. Later we will discuss making the room dark by eliminating unwanted light. This section deals with controlling the light you do want.

General Lighting. There should be sufficient illumination when the main lights are on to clean the room and to do general work that is not involved with light-sensitive materials. For this purpose, regular incandescent or fluorescent fixtures are normally used. The switch for the lights on this circuit should be separated from the other darkroom lights or should have a switch guard to prevent it from being turned on by mistake. The number of lights depends to a large degree on the size of the darkroom or workroom. Generally, two 100-watt fixtures are sufficient.

Safelighting. Safelighting provides filtered light that will not affect light-sensitive materials. Each type of material has a specified filter. Using the wrong filter can reduce the safety factor or offers no protection at all. The intensity of the safelight desired varies from photographer to photographer. Some like a darkroom that is as bright as possible and others a more moody room with cones of safelight only at key spots near the enlarger and print developing trays. Use your own judgment in selecting the type of lighting for the room you plan.

Print-viewing Lights. When the print comes out of the fixer, it's usually evaluated to determine what should be modified to make the next print better. To make an accurate evaluation you need proper lighting. Too little light or too much of the wrong kind can seriously affect your de-cision. Light that is too bright will make prints look weak and washed out, whereas light that is too weak will make them appear to be too dark. The solution is to have a viewing light in the darkroom that best represents the light in which the print will eventually be viewed.

With black and white prints, all you need worry about is light intensity. If you are printing for gallery display, remember that the gallery lights are much brighter than in the average living room or bedroom. Most galleries will have lighting of 80 to 100 foot candles and that intensity should be matched by the print-viewing light. A dimmer switch, available in hardware stores, can be used on the print-viewing light and calibrated to various viewing environments.

With color prints the light in the darkroom ideally should also be the same color balance as the light by which the prints will be finally viewed—often, though not always, daylight. For convenience, many photographers simply match their darkroom light to a daylight balance. Kodak recommends for viewing color prints a light of 50 foot candles or more, a color temperature of approximately 4,000° K, and a color rendering index of 85-100. Deluxe cool white fluorescent lights come close to these requirements. They should not be used for viewing in conjunction with ordinary incandescent lights, which are of a different color balance.

Light Table. It is generally helpful to have a light table built into or sitting on the dry-side counter. A light table is the ideal way to view negatives while making selections for enlargements. The light table can be covered with a large safelight filter so that it can be left on while printing (this will work only if you are printing in black and white) or it can be controlled with a dimmer switch.

Luminous Tape or Paint. You should consider the use of phosphorescent tape or paint to identify key items in the room that you might need to find in the dark, such as focusing magnifier, print tongs, and drawer handles. It's also helpful to indicate any sharp corners so they can be avoided in the dark. Even with good safelighting, the room will be dark when working with film and color materials.

Lighting Circuits

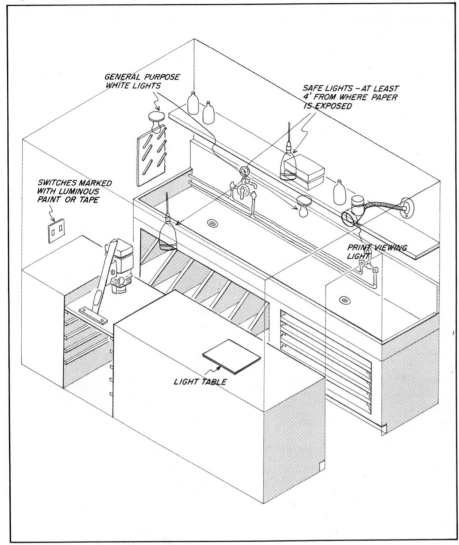

GENERAL PURPOSE WHITE LIGHTS

SAFE LIGHTS – AT LEAST 4' FROM WHERE PAPER IS EXPOSED

SWITCHES MARKED WITH LUMINOUS PAINT OR TAPE

PRINT VIEWING LIGHT

LIGHT TABLE

General Lights. These are standard ceiling fixtures giving sufficient light to work and clean the room when light-sensitive materials are not being used.

Safelights. The number of safelights is determined by the size of the room and the intensity of the light desired. Safelights should be no closer than 4' from enlarger baseboard or processing trays, otherwise fogging of paper is possible.

Print-viewing Light. Most photographers like to check their prints after they have been in the fixer for a few minutes. It's convenient to have a light nearby because prints cannot be evaluated accurately under safelighting regardless of how bright it is.

Light Table. A small light table built into the counter is handy to use in selecting negatives.

Calibrated Print-viewing Light

If you want to make prints that are adjusted for the brightness of light available where your photographs will be viewed, you can calibrate your darkroom print-viewing light using a regular light meter, a standard photographic gray card, and a dimmer switch installed on the print-viewing light. First determine where the prints will be viewed, either in the home or in a gallery. Place the gray card in the position the print will occupy and illuminate it with the lights that will be used to illuminate the print. Take a reading from the gray card with the light meter.

Now place the gray card under the darkroom print-viewing light in the position where prints will normally be set for evaluation. Install the dimmer switch according to the instructions. While watching the light meter, gradually increase the light intensity until the reading matches that obtained at the position the print will eventually occupy. Mark the dimmer switch to indicate its position so you can repeat the setting without additional measurements. If you print for a number of viewing conditions, you will eventually have a dimmer switch with various settings indicated. Experiment with a trial print on the particular printing paper you are using because some papers dry down to a tone that is darker than when they are wet.

Lighting Equipment

Kodak Safelight Filters

Scientifically designed for safelight lamps to provide maximum safe illumination plus protection from white light when using sensitized materials

- OA (greenish yellow)—for black-and-white contact and duplicating materials, projection films
- OC (light amber)—for contact and enlarging papers, High Resolution Plate, Translite Film 5561, Opalure Print Film 5552, and Kodabrome RC Paper
- OO (light yellow)—for flash exposure technique with Kodak Contact Screens (available only in 5½" diameter)
- No. 1 (red)—for blue-sensitive materials, Kodagraph Projection and most Linagraph Papers
- No. 1A (light red)—for Kodalith and Kodagraph orthochromatic materials
- No. 2 (dark red)—for orthochromatic materials, green-sensitive x-ray films, Ektaline Papers, and Linagraph Papers (1830, 1884, 1930, 1932, 1971, and 2201)
- No 3 (dark green)—for panchromatic materials
- No. 6B (brown)—for blue-sensitive x-ray films
- No. 7 (green)—for some black-and-white infrared materials (not available in 2⁹/₁₆" diameter)
- No. 8 (dark yellow)—for some Eastman Color Print and Intermediate Films (not available in 2⁹/₁₆" diameter)
- No. 10 (dark amber)—for Ektacolor 37RC, Panalure, Panalure Portrait and Resisto Rapid Pan Papers; Ektacolor Slide Film 5028, Ektacolor Print Film 4109 (Estar Thick Base) (Not recommended for Ektachrome RC Paper, Type 1993) (Not available in 2⁹/₁₆" diameter)
- No. 11 (appears opaque, transmits infrared radiation)—for use with infrared scope and similar inspection devices
- No. 13 (amber)—for Ektacolor 74 RC, Ektacolor 37RC, Panalure, Panalure Portrait and Resisto Rapid Pan Papers; Ektacolor Print Film 4109 (Estar Thick Base) (Not recommended for use with Ektachrome RC Paper, Type 1993, or Ektacolor Slide Film 5028) (Not available in 2⁹/₁₆" diameter)

© Eastman Kodak Company 1977

Light Tables. Light tables are useful in the darkroom when selecting negatives to be printed. Rogersol makes a number of models, including these free-standing and counter-top models.

5½" Round Safelights. The Kindermann 5½" safelight system consists of a housing, filters, and a universal base. It uses standard 5½" filters available from Kodak and others. The universal base can be mounted on a wall or ceiling or stood on a counter top. An alternative socket base allows the safelight to be screwed into an existing light socket.

Print Viewing Light. A small wall-mounted light to use in evaluating prints is almost a necessity. This model from Edmund Scientific has important features such as a shielded light for increased brightness and a swivel bracket that allows it to be positioned as needed. The arm also slides into a closed position only 3" long and extends out to 11".

Available from Edmund Scientific Co., 7782 Edscorp Bldg., Barrington, N.J. 08007.

Bright Star. This portable Bright Star light available from Porters is complete with safelight filters. It is ideal for making lens adjustments and finding things when the lights are out and paper is in the easel.

Illuminated Magnifier. E.W. Pike makes a combination magnifying glass and flashlight that is useful for examining 35mm contact proof sheets.

Fluorescent Safelights. Chemical Products Company makes a fluorescent light that is designed for darkroom work. It has a better color balance than an incandescent light does and a higher level of illumination. Compared to a 5½"-inch "Wratten Spot" using a 15-watt bulb, this light will deliver between 300 percent and 960 percent more light depending on the wattage of the fluorescent tube you select.

Kodak Two-way Safelight. This Kodak two-way safelight is a popular model. It is inexpensive and effective. The light is directed in two directions for even illumination. To install, screw it into an existing socket and you're ready to print.

Courtesy Eastman Kodak Company

Utility Safelight. The Kodak utility safelight, model D, is a good example of a safelight that can be suspended from the ceiling. The light is then reflected downward from the ceiling for even illumination throughout the room.

Courtesy Eastman Kodak Company

Thomas Sodium Vapor Safelight. This Thomas sodium vapor safelight, available from Nord, puts out light from a very narrow part of the spectrum, one which has the least effect on photographic papers, but to which the human eye is most sensitive. The result is a light bright enough to read the fine print in the next contract for your photographic services. This is an excellent choice if you want a bright darkroom in which to work.

Building a Darkroom Sink

A sink is a basic piece of darkroom equipment. A long sink made out of wood, plastic, fiberglass, or stainless steel will hold print processing trays plus the print washer.

Darkroom sinks make it easier to keep the darkroom clean by containing spills which, at the end of a session, can be flushed out with a hose. Because many chemicals dry to a powdered state that can be carried by air currents onto sensitive materials, it is essential that they be removed and the sink provides the most efficient way of doing so. In addition to improving cleanliness, a darkroom sink allows all of the processing trays to be immersed in a water bath to help maintain their correct temperature.

You can buy a sink, but the vast majority of photographers build their own sinks out of plywood which is then caulked and sealed with epoxy or other waterproofing material.

Making the Sink Sidewall Frame

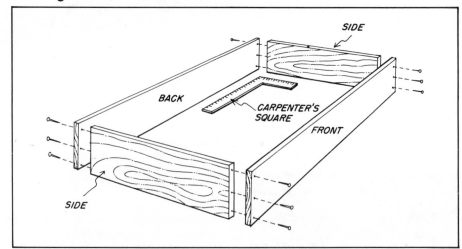

Making the Sink Sidewall Frame. The sink frame can be made out of a variety of materials but the most popular is ½" or ¾" plywood. Because the sink will be painted, a lower grade of plywood called "plug and touch" which is finished on one side is suitable for its construction. The sides should be approximately 8" deep and long enough and wide enough to hold the number of processing trays you plan on using (see pages 48-49 for various sink sizes). After the pieces are cut to the correct length they should be glued and then nailed or screwed into place. Use a carpenter's square to ensure that the corners are square when assembling.

Rail to Lean on

Rail to Lean On. Neither ½" nor ¾" plywood provides much of an edge to lean on. Since you will want to lean on the sink while rocking trays it helps to install piece of ½"-wide casing (molding) along the front sink frame to widen the top edge. This will make the sink front much more comfortable to work on.

Sink Frame

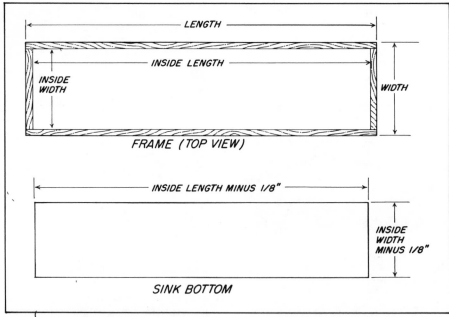

Building and Installing the Sink Bottom. After you have finished the frame, measure the inside dimensions. Cut a piece of ½" plywood so that it fits into the sink side wall frame with as little clearance on all sides as possible. As a starting point the plywood should be cut ⅛" shorter and narrower than the inside dimensions of the sink frame. If it does not fit, sand off the excess wood until it fits snugly into the frame.

Measuring for Bottom Slope

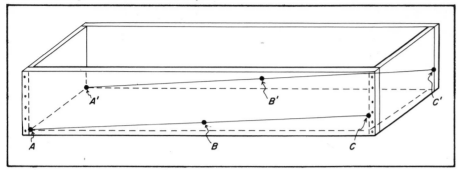

Measuring for Bottom Slope. After the sink bottom has been cut to size it must be installed in the sink so that it tilts enough to drain toward one end or the other. Do this by installing the bottom supports at gradually increasing heights along the length of the sink. Cut these supports out of 1 x 1" or 1 x 2" lumber to a length equal to that of the sink end pieces.

To build in the slope at the bottom, draw a sloping line down both long sides of the inside of the sink frame as a guide line for nailing in the cross pieces. Make one mark at point A and A' flush with the bottom of the sink frame. Halfway

down the sink make a mark at B and B' ⅛" above the sink frame bottom and at the other end of the sink (C and C') place a mark indicating a point ¼" above the sink bottom. Connect these three points with a straightedge and you will have a sloping line as a guide to where to nail the bottom edge of each support piece.

If your drain will be in a far corner and you decide that you also need a front-to-back slope, you can raise the A, B, and C or A', B', and C' measurements an additional ⅛" above the measurements on the other part of the frame.

Installing Bottom Supports

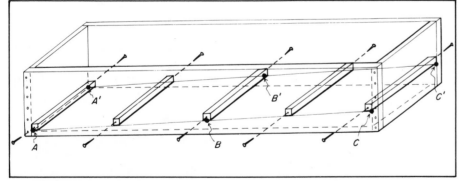

Installing Bottom Supports. Hold each support cross piece in position and drive a long nail through the front of the sink and into the support. Since you will be nailing blind it may help to first measure where the support is to be located inside the sink and then transfer this measurement to the outside. Nail the support on the other side (back) of the sink and

continue with each of the subsequent cross pieces. Make sure that the bottom of each cross piece is aligned with the guide line that indicates the tilt of the sink bottom.

When all of the supports are nailed in place, insert the sink bottom and nail it into place.

Waterproofing the Sink

The assembled sink must be made waterproof before it is used. The first step is to caulk all of the seams on the inside of the sink using an acrylic caulking compound, which comes in tubes and is available at most hardware stores or lumber supply houses. Run a bead around the bottom of the sink and up the four corners. To make it form a smooth surface use a large ¾" to 1" wooden dowel to make a curve in the caulk. This is done by running a bead of caulk the length of the seam and then running the dowel along the bead, smoothing it as it is pulled along.

The sink can now be painted with a waterproofing material. Epoxy paint can be used or you can fiberglass the inside. The demands put on the typical sink do not require the use of fiberglass cloth but it is commonly used. (Strips of fiberglass cloth can be used in conjunction with epoxy resin to seal the seams if you choose not to use acrylic caulk.) Epoxy by itself will tend to crack if the sink is moved or pushed out of alignment. We can recommend the following sink coatings:

Gaco N-55 High Tensile Neoprene Coating is applied like paint but dries to a rubberlike finish. It tends to remain flexible and will not crack at the joints. When used on plywood it requires the use of N-11 primer. The material is manufactured by Gates Engineering Company, Inc., 100 West Street, Wilmington, Delaware. It is available from commercial paint distributors but not at the local paint store. The fumes are highly toxic so instructions must be followed exactly.

Sherwin-Williams Tile Clad II comes in two parts and when mixed and applied dries to a hard surface finish.

Epoxy Resin is the most commonly used coating. It can be applied like paint directly on the wooden sink and will provide sufficient waterproofing. Seams can be sealed by embedding cloth tape in the wet epoxy and then repainting the top surface with more epoxy.

Building a Sink Stand

After the sink itself has been completed it is necessary to find a place to put it other than flat on the floor. If the darkroom is in a bathroom or other room that is used for more than one purpose, the sink can be mounted on chair rails (1½" x 1½" molding) along three walls of the room. This allows the sink to be removed easily and the chair rails do not detract from the room.

However, you may want to build a permanent sink stand that is sturdy enough to hold the sink and can also provide additional storage space. This section covers both of these possibilities.

Leveling the Sink

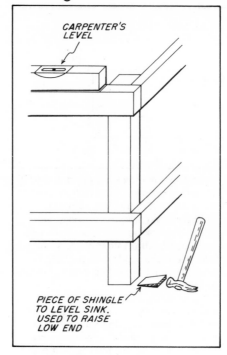

CARPENTER'S LEVEL

PIECE OF SHINGLE TO LEVEL SINK. USED TO RAISE LOW END

Leveling the Sink. Once the sink stand has been finished it should be installed in the darkroom and leveled. Use a carpenter's level and small pieces of wood such as shingle. Put the level on the top rail and level the sink lengthwise using the wood pieces to raise the low end. After you level the sink in the long direction follow the same procedure to level it front to back.

Now place the sink itself on top of the sink stand. The sink bottom's built-in tilt should now be at the correct angle for proper drainage.

Building the Sink Stand

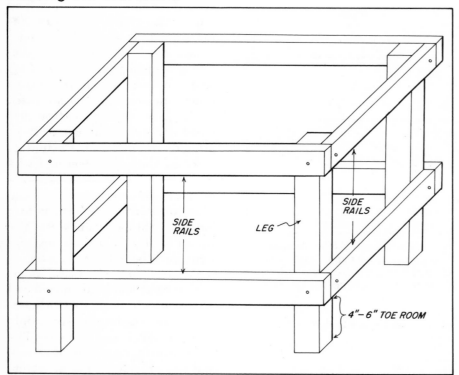

SIDE RAILS

LEG

SIDE RAILS

4"-6" TOE ROOM

Building the Sink Stand. The sink stand should be constructed with 2 x 4s nailed or bolted together. The outside dimensions should be the same as the outside dimensions of the sink itself.

Begin by cutting the base rails to the same lengths as the sink side walls. Make two sets to provide support at both the top and bottom of the sink stand.

Now cut the four legs to the height you want the sink bottom above the floor. Because the sink bottom is actually a few inches above the bottom of the sink side-wall frame, cut the legs a few inches shorter than the ideal height to allow for the difference.

Assemble the two sets of side rail frames for the stand and then bolt or nail the legs in place as shown in the illustration.

Building Undersink Storage

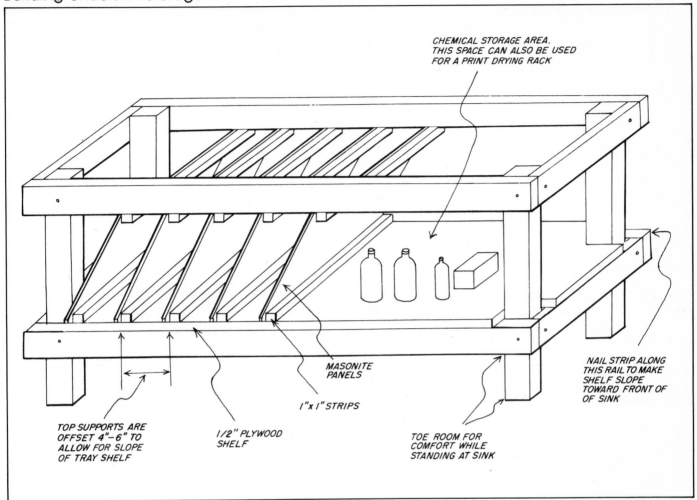

CHEMICAL STORAGE AREA. THIS SPACE CAN ALSO BE USED FOR A PRINT DRYING RACK

MASONITE PANELS

1" x 1" STRIPS

TOP SUPPORTS ARE OFFSET 4"–6" TO ALLOW FOR SLOPE OF TRAY SHELF

1/2" PLYWOOD SHELF

TOE ROOM FOR COMFORT WHILE STANDING AT SINK

NAIL STRIP ALONG THIS RAIL TO MAKE SHELF SLOPE TOWARD FRONT OF OF SINK

Building Undersink Storage. The space under the sink can be utilized for storage of trays and chemicals or even for a permanently installed print drying rack.

The simplest method is to cut a piece of plywood to fit on the lower side rails providing one large expanse of shelf. This would be fine for chemical storage.

One-half of this shelf can be converted to a tray storage area by mounting small wood strips across its width and additional strips offset a few inches nailed across the bottom of the top side rails.

Pieces of masonite can be cut so that when installed they divide the space into a series of sloping compartments wide enough to hold the trays.

The bottom shelf can be tilted toward the front of the sink to ensure drainage should you ever store wet trays. Nail a thin strip of wood no thicker than ¼" along the back rail before nailing in the plywood shelf. When the plywood is nailed on top of this piece it will slope toward the front of the sink stand.

Installing Counters

Installing Dry-side Counters and Storage

Counters and storage cabinets can be custom-made for a darkroom but they can be very expensive. The know-how required to build them yourself is also extensive. The ideal solution is to use kitchen cabinets and post-formed (seamless) counter tops. Cabinets can usually be picked up quite cheaply at sales or in used condition. Since visual appeal is not as important in the darkroom as it is in the kitchen, damaged units, poor sellers, and inexpensive units all become candidates for your darkroom.

Base Units. Counter base units come in standard widths from 9″ to 42″ in increments of 3″. They are standardized at a 24″ depth.

Counter Tops. Post-formed counter tops are made in long strips 25″ wide; the building supply company can cut them to the length you need. There are two styles available, one with a flat lip on the front edge and one with a rolled lip. Avoid the rolled lip since large items such as a paper trimmer will not rest flat on the counter.

FLAT LIP

ROLLED LIP

Currently, post-formed counter tops cost less than $8.00 per running foot. A counter top for a large darkroom with a 10′ dry side (minus 30″ for the enlarger base) would cost approximately $60.00. It would be difficult to custom-build one for less, especially if tools had to be purchased.

Wall Cabinets. Wall cabinets are also available from building supply companies and can be installed above the dry-side base cabinets for additional storage. They come in the same standard widths as the base cabinets, but are only 12″ deep.

Dry-side Wall Cabinets

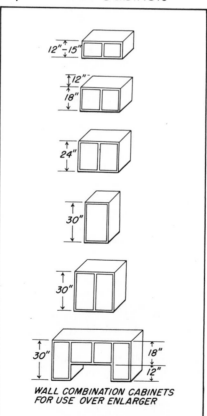

WALL COMBINATION CABINETS FOR USE OVER ENLARGER

Dry-side Wall Cabinets. Wall cabinets come in lengths of 24″ to 48″ in increments of 3″. They range in height from 12″ to 30″.

Dry-side Base Cabinets

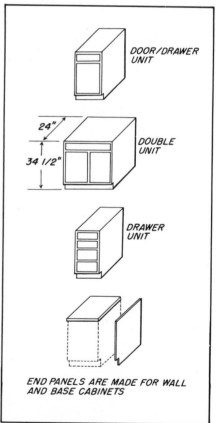

END PANELS ARE MADE FOR WALL AND BASE CABINETS

Dry-side Base Cabinets. Base cabinets are available in sizes ranging from 9″ to 48″ in increments of 3″. They come with doors, drawers, or a combination of both. Although their standard height is 34½″ (36″ once counter top is installed) they can be raised by building a base under them.

Dry-side Assembly

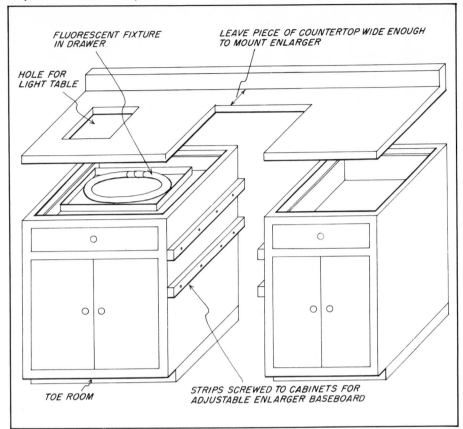

FLUORESCENT FIXTURE IN DRAWER

LEAVE PIECE OF COUNTERTOP WIDE ENOUGH TO MOUNT ENLARGER

HOLE FOR LIGHT TABLE

TOE ROOM

STRIPS SCREWED TO CABINETS FOR ADJUSTABLE ENLARGER BASEBOARD

Dry-side Assembly. This view shows how the dry-side cabinets can be assembled to accommodate the enlarger mount, adjustable easel baseboard, and light table.

When ordering post-formed counter tops you can have them custom-cut and finished for both the enlarger and the built-in light table.

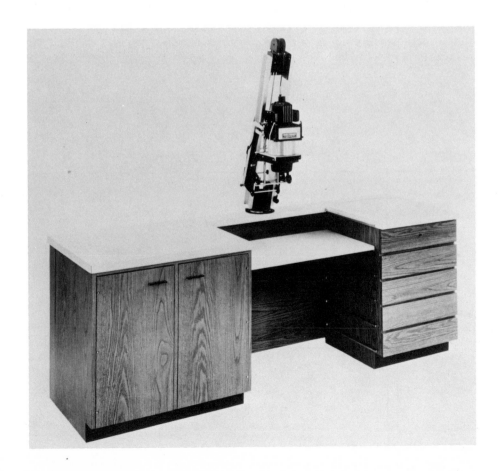

Professional Cabinets. This Leedal dry-side cabinet is a good example of a professionally designed and manufactured unit. Such units are extremely well made but the high quality comes with a relatively high price tag.

Building a Print Drying Rack

A homemade print drying rack utilizing fiberglass screens is easy to build and can either be made to stand alone or built-in. The rack consists of two major elements:

1. Frames with fiberglass screen stretched over them. The frames provide the rigidity required to keep the fiberglass flat and tight. The fiberglass screen supports the print but at the same time allows air to circulate freely on all sides of the print contributing to even, fast drying. Fiberglass screen should be used because it is impervious to darkroom chemicals and will not rust. It is also nonabsorbent so if a poorly washed print does come in contact with it the screen can be washed clean to protect subsequent prints. The frames on which the fiberglass screens are stretched can be made out of 1" x 1" wood cut at a 45° angle to make corner joints similar to a picture frame. For this you need a mitre box and saw costing about $5.00 to $10.00. Frames can also be constructed out of aluminum window screen frames.

Aluminum framing members can be bought either in long lengths or pre-cut to the size you desire. Wooden canvas stretchers available in artists' supply stores also work quite well and are already pre-cut making tools unnecessary

If you choose to make the racks out of aluminum framing, you will also need what is called "Spline," the rubber gasket that locks the screen into the frame, and an installation tool costing about $1.00.

2. Rails on which the frames will slide in and out and a cabinet to hold them. The rail can be either aluminum angle iron, wooden rails made out of 1" x 1" or wood molding that is L-shaped. Regardless of which is chosen, they should be installed level and parallel so the frames slide in and out easily. They should be spaced approximately 3" or more apart to allow for free air circulation in the rack.

If the print drying rack is to be installed under the sink, be sure to build the sink and its stand first so that exact measurements for the print drying rack can be taken from

the actual unit (see page 101). This will ensure that the rack fits into the existing space.

The Easy Way Out

A simple print drying rack can be made with a long piece of fiberglass screen. two wooden dowels, and some string.

The dowels are stapled to each end of the screen and the unit is suspended like a hammock. When not in use, it can be rolled up and stored. It's also easy to keep clean because it can be washed in the sink.

If you use an old (or new) window shade roller in place of one dowel and attach it permanently to a wall, you can pull the screen out when needed. Just attach it to a hook on an opposite wall. When finished, you unhook it and it rolls back up by itself. Be sure the roller is mounted with enough space between it and the wall to allow the fiberglass screen to roll all the way up.

"Hammock" on Window Shade Roller

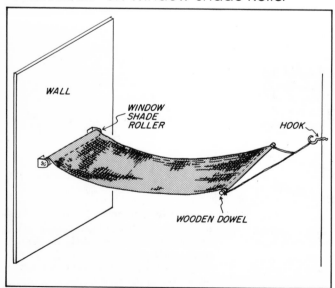

WALL

WINDOW SHADE ROLLER

HOOK

WOODEN DOWEL

"Hammock" Drying Screen

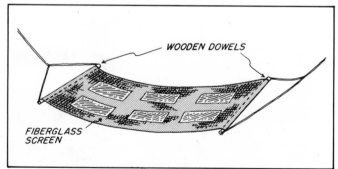

WOODEN DOWELS

FIBERGLASS SCREEN

Print Drying Rack

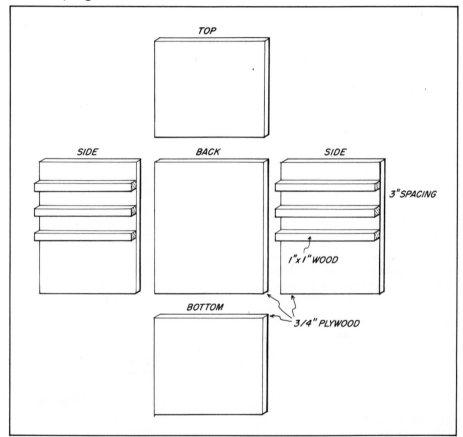

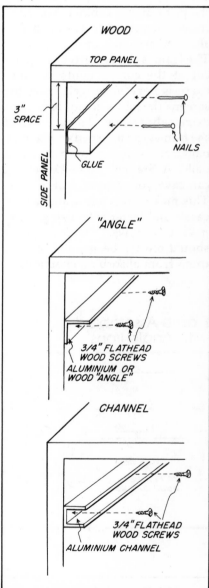

Details of the Frame Supports

Details of the Frame Supports. These drawings show how various types of frame supports can be attached to the side panels of the print drying rack.

Building the Print Drying Rack. The cabinet needed to hold the fiberglass frames can be made out of either ½" or ¾" plywood. The thicker material will give a more stable cabinet. Begin by determining the size frame you need to hold your prints and then calculate the size cabinet you will require to hold frames of the chosen size.

Measure the two side pieces so they are the exact length of one of the dimensions of your frames. The back piece should then be measured off so it is as wide as the other dimension of the frame plus an additional amount at each end (either ½" or ¾" where it will overlap the side pieces).

The back and side panels should be the same height. The height depends on where you plan on putting the cabinet and the number of drying frames you want it to hold.

Measure the top and bottom panels of the cabinet. They should be the same width as the back panel and the same length as the sides plus an additional ½" or ¾" where they will overlap the back panel.

Now measure where the rails on which the frames will rest will be placed. They should be 3" apart. Begin by measuring down from the top of the side panels 3" and draw a line across each panel. Measure off another 3" and do the same and continue doing this for the entire length of both panels. Now cut 1" x 2" lengths of wood as long as the panel is wide. Cut as many as you have marked on the side panels. Nail and glue them into place using the lines drawn to ensure that they are level and parallel.

Nail and glue the side panels to the back panel and then do the same with both the top and bottom panels. The cabinet is now complete with the frame guides in place.

Making the Drying Frames

After the cabinet has been completed, the next step is to build the frames to hold the fiberglass screen. There are three principal ways to make these screen frames: wooden frames, canvas stretchers, and aluminum frames.

Wooden Frames

Wooden frames can be made out of any lumber from 1" x 1" up to 1" x 3". Begin by measuring the inside of the print drying cabinet. Make the frames about ⅛" to ¼" smaller to allow them to slide in and out easily. The frames can be mitred or square cut at the corner joints. Because there is very little weight on the screens the joints do not have to be extremely strong. The corners of the frames can be joined with screws, nails, angle irons, or corrugated nails. A Stanley "Sure-Drive" set can save you a great deal of time. This makes firm joints and is both easier and faster than using either nails or screws. Wooden frames should always be painted to keep them from absorbing chemicals.

Frame Assembled with Stanley "Sure-Drive"

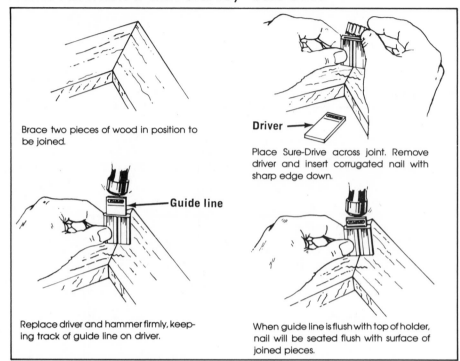

Brace two pieces of wood in position to be joined.

Guide line

Replace driver and hammer firmly, keeping track of guide line on driver.

Driver →

Place Sure-Drive across joint. Remove driver and insert corrugated nail with sharp edge down.

When guide line is flush with top of holder, nail will be seated flush with surface of joined pieces.

Frame Assembled with Stanley "Sure-Drive." This fastening device and tool is ideal for making a large number of joints in a very short time. Be sure to buy corrugated nails no deeper than one-half the thickness of your frame.

Frame Assembled with Angle Irons

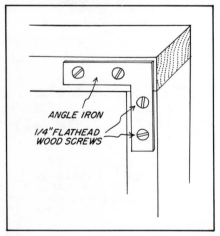

ANGLE IRON

1/4" FLATHEAD WOOD SCREWS

Frame Assembled with Screws

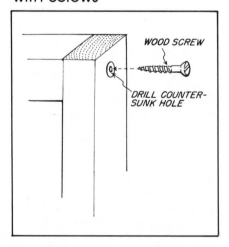

WOOD SCREW

DRILL COUNTERSUNK HOLE

Attaching the Screen to Wooden Frames

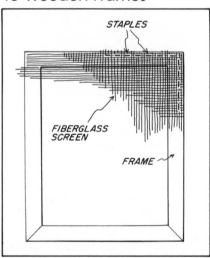

STAPLES

FIBERGLASS SCREEN

FRAME

Attaching the Screen to Wooden Frames. After the wooden frame is assembled, staple the fiberglass screen to it so that the screen is tight and free of wrinkles. The easiest way is to use a staple gun to staple the screen in place. Because galvanized staples are almost impossible to buy, the heads should be touched up with varnish to prevent them from rusting. It is also advisable to paint or varnish the wooden frames before attaching the screening. This will keep them from absorbing chemicals that can contaminate subsequent prints.

Canvas Stretchers

Canvas Stretchers. Wooden canvas stretchers are available from most art supply stores. They come precut in different sizes and can be easily assembled in a variety of combinations. The joints are precut to slip together and they can be glued or nailed to give the joint greater strength.

Aluminum Frame Members and Fiberglass Screen. These photographs show what the aluminum frame members look like. The round material is the "spline" and is used to hold the fiberglass screen in place once the frames have been assembled. Fiberglass screen comes in rolls of different widths. Buy the size closest to the width of your frames.

Aluminum Frames

1. Measure the width and depth of the inside of your print drying rack. Mark two lengths (depth minus ⅛") of screen section for the side frame pieces and two widths (width minus ⅛") for the top and bottom of frame pieces.

REMOVE U-SHAPE SPLINE

OR REMOVE GLAZING CHANNEL

2. Remove the U-shaped splines or glazing channels from all the frame members.

LENGTH OF MEMBER — 45°

3. Mark 45-degree angles at the measured points.

SAW END AT 45° ANGLE

4. Saw off the ends, using a fine-toothed coping or hack saw. Smooth cut ends with file or sandpaper.

INSERT CORNER LOCK

5. Insert corner locks into the two short frame pieces. Slip the two long frame pieces onto one of the end pieces. Finally, add the other end as shown to complete the frame.

Aluminum Frames. You can either buy pre-assembled aluminum frames from a window supply house or you can assemble them yourself. To do a complete

SQUARE CORNERS

6. Cut screening to outside dimensions of frame. Cut carefully between two screen wires to keep screening square. Place frame on table and scatter scraps of frame section in the center area to hold screening level with top of frame. On large frames you may want to nail small ¼"-thick blocks around frame to maintain squareness as shown in illustration 2.

SMALL 1/4" WOOD BLOCKS AROUND 4 SIDES

7. Line up screening with the outside edge of the screen groove at the side and end of the frame shown. Bend the screening into the side and end grooves. When using fiberglass screen it should fit down, across, and up inside of grooves.

OUTSIDE EDGE OF GROOVE

8. After completing operation along one side (as in step above), cut off excess screen cloth along line even with outside edge of groove in other adjacent leg.

BUTT JOINT

9. Cut U-shaped splines 1/16" less than length of spline groove; make butt joints at the corners. Next, tap spline into groove using block of wood with rounded front corner (on one long frame piece) to hold screening securely. In the same manner, form screen cloth on the two short sides, cut off excess screen cloth, and insert spline. Then, complete fourth side.

job you will need frame members, a mitre saw, a "spline" tool, and fiberglass screen.

Courtesy Reynolds Aluminum

Building a Light Box

A light table built into the dry-side counter makes it much easier to evaluate and select negatives for printing. This is especially true if you use medium or large film formats. Holding a 4 x 5 negative up to a bare ceiling bulb gives a very unevenly illuminated image. With a light table you can also evaluate an entire roll of 35mm film and not have to guess which negative is closer to the ideal as a result of being able to look at them only one at a time.

To build a light box, select a space separated from the enlarger by a short distance (leave working room on both sides of each) and located directly over a drawer or other unobstructed counter surface.

Purchase a metal rim frame such as is used to mount a sink on a glass or ceramic working surface into a kitchen counter. Hudee Count'r Guard is one such unit, available at plumbing or building supply stores. It requires only a saw to cut a hole in the counter and the rest of the assembly is easy. Once you have the rim, buy a piece of smooth-surface frosted glass cut to fit the frame at a glass supply company.

Round Fluorescent Fixture. This round fluorescent fixture by Sterling Lighting is ideal for illumination of a light table installed in the counter top.

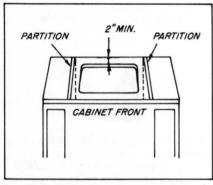

Locate the desired position of your light table insert on the counter top, usually close to the enlarger for convenience, and check for proper clearance. Be sure that the compartment under the location is at least 2" wider and deeper than the overall size being used. This will assure sufficient room to fasten the holding lugs. Be careful not to cut the supports on the underside of the counter top.

Position the frame assembly, right side up, on top of the counter in the location desired (step #1 above) and trace around the frame as shown.

Cut along the traced line carefully. This can be easily accomplished by drilling a ⅜" starter hole just inside the traced line and cutting along the line with a medium or fine tooth electric saber saw. Be sure to keep edge of saw vertical. A manual key-hole saw may also be used to make the cut-out. Use only fine tooth saw for manual cutting, and cut only on the down stroke to avoid splitting and delaminating the counter top surface. (NOTE: when using an electric saber saw, it is advisable to cover the counter top surface on the outside of the traced line with masking tape to protect the surface from being scratched by the vibrating base, or foot, of the saw.)

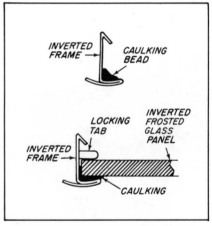

Assemble your light table insert by placing the frame upside down on a flat surface, and applying an adequate bead of caulking (such as clear silicone bathtub seal) around the under-inside top edge of the frame top flange.

After caulking the inside of the frame, insert the piece of frosted glass with the frosted side (bottom side) up, and place in the frame. With the insert positioned in the frame, bend one of the perforated press out locking tabs in the frame, on each side of the assembly, inward to hold the insert in the frame for installation. This need not be a tight fit as the installation lugs will secure the assembly firmly when installed.

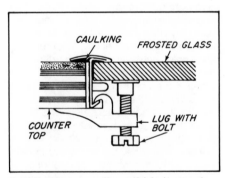

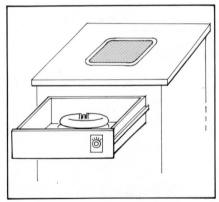

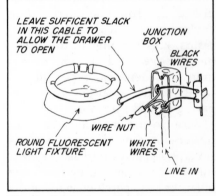

Seal the frame on the outside by applying a uniform bead of caulking to the under-outside edge of the frame top flange.

Install the light table assembly into the counter top cut-out. From the underside of the counter top, attach the lugs onto the hook of the frame leg. Always place two lugs as close as possible to each side of the corner bends. Space and tighten lug bolts evenly and firmly until top flanges of the frame are clamped tightly to both the counter top and the insert. Caution: Do not overtighten lugs. Additional unnecessary pressure may distort the frame causing gaps.

Courtesy Hudee Manufacturing Co.

Use the drawer under the counter or build in a box to hold the fluorescent light fixture. The inside should be painted white to give an even distribution of light.

Wire the light using either a regular on-off switch or a dimmer switch made for fluorescent lights. Mount the switch on the front of the drawer where it will be in easy reach. The junction box for the connection should be under the counter and out of the way. Be sure the line running to the drawer has sufficient slack in the wire to allow you to open the drawer to change the tube when necessary.

Mounting the Enlarger

Normally when you purchase an enlarger it comes mounted to a wooden or composition baseboard. With minimal effort you can make improvements in two significant areas: reducing vibrations and increasing the size of prints that can be made.

Reducing Vibration

The sharpness of an enlarged print depends on the sharpness of the camera and enlarging lenses, the type of film used, and the shutter speed or firmness of support used at the time the picture was taken. A factor quite often overlooked is the steadiness of the enlarger at the time the enlargement is made. There is vibration in every enlarger column. This vibration is either picked up from the surrounding environment such as passing trucks, trains, kids running in the apartment above the darkroom, or it is induced when you make adjustments to the enlarger while preparing to make a print.

Because the enlarger acts as an upside-down pendulum the vibrations picked up by the base are magnified by the time they reach the enlarger head perched on top of the column.

Since all enlargers, regardless of manufacturers' claims, are subject to vibrations the true science should be applied to reducing vibrations or damping them out of the system as fast as possible. As long as the column is not oscillating at the time the print is made the image will be sharp. Part of the damping of the vibrations will be a result of good design on the part of the enlarger manufacturer. The rest depends on where you use the enlarger and how you mount it. The best design in the world will not make an enlarger steady if it is used on an unstable base.

The Pendulum Effect

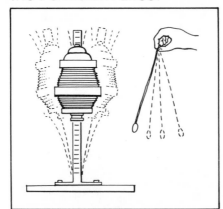

The Pendulum Effect. The enlarger column acts as an inverted pendulum. The vibrations that are picked up by the baseboard are magnified as they go higher up the column. The column will no longer act as a pendulum if the top of the column is supported. This would be the same as holding the bottom of a pendulum and preventing it from swinging.

Damping Vibrations

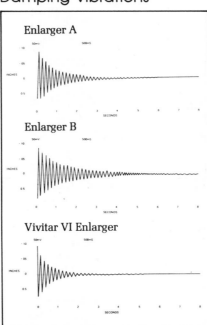

Damping Vibrations. Contrary to what you might think, making an enlarger column more rigid (or stiff) will not help to dampen out the vibrations faster. In fact, a stiff column will only vibrate at a higher frequency which makes vibrations last longer. These graphs show how the Vivitar IV enlarger, by using a more flexible column, actually dampens vibrations faster than a more rigid enlarger would.

Eliminating Vibrations

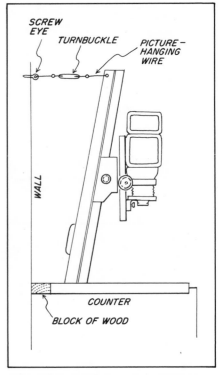

Eliminating Vibration. The enlarger can be made more steady, giving sharper prints, by attaching the top of the column to a wall or other very solid surface. Be careful, however, since this will not help, and in fact can make things worse, if the wall is not solid and stable. Buy some picture hanging wire, a screw eye, and a small turnbuckle in the hardware store. Cut the wire into 2 lengths and attach to either end of the turnbuckle. Now screw the screw eye in the wall directly behind the enlarger and fasten one of the wires to it. Fasten the other to the enlarger (you may have to drill a hole for it). Now tighten the turnbuckle just enough to put pressure on the enlarger column. Too much pressure will distort the column so be gentle.

If you want the enlarger farther out from the wall, insert a block of wood of the necessary length behind it. This will keep the enlarger from moving backward as the turnbuckles are tightened.

Increasing Print Size

The major factor that determines how large a print you can make with a given lens/film format combination is the distance between the negative and the paper on which the print is being projected. Most enlargers are capable of making prints up to 11" x 14" on the baseboard and longer columns are also available as options allowing prints as large as 16" x 20" to be made. In either case larger print sizes can be made by wall mounting the enlarger.

Wall mounting the enlarger is usually done in conjunction with building an adjustable enlarger baseboard. This increases the range of print sizes that can be made conveniently. The following pages illustrate how to build one of these units.

Most enlarger manufacturers make wall mount units for their enlargers that are relatively inexpensive. You can also build your own, provided you are handy with tools. Before doing so it is wise to check how steady the wall in the room is. Exterior walls are generally well made since they are designed to carry the weight of the house. Interior walls are either load-bearing or not; the ones that are not load-bearing are usually less steady. If possible, use an exterior wall or an interior load-bearing wall to mount the enlarger. Generally, shorter walls will be more stable than taller walls because their supports are closer together.

Using Two Turnbuckles

Using Two Turnbuckles. A single column enlarger can be made even steadier by using 2 sets of turnbuckles.

Wall Mounting the Enlarger

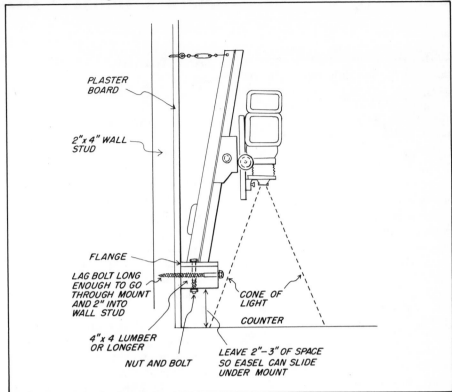

Wall Mounting the Enlarger. The first step in mounting the enlarger is to devise a support to which it can be fastened. The type of support will vary depending on the type of flange used to bolt the enlarger to its base. The easiest support can be made from a few feet of 4" x 4" lumber from a local lumber supply store. If the flange on the enlarger is larger than 4" buy a 6" x 6" or larger piece of wood. This can be bolted to the wall studs (not to the plaster or plaster board) with long "lag bolts" and then the enlarger can be mounted to it. The top of the column should then be supported with turnbuckles and picture-hanging wire to eliminate any vibrations in the column.

Another Wall Mount

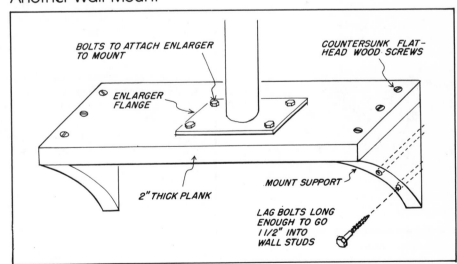

Another Wall Mount. In some cases it may be necessary to build a more complicated support on which to mount the enlarger. If the flange on the enlarger is wider than 6" it is generally better to use a 2"-thick plank, wide enough to accommodate the enlarger mounting flange. This plank can then be mounted horizontally to the wall by cutting supports for both ends out of the same plank.

Building an Adjustable Enlarger Baseboard

With a given film format/lens combination the sole determining factor as to what size prints can be made is the distance between the negative and the paper surface. This can be increased by raising the enlarger head up the column but at some point it can go no farther. In addition, problems with vibration are increased as the head is raised higher.

An adjustable baseboard can be built to allow for greater print sizes. It is essentially a unit that decreases or increases the negative-to-easel distance by raising or lowering the shelf on which the easel rests. The lower the shelf the greater the size of the enlargement.

Print Sizes

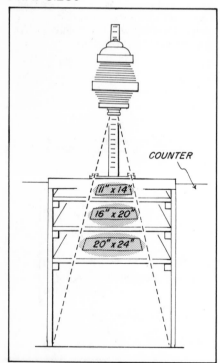

Print Sizes. The enlarger projects a cone-shaped image that grows in size the farther it gets from the enlarger lens. To obtain a larger image the easel must be placed farther from the lens in a wider section of the cone.

Determining Shelf Heights

When making an adjustable enlarger baseboard you should take into account the size of the prints you make most often. The shelf for this print size should be placed at countertop height for maximum comfort. Very much larger print sizes will be lower and very much smaller print sizes higher, but because they are made less frequently the resulting discomfort is minimized.

Most enlargers will print up to 11" x 14" on the baseboard and some will go as high as 16" x 20". Therefore, it is likely that one of these sizes will be the one placed on the shelf at countertop height.

Keep in mind that if you crop your prints considerably you may actually be enlarging to 16" x 20" size to obtain the 11" x 14" print you want.

Selecting the Easel Shelf Size

The size of the enlarger baseboard you need is based on the size of the largest easel you plan on using. If you normally print 8 x 10 but occasionally want to print up to 20 x 24, the baseboard should be designed to handle the easel for a 20 x 24 print in either a horizontal or vertical alignment. This will require a shelf size of at least 28" x 28"; the shelf, side, and back panels plus the shelf supports should be cut accordingly. Be sure to allow for the size of the easel, not the print, plus handling room on either side of the easel.

The shelf can have handles attached to the top side on both sides to make it easier to lift in and out when it's being raised or lowered.

Negative-to-Easel Distance

Negative-to-Easel Distances. When making an enlargement from a given negative size, the significant factor determining the size of enlargement that is possible is the distance between the negative and the paper on which the image is projected. Secondary factors that influence maximum print size include increased exposure times, reciprocity failure, loss of contrast, and vibration, but for the moment these will be discounted. This table is designed to give you the approximate distance your negative must be from the paper (easel surface) to obtain a specific print size from the most common film format/enlarger lens focal length combinations. Decide first what print sizes you want to make. Once that size is established, you can determine what range of distances has to be obtained for the minimum and maximum sizes you want to print. If, for instance, you want to make both 5 x 7 and 20 x 24 prints using a 50mm lens and 35mm film, you must be able to increase the distance between the negative and the easel from a minimum distance of approximately 11" to a maximum distance of 36" or a total range of 25". Some enlargers can accommodate this range on the baseboard that comes with the enlarger, but on most you will either have to project the image on the floor, tilt the head to project on a facing wall, or build an adjustable enlarger baseboard.

	If Your Film Format Enlarging Lens Combination Is:			
Print size desired	35mm film 50mm enlarging lens	2¼ x 2¼ film 75mm lens	2¼ x 3¼ film 100mm lens	4 x 5 film 150mm lens
8 x 10	18"	15"	17"	18"
11 x 14	26"	20"	22"	23"
16 x 20	34"	27"	30"	30"
20 x 24	37"	33"	36"	36"

How to Build It

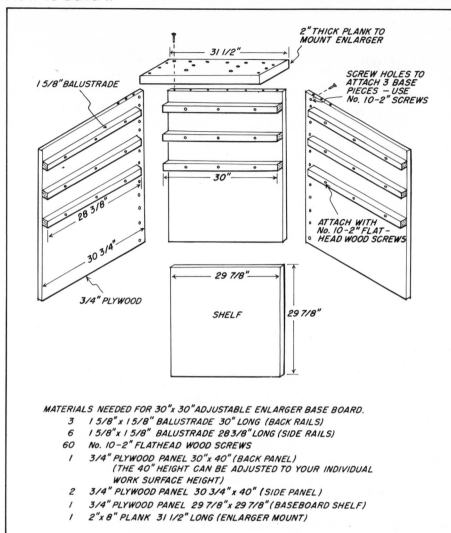

2" THICK PLANK TO MOUNT ENLARGER

31 1/2"

1 5/8" BALUSTRADE

SCREW HOLES TO ATTACH 3 BASE PIECES – USE No. 10-2" SCREWS

28 3/8"

30"

30 3/4"

3/4" PLYWOOD

ATTACH WITH No. 10-2" FLAT-HEAD WOOD SCREWS

29 7/8"

SHELF

29 7/8"

MATERIALS NEEDED FOR 30"x 30" ADJUSTABLE ENLARGER BASE BOARD.

3	1 5/8" x 1 5/8" BALUSTRADE 30" LONG (BACK RAILS)
6	1 5/8" x 1 5/8" BALUSTRADE 28 3/8" LONG (SIDE RAILS)
60	No. 10-2" FLATHEAD WOOD SCREWS
1	3/4" PLYWOOD PANEL 30"x 40" (BACK PANEL) (THE 40" HEIGHT CAN BE ADJUSTED TO YOUR INDIVIDUAL WORK SURFACE HEIGHT)
2	3/4" PLYWOOD PANEL 30 3/4"x 40" (SIDE PANEL)
1	3/4" PLYWOOD PANEL 29 7/8"x 29 7/8" (BASEBOARD SHELF)
1	2"x 8" PLANK 31 1/2" LONG (ENLARGER MOUNT)

How to Build It. Cut the shelf and 3 side panels from a sheet of ¾" plywood. The back panel should be cut the same width as the frames plus ⅛" for ease in getting the frames in and out. The side panels should be cut to the same length plus an additional ¾" because they will be screwed into the ¾"-thick back panel. The back rails should be the same width as the back panel. The side rails should be only long enough to be flush with the front of the unit and with the back rails.

Assemble the 3 large plywood panels and then measure and install the back and side shelf supports.

Mount a plank at least 2" thick to the top back of the unit as a support on which to mount the enlarger. The first (top) shelf support should be low enough to provide clearance between the top shelf and the board on which the en-larger is mounted for the easel to fit, otherwise you may not be able to cen-ter the image on the easel.

Assembled Unit

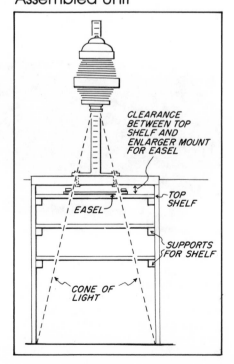

CLEARANCE BETWEEN TOP SHELF AND ENLARGER MOUNT FOR EASEL

TOP SHELF

EASEL

SUPPORTS FOR SHELF

CONE OF LIGHT

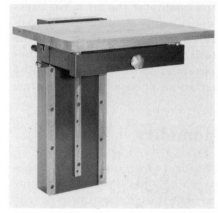

Fotar Enlarging Table. This enlarging table from Colenta America is extremely sturdy. It's expensive, but a butcher block baseboard and ease of operation would make it worthwhile for someone making a great many prints and changing print sizes frequently.

Mural Enlargements. Rather than turn or invert the enlarger, you can use a mir-ror placed at a 45-degree angle to the easel. The image will reflect off of the mirror onto a facing wall. It's best to use a mirror with the reflecting surface on the front of the glass to minimize dis-tortion.

Air Quality

The quality of the air in the darkroom directly affects both the quality of work done there and the health and enjoyment of the photographer. Several aspects of the darkroom air have to be considered.

Humidity

The ideal darkroom humidity is between 45 and 50 percent. In some parts of the country this is easy to maintain without controls, but sometimes control is an absolute necessity. Air that is too damp will rust equipment and make it perform inaccurately; air that is too dry will create static electricity problems and increase problems with dust. A dehumidifier can help a damp room (a side benefit is that the water run off from the dehumidifier can be bottled and used as distilled water for negative processing). A room that is too dry can be corrected with the addition of a humidifier.

Temperature

The ideal darkroom temperature is approximately 68°F, the temperature at which most photographic chemicals are used. If temperatures vary considerably, time is spent worrying about water baths, comfort, and the timing of the various developmental processes. To control the temperature you can install heaters or air conditioners. Air conditioners are especially useful because they will also filter and dehumidify the air as they are cooling it. If you use an air conditioner try to have the air flow from the dry side to the wet side so that steam and vapors rising from the sink are not carried over to the dry side. Be sure to buy an air conditioner that can operate on fan only so that the room can be ventilated without being cooled.

Ventilation

The minimal controls required in a darkroom concern air flow and turnover. The air in the darkroom must be changed every 6 to 8 minutes for comfort. To make this possible a fan and vents must be installed. The fan should always be filtered and the air stream should enter the darkroom from the dry side. Outlet vents should be over the sink on the wet side. This arrangement increases the pressure in the room so that unfiltered air from outside does not carry dust into the darkroom. The flow from dry to wet side keeps the vapors from the sink contained and the outlets over the sink provide a way for the air to be carried from the room. All vents and fans should be light-proof.

Dust

Dust must be kept out of the room, or removed, if any dust seeps in. The best device is an electrostatic air cleaner to filter particles out of the air.

How to Find the Size Fan You Need

Air in the darkroom should be changed every 6 to 8 minutes. To determine the size fan needed you have to know the number of cubic feet in the room. Fan capacities are rated in cfm (cubic feet per minute). To determine the cubic feet in your darkroom, measure the room's width, length, and height. Multiply these dimensions to give you the total cubic feet in the room. Divide that figure by 6 to determine how many cubic feet per minute the fan must move if it is to change the entire room every 6 minutes. Example: if the room is 8' wide, 10' long, and 7' high: 8 x 10 = 80; 80 x 7 = 560 cubic feet. 560 divided by 6 = 93 cubic feet per minute. The fan should be approximately 100 cfm rated.

Electrostatic Air Cleaner. Eliminating dust from the darkroom can be a full-time job. If you don't get it out of the air you have to get it off of the negatives. If you don't get it off of the negatives, you have to spot the prints. If dust is a problem, you can install either a wall mounted or tabletop electrostatic air cleaner such as this Labaire model from Leedal. It works by charging dust particles so that they will adhere to a collector with an opposite charge. Because the dust builds up on these collectors, you should also consider their ease of cleaning. This model collects particles down to .01 microns. The collecting screen is washable.

Darkroom Air Flow

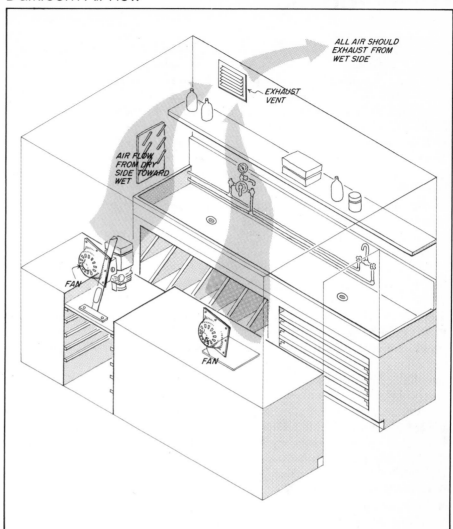

ALL AIR SHOULD
EXHAUST FROM
WET SIDE

EXHAUST
VENT

AIR FLOW
FROM DRY
SIDE TOWARD
WET

FAN

FAN

Darkroom Air Flow. If the fan is mounted to blow into the room, the fan should be installed on the dry side of the darkroom and the vents on the wet side. The air entering the room will keep it at a positive pressure and air will flow out of the cracks in the room, which keeps the dust out.

Should you decide to use the fan as an exhaust fan blowing air out of the room, it should be mounted on the wet side so that the moist air from the sink and chemicals exit immediately without being distributed throughout the room.

Ventilator Fan. Special darkroom fans such as this Starfield ventilator from Porters are specially baffled to prevent light leaks. This fan has a capacity of 200 cfm, which is sufficient to change the air every 6 minutes in a darkroom 10' x 16' x 7' or smaller.

Exhaust Vents. Darkroom vents should be light-proof. Spiratone supplies these "Darkroom Breather" vents in four sizes: 10 x 8, 12 x 12, 18 x 8, and 24 x 12.

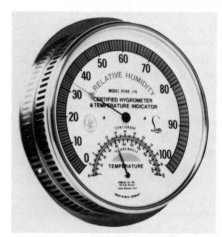

Humidity and Temperature Indicator. This combination humidity and temperature indicator from Abbeon Cal. Inc. is a good item for the darkroom. Then again perhaps ignorance is bliss.

Light-proofing

Light-proofing is essential to prevent light-sensitive film and paper from fogging. Many prints lack contrast between shadow and highlight areas because the paper or film was exposed to nonimaging light that made the contrast muddy. This effect is sometimes so slight that it can be discovered only by running a proper test, but once comparison prints are made the loss of quality will become immediately apparent.

Film, with its higher speed, is much more susceptible to light than is enlarging paper; therefore, a room in which printing is done need not be as light-proof as a room in which film is handled. A kitchen or other temporary darkroom can usually be light-proofed sufficiently to make prints (or you could print only at night) and film can be loaded into reels and placed in daylight tanks inside a changing bag. To be sure a room is light-proof enough to print first stand in it with the lights out for at least five minutes so your eyes have a chance to adjust completely. If you then cannot see a plain white paper held against a dark background the room should be safe. A few small leaks around doors and windows are safe if they are not near the enlarger or processing trays or paper cutter. Such leaks can be eliminated, however, with aluminum foil crumpled and stuck into holes or taped in sheets over larger openings. Larger areas can be covered with light-proof cloth or black garden plastic and tape.

Windows

Windows can be light-proofed using special shades made specifically for the purpose. These shades are relatively expensive but are convenient if the darkroom must be used for other purposes. A somewhat less expensive method is to use light-proof cloth fastened to the wall or window frame with velcro tape, which is available in sewing supply stores. One part of the tape can be permanently mounted to the window frame and the other sewn to the cloth. The two can then be stuck together and pulled apart as need be. When the cloth is not being used, it is easy to fold and store.

A third method is to use masonite paneling and either velcro tape or screws to hold it in place. These panels can be made cheaply and are totally light-proof.

Windows facing sources of subdued light can be covered with red plexiglass to act as a safelight. Always run a safelight test after doing this. If paper fogs, use a double thickness of plexiglass.

The cheapest and easiest method of all is to paint the windows black, but this works only if you never want light through them.

Doors

The ultimate door is a revolving one, but most people cannot afford the expense. An alternate solution is a light trap, which is inexpensive but does require a lot of floor space. Several possible designs are shown on pages 50-52. These entryways are ideal because they allow people and air to circulate freely without light entering the darkroom. Light traps should not face a bright light source because reflections can work their way into the darkroom. If this is impossible to avoid, the entrance can be covered with a hanging cloth with a chain or weights sewn in the bottom to hold it down.

Light-proofing a Shade

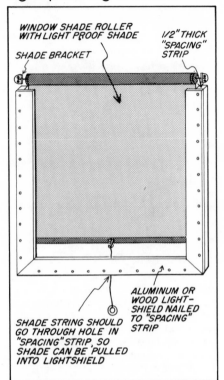

Light-proof Shade. These are perfect for the room that must serve more than one purpose. Release the latch and ZAP . . . the light is back in the room and shade has disappeared. Reasonably priced custom-made models are available from Draper Shade Co.

Light-proofing with Panels

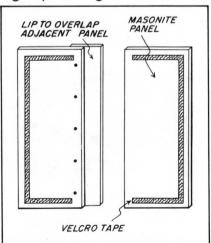

Light-proofing with Panels. Use either one large panel or a series of smaller panels fastened to the wall or window frame with velcro tape. This will allow for easy installation and removal. Handles on the top and bottom of each panel make the chore even easier.

Light-tight Drawer/ Paper Safes

A place to store paper when the lights are on is a real convenience. It is time-consuming and bothersome to work directly from the paper box, especially when large numbers of prints are being made. Better to build a light-proof drawer or buy a paper safe.

Vents, Fans, and Heaters

All equipment installed in the walls of a darkroom should be light-tight. Some vents and fans are made specifically for darkroom use. If you choose to use a regular fan, a louvered box can be made to cover it making it light safe. You should also remember that some space heaters have radiating coils that can emit sufficient light to fog paper. If you plan to use one that emits a glow, be sure to run the safelight test given on this page.

If the darkroom is located near the furnace or hot water heater, make sure that if they suddenly turn on the light emitted won't fog your prints.

Light-proof Drawer

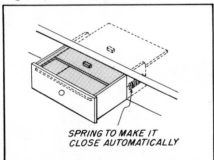

SPRING TO MAKE IT CLOSE AUTOMATICALLY

Light-proof Drawer. A light-proof drawer makes the printing process a great deal easier. The one illustrated here has a top, sliding in grooves, that closes automatically when the drawer is closed. The piece of wood on the top slide hits the piece of wood on the bottom of the counter top and closes the interior lid. The springs attached between the drawer and the wall ensure that the drawer closes automatically. All of the interior surfaces of the drawer should be painted a flat black to reduce reflections.

Changing Bags and Tanks. Many darkrooms are safe to print in but have too much light to load and unload film safely. The solution is to use a changing bag that is completely light-proof. Film can be loaded onto developing reels and placed in a daylight tank similar to this Nikor model. The changing bag is manufactured by Burke & James.

Papersafes. If you do not want to build a light-tight drawer, you can buy a papersafe to hold your paper. Be sure to get one that is light-proof and self-closing. You can test for light-tightness by leaving a sheet of paper in one for a day and after developing it comparing it closely with an unexposed sheet.

Safelight Test

Printing paper has a characteristic response to light that makes it relatively more sensitive to additional light after it has been partially exposed. To check properly how light-tight your darkroom is, use paper that has already been sufficiently exposed to have passed its exposure "threshold" and is at its most sensitive:

1. Focus the enlarger on the easel using a standard negative. Have the easel blades cover a margin of the paper so it will not be exposed when the print is made.

2. Expose Print #1 as you would normally WITH THE SAFELIGHTS ON and develop and fix it as recommended.

3. Expose Print #2 in the same exact way except HAVE THE SAFELIGHTS OFF. Develop and fix it as you did Print #1.

4. Expose Print #3 in the same way WITH THE SAFELIGHTS OFF. Before developing put the print where the developer tray normally is and cover three-quarters of it with an opaque card. Turn the safelights on and expose the exposed strip for one minute, move the card to expose another strip and expose that for two minutes, move it again and expose the new strip for four minutes. The test print will have four exposures of seven, three, one, and zero minutes total exposure. Now develop and fix this print as you did #1 and #2.

After the prints are dry they should be identical in both the shadow and highlight areas as well as the white borders. If Print #1 has a lower contrast or dirty highlight areas in comparison with Print #2, there is a problem with the safelights. You should check their wattage, the condition of the filter, and the distance to the enlarger and developer tray. If Print #3 differs from #2 in any of the time periods tested, it will give you the maximum time a print can be exposed to the safelight. You will also note that on Print #3 the corresponding margin is unaffected, which proves that paper becomes more sensitive to additional exposure after crossing its threshold.

Those Added Comforts

It's rare that you will have a reason to fill your sink with champagne bottles as Gil Amiaga did for the opening of his new studio. There are, however, small things that can be added to a darkroom to make it a more pleasant place to be when all of your listless friends are lying on the beach.

Phone

To avoid the dilemma of having to hurry up with a print or miss a call from your editor, an extension phone permanently installed in the darkroom can save time and pictures. It's also a good way to keep in touch with the outside world when performing some of the more boring aspects of your work.

Stereo

A radio or extension speakers from a good stereo will add a lot to the enjoyment of printing.

Television

Believe it or not, there are photographers who have filters taped over their television sets so they can watch the Cowboys game while printing. They have a tendency to get their zone systems confused with zone defenses, but that's one of the hazards of doing two things at the same time.

Photograph by Gil Amiaga.

Floor Mats

Standing on a hard floor all day was fine in a nineteenth-century sweat-shop, but in a comfortable dark-room it is definitely out. There are commercial floor coverings such as Ace Core-Lite and Leedal floor mats made especially for the dark-room. A piece near the enlarger and a strip along the front of the sink will usually suffice if you don't want to do the entire floor.

Contents

Sinks • **122**
Water Quality • **124**
Temperature Regulation • **126**
Automatic Temperature
Regulation • **128**
Processing Trays and Tongs • **130**
Wet-Side Accessories • **132**
Roll Film Tanks and Reels • **134**
Washers • **136**
Timing Systems • **138**
Chemical Storage • **140**

Sinks

Most beginning photographers start by putting trays of chemicals on the kitchen table or counters. They soon learn that spills are impossible to avoid and temperatures in the trays difficult to hold at a constant level. In addition, the cleanup time is longer than need be because of the care with which the counters and tables have to be cleaned. The solution is a sink large enough to hold all of the processing trays. Photographic sinks should have a large area and a shallow depth. They can be equipped with temperature control faucets, standpipes, and duckboards to make them even more efficient. You can build your own of wood as shown on pages 98-99 but commercial models are available that are perfect for the home darkroom.

Commercial sinks come in either plastic or stainless steel models. Stainless is extremely long lasting but much more expensive. Stainless sinks also tend to be a little noisy with trays and tongs banging against them but their durability and ease of cleaning make them a dream to use. Plastic sinks are equally efficient at keeping the spills contained, are also easy to clean, and given reasonable care should outlast even the youngest photographer. Sinks can be ordered from suppliers either with or without stands. The stands make them portable if you are moving. They can also be built in without using the stand but in doing so you are making it much more difficult to remove and install in another location. Be sure the stand is made of a corrosion-proof material or is well painted; the chemicals used in photography will badly corrode most steel stands and rust scaling will detract from the cleanliness and appearance of the room.

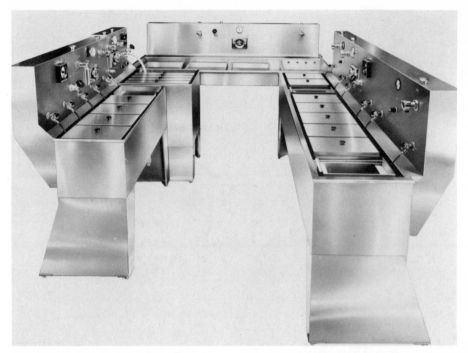

Stainless Steel Darkroom. This Calumet darkroom set-up illustrates equipment for a high-volume operation. The sinks provide for bulk processing of film and prints and have all of the best possible features, including temperature regulation, gaseous burst agitation, stainless steel construction, and daylight tanks.

Sink with Ribbed Bottom. This NuArc plastic sink features the dump trough in the back and a ribbed bottom making duckboards unnecessary. A simple straightforward design.

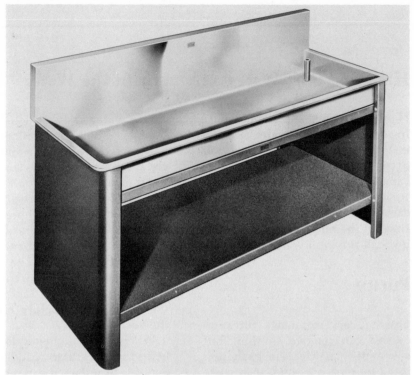

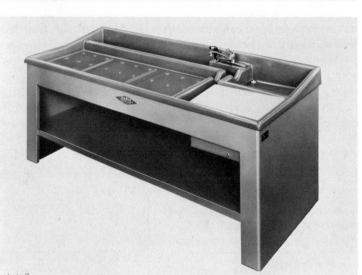

Arkay Sink. This Arkay sink is representative of the many well-designed stainless steel sinks available commercially. The key features are the high splashboard and the rounded corners in the sink that make for fast and easy cleaning. This illustration also shows a standpipe inserted. When the sink is filled, the water rises only to the top of the standpipe and then overflows into it and down the drain. A number of standpipes of different heights allows you to fill the sink to different levels depending on what is in the water bath. Trays would need a low level of water to keep them regulated, but developing tanks could use a higher level.

Plastic Sinks. This ABS plastic sink by NuArc has a unique design which allows you to dump chemicals without affecting the temperature bath for processing trays. The trough running along the back of the sink is connected to a fast-emptying drain. The sink also features a ribbed bottom which allows water to circulate freely under the tray for more efficient temperature control. It comes equipped with a built-in viewing area which doubles as a light table and squeegee board. Ideal for those working with large negatives or graphic arts materials.

Note the sink sprayer that makes cleaning up easy. This device can be installed on any sink, including one you build yourself.

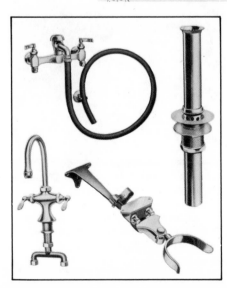

Sink Accessories. When building or buying a sink, there are several accessory items that can be considered. The illustration above shows a knee-operated mixing valve from Eljer that allows you to mix the water at any temperature you desire using your knee, which leaves your hands free to hold the processing trays, film, or whatever. The high faucet is ideal because it allows for the placement of large graduates and bottles under it for filling. The faucet with the rubber hose attached does the same thing and also eliminates noisy drips, since it lies on the bottom of the sink when not in use and any water coming out slips quietly onto the sink bottom. The illustration of the drain and standpipe shows how it is assembled.

Courtesy Eljer Plumbingware.

Foot-Operated Valve. Kohler makes a foot-operated control valve that allows you to vary the temperature of the water flow while keeping your hands free. Designed for hospital work, it can also be used in the darkroom.

Water Quality

Water quality in this section refers to everything but its temperature which is discussed in the section on temperature regulation. (See pages 126-129.) There are several basic components that affect the quality of water used in photography.

Suspended Solids

These small, solid particles exist in all water systems. They originate at the source or enter into the water at some point in the distribution system, and can be removed by using water filters. Their removal becomes increasingly important if you are using a temperature regulating valve that can be damaged by solid particles in the water.

Although these particles have relatively little effect on prints, they have a tendency to adhere to negatives and once they have dried to the surface it is impossible to remove them.

Hard and Soft Water

Hard water can make chemical mixing difficult and soft water can soften the gelatin on film and paper after long washing cycles. The range of allowable hardness of water is from 40 to 150 parts of calcium carbonate ($CaCO_3$) per million. To find out the range of your own supply, call the local water authority.

Purity

Only a very expensive filtration system can remove anything but suspended particles. For badly polluted sources, one solution is to use distilled water at least for washing the negatives. You can store water that runs off of the air conditioner or dehumidifier cooling coils or buy a small distillation unit. Discolored water can cause prints to stain; it can usually be cleaned with a charcoal filter.

Air in the Water

Air in water and solutions causes bubbles to build up on film and paper surfaces preventing developers and other chemicals from coming in contact. This should be prevented if uniform development, fixing, toning, and washing is to be achieved. Either boil the water to drive off the air or add an aerator to the incoming line. The aerator forces large bubbles into the water and these combine with and remove the smaller ones before rising to the surface.

When stirring chemicals it also helps to use a stirring paddle with a wide blade and narrow handle. The narrow handle disturbs the surface of the solution less than a larger object would and prevents additional air from entering. Some chemical mixers are designed to go one step further and are magnetically operated paddles without handles so very little surface disturbance occurs.

Water Impurities

If you are using water from a source other than a municipal water supply, you should have it analyzed by a lab to determine its contents. The following table gives some of the maximum allowable limits for commonly encountered chemicals.

Practical Limits for Common Impurities in Water Used for Photographic Processing

Impurity	Maximum or Range or Content (ppm*)
Color and suspended matter	None
Dissolved solids	250
Silica	20
pH	7.0 to 8.5
Hardness, as calcium carbonate	40 (preferable) to 150
Copper, iron, manganese (each)	0.1
Chlorine, as free hypochlorous acid	2
Chloride (for black-and-white reversal)	25
Chloride (for color processing)	100
Bicarbonate	150
Sulfate	200
Sulfide	0.1

*parts per million

© Eastman Kodak Company 1967, 1974.

Water Distiller. Edmund Scientific also makes a distillation unit. This model makes up to 4.8 gallons every 24 hours. Plugs into any 110 volt outlet and requires no plumbing.

Available from Edmund Scientific Co., 7782 Edscorp Bldg., Barrington, N.J. 08007.

Water Filter. Filters are rated by the size of the particles that they remove from the water. The largest filter you should use for photographic processing is 50 micrometers. A smaller filter will make the water cleaner and the filter dirtier, requiring more filter changes without noticeable effect on your negatives or prints.

Water filters come in cold or hot models. The basic difference is their respective abilities to resist temperature damage. The hot line filter is usually designed to withstand high temperature and pressure over a sustained period of time. The cold filters are not subjected to this stress, so their quality (and price) is not as high.

This illustration shows a Leedal model and the filter element inside.

Water Distiller. This Medi/Tech water distiller is easy to operate and produces up to 56 ounces of distilled water every 8 hours. This company also has a larger model with three times the capacity. The unit plugs into the wall and requires no expensive installation. Distilled water is rarely a necessity, but some photographers use it as a final rinse for negatives.

Unitron Self-cleaning Water Filter. The Unitron Universal Self-Cleaning Water Filter is designed for both amateur and professional photographic use in black and white and color processing systems. The filter comes with all the essential fittings required for either temporary use on outlets such as kitchen faucets or for permanent installation with elaborate processing equipment. The filter can handle up to 360 gallons per hour at temperatures up to 140 degrees F (60C) in continuous operation and can remove particles down to 20 microns (450-mesh) in size. A built-in valve allows the filter to be flushed out whenever required.

Unitron is a registered trademark of Ehrenreich Photo-Optical Industries, Inc.

Water Softener. If you are bothered by hard water and do not want to install a water softener, you can at least treat the water you use for chemical mixing with this Edwal additive.

125

Temperature Regulation

The more heat you have in photographic processes, the faster things happen. It is easy to understand the importance of temperature regulation in controlling the rates of chemical reactions found in developing, fixing, toning, and washing. As a rule of thumb, a 10°F. change in temperature will double or halve the rate of a chemical reaction. Solution temperatures can be regulated in several ways to ensure that processes occur at expected rates and can be repeated.

Controlling Ambient Conditions

Having the room temperature close to the temperature at which chemicals are used helps reduce the need for more exotic controls. It usually is not sufficient to make conditions perfect, but it works and saves a great deal of time because if stored chemicals are at the correct temperature they can then be used without additional heating or cooling.

Controlling the Temperature of Incoming Water

When mixing chemicals, washing prints, or trying to maintain a constant temperature in a water bath it helps to have a thermostatically controlled water valve. These can be preset to maintain a temperature within a given design range (usually ½°) despite changes in line temperature or pressure. They are a good investment and significantly reduce the problems involved with working in a darkroom.

Controlling the Temperature of Water Baths

Chemicals can be maintained at the proper working temperature by immersing the container in which they are held in a water bath that is maintained at the correct temperature. The larger volume of the water bath makes the temperature more stable and will keep the smaller volume of chemical solutions from changing temperature. A water bath can be made by immersing a tray or tank in a larger one into which water at the correct temperature has been poured. The larger the amount of water in the bath the easier it is to obtain and control a stable temperature. If you have a sink it can be plugged with a standpipe that you can buy or make out of a plastic graduate. The standpipe will allow the water in the sink to rise only to the top of the pipe, at which point it overflows into it and down the drain. The large volume of water in the sink will maintain a stable temperature for a long period of time.

In the absence of a temperature regulating valve and standpipe the water bath temperature can be maintained with either an immersion heater or recirculating unit.

The temperature can also be controlled by adding hot or cold water occasionally to raise or lower the temperature.

It helps to have a stainless steel graduate to use for changing the temperature of small volumes of chemicals. Stainless steel is an excellent conductor of heat and immersing it, full of the chemical, into a hot or cold bath will quickly change the temperature of the solution it contains. The same effect can be obtained with a plastic graduate but it takes much longer to obtain the same degree of change.

Temperature regulation of the water in most darkrooms will depend to a large degree on the amount of hot water available to your house or apartment. You may well find after spending $300 on a temperature regulating valve that your hot water capacity is sufficient for only half an hour or so of water at the desired temperature. It's better to know beforehand what the capacity of your heater is, what your consumption is expected to be, and how the two relate. If you have to install a larger hot water heater for the darkroom, you can derive a side benefit (the whole family can take long, hot baths one after the other).

Ice Cubes in Plastic Bag

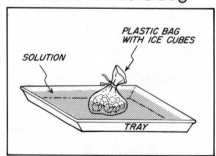

Ice Cubes in a Plastic Bag. If you overshoot and your temperature climbs too high, it can be lowered without diluting the mixture by placing ice cubes in a plastic bag into the solution. The melted water is retained in the bag.

Recirculating Heater. The basic application of a recirculator is to keep the water at a constant temperature without adding any new water to the system. This conserves water (however, it consumes electricity), because the temperature of the water in a water bath can be raised without adding new hot water. The recirculator pumps the water out of the sink or bath, heats it, and then returns it at the preselected temperature. Look for the rated capacity of the recirculator in terms of both flow rate (gallons per minute) and temperature range. It's also helpful to know what its range is in relation to the ambient temperature of the room. Can it hold 68 degrees on a minus 32-degree day in your northern Maine darkroom?

Immersion Heaters. The least expensive way to control temperature in a fixed body of solution is with an immersion heater. They work on the same principle as electric probes used to heat a cup of coffee. The electricity raises the temperature of the heating element and that heats the water. Some immersion heaters are quite sophisticated with thermostatic controls and circulating pumps so the temperature is maintained uniformly throughout the solution. Without adequate circulation, the temperature would be uneven.

Stainless Steel Graduates. Stainless steel graduates are great conductors of heat and can be used for raising or lowering the temperature of solutions placed in them. Immerse the graduate in a water bath at the desired temperature or do what Neal Slavin does and use a hot plate to bring the temperature up quickly.

Thermometer in Fitting. If you don't go all the way with temperature regulation, it's at least helpful not to have to hold the thermometer in the stream of water with one hand while trying to adjust two faucets with the other. The solution is a fitting into which a thermometer is permanently mounted. You still have to regulate the temperature manually, but at least you can check the temperature without standing there holding the thermometer. This model is by Pfefer.

Water Bath. One way to maintain a water bath requires a heating element, a temperature control device, and a circulating pump. The pump is necessary to ensure evenness of temperature throughout the solution. This Photo-Therm Model 14 has all of these elements combined into one and can maintain the water within one-tenth of a degree of the preset temperature.

Automatic Temperature Regulation

For photographers who spend a great deal of time in the darkroom, one of the main problems is regulating the temperature of the water flow into water baths and print and negative washers. It is a great luxury to be able to avoid constantly monitoring and adjusting the temperature of the incoming water. Manufacturers have developed a number of units that reduce or remove this onerous chore; this section illustrates and describes some of the most popular ones.

Measuring Your Outlet's Flow Rate

When it comes time to order the temperature regulator for your sink you will have to specify the flow rate at which the temperature regulating valve will normally operate. This allows the supplier to install a collar that will allow you to use the temperature regulating valve without having the water on full force. Measuring the flow rate is a simple matter.

Find a 5-gallon can and connect it to a sink outlet with a rubber hose. Turn the water on at the flow rate you intend to use. Time how long it takes for the 5-gallon can to fill. Divide that time by 5 and you will have the gallons-per-minute flow rate you will be using.

The flow rate will vary seasonally with the lowest rate likely to occur in the hot summer months when neighbors are watering their lawns and filling their pools. This should be taken into consideration when measuring the rate of flow.

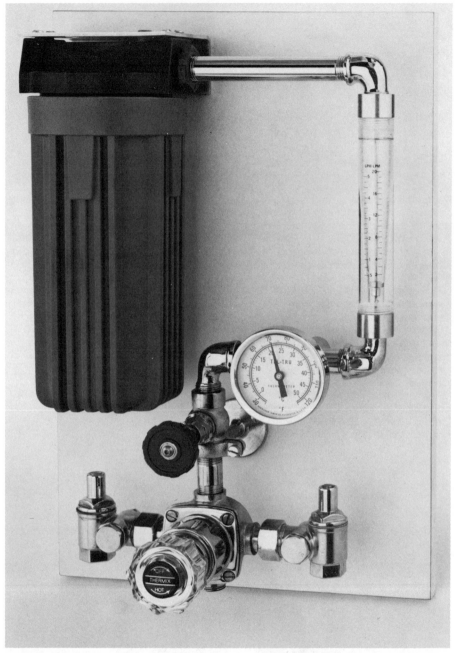

Thermostatic Valve. Thermostatic mixing valves work by the same basic principle on which the thermostat in a home heating system works. When the water temperature in the outflow drops, the supply of hot water is increased and vice versa. Most valves work best at or near their highest rated flow capacity. Be sure that you do not buy one that is always operating at the lower limit for which it was designed.

The convenience of these devices comes from setting the required temperature only once and then having the valve hold it, automatically freeing your hands and mind for other things.

Most well-made units have a vacuum breaker that prevents the siphonage of water back into the water supply system. In many areas this is required by building codes.

Because most units operate best at their maximum rated capacity, it's important that you determine the flow rates you will be dealing with and notify the company from which you are buying what range you expect from their valve. For most home darkrooms, a flow rate from ½ to 2 gallons per minute will suffice for all operations, including washing.

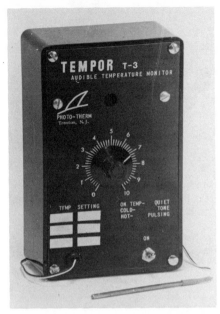

Talking Thermometer, "Tempor," by Photo-Therm. When you use a water heater or temperature regulator, there is a tendency not to check the temperature of the solutions as often as you should, the rationale being if you spend $300 to keep the temperature constant, it damn well better be. It might be prudent to check anyway, but in case you're too lazy or forgetful, how about a thermometer that talks to you? This unit will keep quiet unless the temperature deviates from the preset level. Then it indicates by a tone if the temperature is too low or too high and by how much.

Flowmeter. Washing prints and negatives requires a relatively low flow rate. Using too much more than is necessary wastes water and does not add to the rate of cleaning. In addition, thermostatic temperature regulators operate best at selected flow rates. It is possible to monitor the flow rate on a continual basis by installing an inline flowmeter similar to this Leedal model.

Water Chiller. In some areas of the country at certain times of the year the incoming cold water is at a higher temperature than the darkroom requires. Most photographers grin and bear it, but the more affluent consider the installation of a water chilling unit.

A thermostatic mixing valve requires a sufficient difference between hot and cold supply lines to operate accurately. So if you are considering installing one of these valves in areas of the country where the cold water is above 60 degrees, you may find that the mixing valve will not work without the installation of a water chiller. Check this with both your water department (they can tell you the highest temperature to expect) and the manufacturer of the valve and chilling unit. This unit is from California Stainless.

129

Processing Trays and Tongs

Trays

It's been said that all Edward Weston had in his darkroom were a lightbulb, a printing frame and three wooden developing trays. This indicates either the importance of trays or the lack of importance of everything else. The primary function of trays is to hold chemicals, but variations in design, materials, and purpose do affect, slightly, the usefulness of the various models.

The trays should be deep enough to prevent unwanted overflow when agitating the tray full of chemicals. And they should be large enough to handle a print easily, either by hand or by tongs, without trapping the print between sides that are too close together. Ribs on the bottom reinforce the tray and also make picking up prints easier.

Inexpensive trays can be too small to hold the sized prints for which they are marked. Rather than buy a more expensive tray, however, you can buy the larger size of the less expensive one and save some money.

A tray should be rigid enough so that you can lift it when full of chemicals without it bending under the weight and spilling chemicals. Try flexing the tray by holding the corners and twisting. If there is too much flex buy another model.

To reduce the possibility of tray contamination, label the trays for developer, stop bath, and fixer and then use the same tray for each chemical every time. Use entirely separate trays for such things as toning solutions.

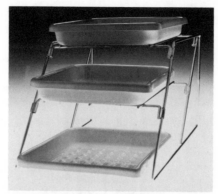

Leedal Tray Rack. A great deal of space can be saved by using a tray rack that holds trays one on top of the other. If you are concerned about possible contamination from chemicals splashing from one tray to another as a result of this arrangement, use the tray rack to hold two fixing trays and the water holding tray. This way contamination, should it occur, will have no effect on the prints. The prints should always progress from the top down to reduce the danger of contamination. If you have to use developer, stop bath, and fixer in the rack, put the developer on top, then stop bath, with the fixer on the bottom level. This Leedal model is made of stainless steel. A somewhat less expensive, but well designed, model is available from Richard.

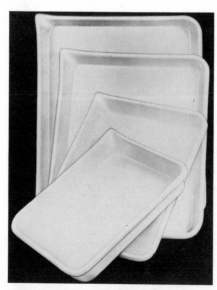

Plastic Print Trays. These Photoquip trays are typical of high-quality plastic trays that are perfectly suitable for darkroom purposes. The pouring lip makes pouring the chemicals back into the bottle or down the sink much easier.

Ambico Wave Tray. This tray has been specifically designed to aid in agitating the print while it is being developed or fixed. The rocker-type bottom makes it easier to set up a rocking motion to agitate the chemicals over the print's surface.

Deep Hypo Tray. There is a tendency for prints to back up in the hypo tray, and the added agitation required makes it desirable to have a deeper tray than is needed for development or stopping. This problem has been solved by trays such as the Arkay deep hypo tray.

Canoe Trays. This Heath Mitchell color canoe has a unique design. It has a curved bottom and sides so that the tray can be rocked, flowing the chemicals back and forth over the print. It is especially useful in developing color prints because it requires a smaller quantity of solution than a traditional tray design does.

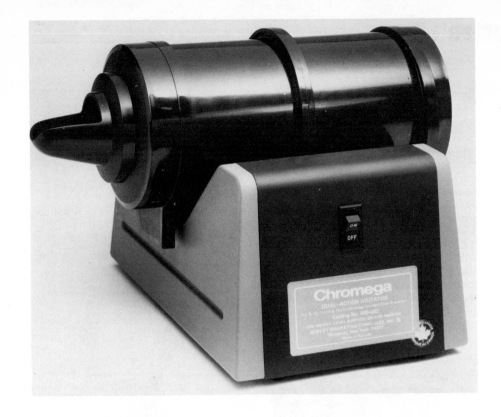

Print Drums. Print drums were initially designed to allow development of color prints in a well lit room. They also have the advantage of requiring a smaller quantity of chemicals to get the job done. Drum agitators are available to keep the solutions moving, making the entire development process easier. These drums are also available in larger sizes for mural processing. They are often used for color printing because safelights generally cannot be used and it's easier to develop the print in a drum than in the dark. With black and white printing, however, drums remove the excitement of seeing the print emerging from the white paper.

Mural Processing. Making very large prints or murals presents definite processing problems. It's actually possible, but somewhat messy, to sensitize your living-room wall, project an enlargement on it, and then develop it using paint rollers. If you make mural-size prints only once in a while, you can use 2″ x 4″ lumber to build a frame that is then lined with plastic sheeting and filled with chemicals. If you would like to have a more permanent system, this Maxwell mural developing tube might be just what you are looking for. They are large enough to handle prints that are 48″ x 96″. These tubes also require less chemicals than an open tray would. Large murals can be washed with a hose.

Other possibilities for processing murals are wallpaper troughs sold by paint and wallpaper stores, and plastic drain pipe cut lengthwise and sealed at each end with plastic caps.

Print Tongs. Print tongs are giant tweezers that allow you to agitate and remove prints from processing trays without using your fingers. They reduce contamination and keep your fingers clean so that the next time you change a negative in the enlarger you don't ruin it with fixer. A good print tong should hold the print securely but not at the expense of damaging the emulsion. Plastic tongs are usually the best; they combine cleanability and holding power. If you buy tongs with rubber tips they are subject to contamination, so mark them to indicate which is for developer, stop bath, and fixer.

Wet-Side Accessories

Just as the kitchen of a good French chef is made more enjoyable and more productive as a result of high-quality and useful accessories, so is the darkroom. Not having a graduate large enough to mix a solution or a stirring rod long enough to keep your hands out of the solution when mixing are frustrations that can and should be avoided. These pages describe some of the accessories that are available and what questions to consider when buying them.

Funnel. A funnel is almost a necessity if you want to pour chemicals from a large graduate into a bottle with a narrow neck. Two funnels are handy to have because you can mix your chemicals right in the storage bottle using one funnel to pour in the dry powder and the other to pour in the water. Funnels are usually cheaper in the hardware store than in the camera store and serve the same function.

Photo courtesy of Nalge Company, Division of Sybron Corporation.

Stirring Rods. Stirring rods are useful when mixing powdered or liquid chemicals. They are usually designed with narrow handles and larger blades on the bottom. The narrow handles reduce the amount of disturbance at the surface, preventing air from entering the solution. The blades increase the agitation below the surface and are available in a wide range of styles, including ones with holes and others with heads that can be used for crushing powdered chemicals.

When buying a paddle, make sure that the handle is long enough to provide you with a grip when fully immersed in the largest mixing container you use.

Towels. It helps to have towels to wipe your hands and to clean up spilled chemicals. The least expensive method is to use paper towels, but occasionally it helps to have some that are lint-free. Photowipes, made by the Photo Materials Co., are handy to have around. They are too expensive to clean the floor with, but are very convenient for equipment.

Aprons. When mixing chemicals it doesn't take much of a slip to spill them on your clothes. To be on the safe side, it might be worthwhile to have a vinyl apron handy. They only cost a few dollars and can save their purchase price in ruined clothes. This apron is from Bel-Art; EPOI and Kodak have similar models.

Graduates. Graduates are containers with scales marked on their side, used for mixing, holding, and measuring chemicals. Every well-equipped darkroom should have a variety available. The basic graduate comes in either plastic or stainless steel. The stainless is much more expensive but it is useful for temperature regulation. Because stainless steel is a greater conductor of heat, you can raise or lower the temperature of chemicals quickly by pouring them into the graduate and immersing the graduate in either hot or cold water as the situation requires. The same effect can be achieved with a plastic graduate, although it takes longer.

A tall, thin graduate is also useful for measuring small quantities of chemicals. Trying to measure 1 ounce of stop bath concentrate to mix with 1 gallon of water is very difficult with a large, wide graduate.

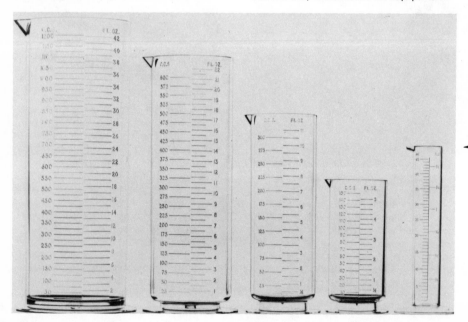

Thermometers

Thermometers can be divided into classes based on the principles by which they operate. Your selection should be based on accuracy, cost, and durability.

Liquid in Glass. This type is identical in principle to the thermometers that we take our own temperatures with. It consists of a bulb full of a fluid, usually alcohol, and a long narrow tube marked in degrees. As the fluid heats or cools, it either expands or contracts.

These thermometers are extremely accurate, relatively fast acting and long lasting if you don't break them. If the thermometer overheats you may break the tube. To work accurately, the entire column of liquid that indicates the temperature should be immersed in the liquid you are measuring.

Liquid in Glass with Metal Backing. Some thermometers are reinforced with a metal backing to prevent them from rolling or breaking as easily. These are ideal for tray thermometers, but if the scale is on the backing and not on the tube itself, the thermometer can get out of register and indicate the incorrect temperature.

Dial Thermometer. These thermometers have large dial faces that are very easy to read. The needle moves because of the expansion or contraction of a bimetallic strip. These thermometers are also quite accurate and durable but because of their mechanical nature are more sensitive to physical abuse. If a glass thermometer breaks you will know it, but if one of these does you may not. The dial face is also prone to leaking because the seal between the glass and metal case will not last forever. Occasionally calibrate them by comparing with a thermometer that is known to be accurate.

Electronic Thermometers. This is a rapidly growing and expensive class of thermometer. They are available with digital readouts and even audible ones. It is sometimes difficult to read the temperature on a glass or dial thermometer because of parallax and the small numbering on the thermometer itself. This problem is eliminated with the digital thermometer that gives you a direct numerical readout of the temperature. As new developments occur and competition increases, the prices of these units will probably drop and they will become quite common in darkrooms. They are sensitive to mechanical damage and moisture because of their electronic nature.

Tray Thermometer. This Kodak tray thermometer is typical of those made to be left immersed in developer trays for quick and easy monitoring of the solution's temperature. Be gentle with thermometers such as this because the scale is not on the glass tube itself. If the tube is slid up or down in the metal case it will read an incorrect temperature.

Courtesy Eastman Kodak Company

Kodak Glass with Metal Backing Thermometer. This glass thermometer is longer lasting because it is attached to a metal backing that provides support for the glass tube.

Courtesy Eastman Kodak Company

Glass Thermometer. This glass tube Kodak thermometer is fast acting and reliable. It is a little slippery to grip with wet hands, so handle it carefully. As a safety precaution, wrap a rubber band around the end to provide you with a better grip. It will also help prevent it from rolling off the counter. If you do jar a glass thermometer you will sometimes find that an air bubble has entered the column of alcohol. If this happens, you can heat the thermometer gradually until the column is filled entirely with alcohol. When it cools, the column will usually be rejoined. Overheating, even a little, will pop the top off the glass tube. This model has a range from 30 degrees to 120 degrees F.

Courtesy Eastman Kodak Company

Digital. This Electro:therm model is typical of the new breed of electronic thermometers with digital readouts. They are extremely accurate and the digital readout makes it impossible to misread the temperature. This model has a range from 32 degrees to 230 degrees F (0-110 degrees C) and has an accuracy of + or - 0.2 degrees F (0.1 degrees C). It is powered by a 9-volt battery.

Dial Thermometer. The advantage of a dial thermometer such as this Kodak model is that it is extremely easy to read. The light will not be defracted, as it can be with a glass thermometer. In some models a mirror is used to reflect the needle and when the needle and its image are seen in perfect alignment, viewing parallax has been eliminated. This ensures that you read the correct temperature by showing you the correct viewing angle.

Courtesy Eastman Kodak Company

Roll Film Tanks and Reels

Photographers using 35mm or 2¼ format film are confronted with the difficulties of developing a long strip of film. The commonest solution is to coil it on a reel so that there is sufficient space between the surfaces to allow for the circulation of chemicals but not so much that the coil occupies a large space. This basic principle is packaged today in three variations: stainless steel tanks and reels, plastic tanks and reels, and a combination of stainless steel tanks with plastic tops. Traditionally most pros have used the all stainless steel tanks and reels because they perform extremely well and last almost forever. However, one problem is that they may leak around the top if the tank is inverted during agitation. This difficulty has been solved by marrying a plastic top to the stainless steel tank. The seal is tighter and less susceptible to leaks. Many photographers use the all plastic tank and reel, which has the advantage of a reel that can be widened or narrowed depending on the film format you happen to be using. With the stainless steel reels you will need a set for each format you shoot.

Stainless steel tanks will lose or gain heat more quickly because of the conductivity of stainless steel, so if the room is a great deal hotter or colder than the chemical solution, use either a water bath or change to plastic tanks which will act as an insulator.

Stainless Steel Tanks. These stainless steel tanks from Burleigh Brooks are representative of what most photographers tend to use. They are well made and durable. Some reels by other manufacturers have different catches for the end of the film and some of these designs work better than others. It's best to take a piece of film with you when you buy to see how easy it is to insert and how well it is held.

The long rod is used to raise and lower the reels. Always buy enough reels to fill the tank and use them all if you are developing one roll of film and you agitate by inverting the tank. If one reel slides up and down the tank, development will be affected because of the increased agitation.

Plastic Reels. This Paterson plastic reel shows the mechanism by which it can be widened or narrowed to accommodate different film formats. The small bearing on the right is part of the self-loading device that makes these reels extremely easy to load just by turning the sides back and forth.

Stainless Steel with Plastic Tops. These stainless steel tanks with plastic tops from Omega are reported to be an improvement over the completely stainless steel tanks and lids because they do not leak if the tank is inverted. Available in sizes ranging from a single reel to fourteen reels at one time.

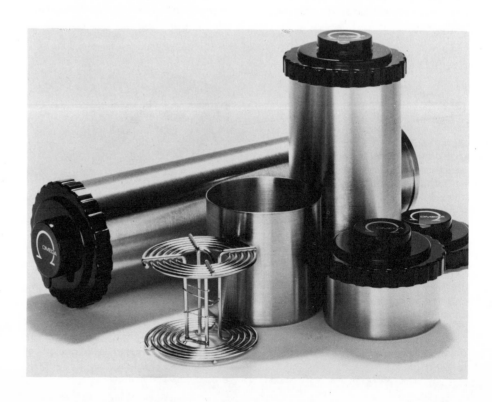

Film Cartridge Openers. If you have a 1954 Ford convertible, you might be able to find a "church key" in the trunk or under the back seat. It will work fine for opening 35mm cassettes. If you want to step up, you can buy something like this Nikor cassette opener. Kodak also supplies openers for 110 and 126 cartridges.

Instant-load Developer. This Brooks Instant-load developer qualifies as the world's smallest darkroom. It allows the development of film without removing it from the cassette. Because of the limited space and small quantity of developer, uniform agitation and full development is exceedingly difficult.

Film Tank Agitator. The Hanson Cycle-Select film agitator can be programmed to invert your film tank at preselected intervals. When developing for fine grain, it is not uncommon to encounter development times of over 15 minutes. Having to invert the tank every 30 seconds for this long a period is tiresome, especially when a large number of reels need development.

Some photographers have tried to use print drum agitators for film development, but this will give unsatisfactory results. The revolving drum creates centrifugal force which holds the developer against the sides of the tank. The film on the inner part of the reel is therefore not immersed in developer and the film will develop unevenly. The Hanson Cycle-Select agitates by inverting the tank, eliminating this problem and exactly duplicating the process used by hand, except that this machine creates uniform and predictable movement that hand movement cannot. It also frees you to do other chores. There are models for all Nikor and Kindermann size tanks plus several sizes of Paterson and Jobo. Models will be constructed for other brand tanks at no additional charge.

Plastic Tanks. Nikor, which is practically synonymous with quality stainless steel tanks, has recently introduced a plastic model that appears to be very well designed. The ABS plastic from which they are made is virtually indestructible. An "O" ring seal is used to stop leaks and once the top has been tightened, the tank can be inverted without any danger of leaking.

The tank also has a funnel-shaped top to make loading and dumping chemicals easy. It comes with adjustable reels that handle 110, 35mm or 120/220 film formats.

Automatic Film Loaders. Loading stainless steel reels requires the development of a "feel" for when the film is reeled up correctly. This takes practice and you cannot let the first few attempts discourage you. If you want to try a more mechanical (but not necessarily more effective) method you can buy automatic film loaders. This Kindermann model is typical. A similar loader is also available from Nikor.

Washers

The washing of prints and negatives is absolutely essential if they are expected to last. Many photographers are careless with this step, not fully realizing that the effects of poor washing may arise days or years after the processing. Prints and negatives that are not fully washed of chemicals deteriorate and unfortunately contaminate other prints and negatives with which they come into contact. If a poorly washed print is placed on a drying screen or run through an electric dryer, that screen or dryer is contaminated and will affect the prints that follow. There is no excuse for not washing well—it is the one unforgivable sin of photography.

The technology of archival print washing is just beginning to develop, but enough is known to show that the quality of the washing depends on the number of complete water changes in a water cycle.

To be effective, wash water must circulate on all sides of a negative or print. Its failure to do so will leave spots that continue to be contaminated even when the rest of the print or negative is safe. Just laying prints in a tray with a hose circulating water over them is not enough. The flow must be enough to change *all* of the water in the washer at least five times.

Negative Washers

Leaving the reels in the developing tank and running water in the top does not provide for even washing of the negatives. The water tends to wash those at the top faster than it washes the ones at the bottom and because the film is in a coil, the water flow will not be evenly distributed along the film but will tend to wash better in the direct stream from the faucet. To compensate for this, several new washers have been developed to ensure that the water is evenly distributed throughout

the tank and that heavy chemicals do not rest on the bottom of the tank as they would if water were poured in from the top.

Print Washers

The key ingredients in good print washing are to keep the prints separated so that wash water can freely circulate around them, and to follow the paper manufacturer's directions regarding the time they should be washed. To shorten washing times, you can use Hypo Clearing Agent made by Kodak or Perma-Wash manufactured by Heico.

Washing prints for archival purposes is not an easy task. Maintaining an adequate rate of flow and keeping the photographs separated are not enough to ensure complete washing. The dynamics of fluid flow (that is, the wash water) depend on several factors; the placement and orientation of prints in a washer can affect the flow. If all of the prints are horizontal, they can have air pockets or pockets of low water flow regardless of how high the water flow is elsewhere in the washer. To be absolutely safe, buy a washer designed for archival purposes and follow instructions.

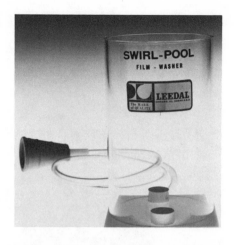

Film Washer. This Leedal film washer is typical of the film washers that introduce the water at the bottom in more than one place. This allows the contaminated water to rise, lifting the heavier chemicals that contaminate film to the top of the washer and over the side. If the water entered from the top, the heavier chemicals would tend to stay on the bottom. The swirling action retards the formation of air bubbles which inhibit washing. The film reels are inserted directly into the washer. This brand is available in two sizes that handle either four or eight 35mm reels or two or four 120/220 reels.

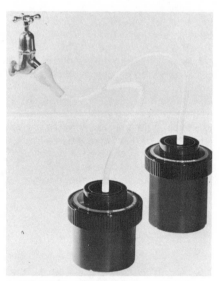

Built-in Washer. The Paterson film developing tanks are designed with a built-in washer. The hose is connected at one end to the top of the washer and at the other to the faucet. The water enters from the bottom of the tank and leaves from the top, taking the chemicals with it.

Paterson Print Washer. This Paterson print washer is well designed to keep the prints separated and vertical to eliminate air pockets. Can accommodate a dozen 12 x 15 prints at one time.

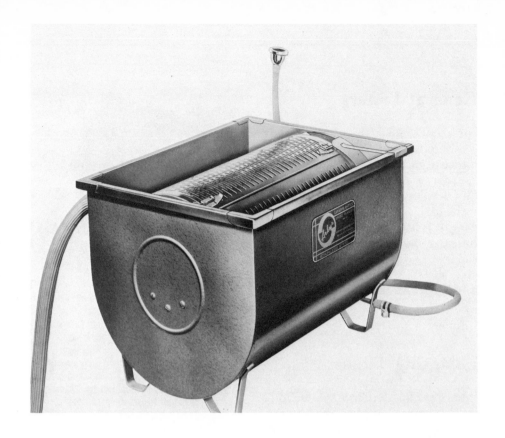

Revolving Drum. This Arkay Loadmaster washer is typical of washers using a revolving drum. A gate in the drum is opened and the prints are placed inside. The jet of water entering the washer acts like a millrace and the drum revolves like a water wheel. The level of water never completely covers the drum, so as the drum revolves the prints tend to become dislodged when they reach the surface of the water ensuring that they do not stick to the drum and wash unevenly. These washers are effective but can cause mechanical damage to prints, such as bent corners, etc. A similar design is available from Pako.

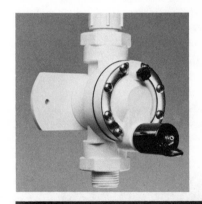

Print Drum Washer. When using a drum for processing color prints you can buy a print washer that attaches to the drum. It is a serviceable, if not a super-efficient, washer since the water circulation on the back side of the print which is against the drum wall is quite low. This Pfefer model will fit Cibachrome, Colourtronic and Western processing drums or other drums with a 4 3/16" O.D.

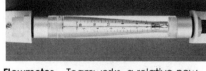

Tray Siphon. Kodak makes a very efficient tray washer that also contains a siphon. The design assures that the heavier chemicals that tend to accumulate on the bottom of the tray are removed by the siphoning effect. If you were to place a hose in a tray and expect the water flow to lift the chemicals over the rim, the washing times should be greatly increased. This siphon lifts the water from the bottom of the tray, reducing the time needed for washing well.

To wash effectively prints should be placed in a tray twice their size. This allows the water coming from the siphon to spin the prints and gives them much needed agitation.

Courtesy Eastman Kodak Company

Flowmeter. Teamworks, a relative newcomer to the print washing field, has introduced some unique products that can help conserve water. This Teamworks flowmeter and its solenoid valve, when connected to a Gralab or equivalent timer, will shut off the washer at a pre-selected time.

137

Timing Systems

Electronic sophistication is affecting traditional darkroom equipment primarily in the design of exposure meters and timers. Few other areas are currently so overrun with new designs and models. In most cases, the absolute accuracy of many of the newer units is not necessary; what is necessary is that your timer repeat each timing cycle exactly as every other. If the timer takes 65 seconds to indicate a minute, that's okay as long as it does it every time. The only exception to this rule is when you are working with color materials that are much more sensitive to the absolute timing of processes.

Timers can be broken down into two main classes, mechanical and electric. Mechanical timers are operated by winding a spring; electrical timers require a source of energy from either a wall outlet or a battery. Electric timers can use either motors or transistors. Electronic timers will often have a digital readout.

The old standby in most darkrooms is the Gralab timer, which is used for timing everything from development, to printing, to making coffee. Its timing range from 1 second to 1 hour makes it useful for timing many activities. Many of the newer timers now on the market are designed for specific purposes and should be used only for those for which they are designed.

General Timers

For a timer to be useful for all darkroom activities it must accurately measure short intervals in printing exposures and longer intervals in film development. It is also helpful if the dial is large and glows in the dark. If it is to be used as a general timer, it should also have some of the best features of enlarging timers, such as electrical switching capability and repeatability.

Enlarging Timers

When making enlargements you need a timer that is extremely accurate in the range of approximately 5 seconds to 1 minute (or longer for color printing). The timer should also have the capability of turning off the enlarger at the end of the preselected timing cycle. It is also convenient to have a reset device that allows you to repeat a preset period of time. This is especially helpful when making a large number of identical exposures, such as proof sheets. A luxury is to have the timer programmable so that it stops and starts at different intervals during its cycle allowing you to time a variety of continuous activities without having to reset the clock for each step.

Gralab Timer. For practical timing of both development and enlarging there isn't anything quite like the Gralab timer. This timer is probably the most used timer in the field and although it isn't digital or electronic it's proven and it works well.

It has a large dial, it glows in the dark, and has a timing range from 1 second to 60 minutes. It also has a circuit to turn off the enlarger at the end of the preset cycle.

Dry-side Enlarging Timer. The Digital Time Commander from Vivitar provides accurate, repeatable timing for black and white or color printing exposure times. Using an illuminated calculator-type keyboard and large variable intensity LED display, times of up to 99½ seconds can be entered into the DTC in half-second increments. Comes complete with AC power supply.

Wet-side Electronic Timer. Electronics technology and calculator-type styling with LED readout are combined in the Process Time Commander, a processing timer by Vivitar. Capable of retaining up to eighteen individual time "instructions" through three separate linkable programs, the Vivitar PTC can be set to run either in the manual or automatic mode. The device comes complete with switchable outlet AC power supply and convenient wall mount bracket. Also features an audible "metronome" to allow timed dodging and burning without having to look at the timer. Features electronic readout of solution temperatures with optional accessory probe.

Kearsarge Timer. The Kearsarge 401 provides 1-second audio signals for burning and dodging and 30-second audible signals for film agitation. Two timing ranges are from 0 to 99.9 seconds for printing, and 0 to 99.9 minutes for processing. The programmable memory allows for setting the time of the next step while the timer is running. It features a digital readout that has an automatic self-dimming feature.

Mechanical Timer. Humble? Yes, but you can still develop your film when the electricity is out. Kodak still makes this versatile mechanical clock with a timing range of 1 second to 60 minutes. It has both minute and second hands and a switch allows you to stop the timer and reset without resetting the hands.

Courtesy Eastman Kodak Company

Audible Repeating Timer. Omega's Audible Repeating Timer signals the time both visually and audibly. It times up to 60 seconds, and therefore is useful only as an enlarging timer. It automatically turns off the enlarger at the end of the cycle and resets itself to the preset time.

Program Timer. The Omega program timer allows for control of sequential processing steps. Programming is accomplished by inserting brass indexing tabs in the molded timing dial at the required intervals. A bell signals the end of each sequence and the timer shuts off the equipment (for example, the print drum agitator used for color print development) connected to its timing outlet. The dials can be removed and stored and a library of programs built for different processes. The timing range is from 30 seconds to 29½ minutes in 15-second increments.

Electronic Enlarging Timer. The Omega E-99 timer has two timing ranges, .1 to 9.9 seconds in .1 second increments and 1 to 99 seconds in 1-second increments. An accessory footswitch is available. One of the disadvantages of a timer such as this is that you cannot see how much of the cycle has elapsed and how much remains. That is an inconvenience to many photographers who like to dodge and burn at certain points in the exposure.

Mechanical Enlarging Timer. This Omega 60-second timer is an excellent example of a relatively inexpensive mechanical timer. The electric cord provides power to the enlarger when the clock is switched into its timing interval.

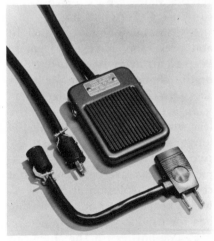

Footswitch. A footswitch to turn the enlarger on and off is handy when, for example, you're confronted with a 10-second exposure in which you have to dodge or burn for 8 seconds. By pressing the switch with your foot it will turn on the enlarger and leave your hands free to do other things.

Chemical Storage

Storing chemicals is really a two-part problem. The simpler problem is where to store unmixed chemicals such as developer or fixer. An easy solution is to keep them in a storage cabinet somewhere outside of the darkroom, which will protect boxed or half-used containers from the high humidity. The more difficult problem involves storing mixed chemicals. If you are a prodigious photographer and process through developer, stop bath, fixer #1, fixer #2, hypo-clearing agent, and toning, as well as negative developers, wetting agents, and possibly color photography chemicals, storage of mixed chemicals can be a troublesome matter. The basic rules that should be considered when planning for mixed chemical storage are:

1. The chemicals should be stored in containers that do not react with their contents.

2. The chemicals should be stored conveniently near where they are used, such as a shelf over the sink.

3. They should be accessible. If you mix in large quantities for economy or because you use a lot, it's easier to plan on containers with spigots than it is to lift 5-gallon containers every half hour.

4. Containers should be airtight and preferably have a system to keep all air away from the surface of the chemicals. When air interacts with chemicals it oxidizes them —an undesirable effect—so the less surface exposed to the air the longer your chemicals will last. The two best techniques for accomplishing this are containers that collapse as solution is removed, which keeps the air out, or floating lids for rigid storage containers.

5. The bottles for the chemicals should be opaque or amber colored because light speeds the degradation of the chemicals.

Bulk Storage. Large quantities of mixed chemicals can be stored in plastic storage tanks. To make sure they are stored properly, use a tank with a floating lid. This lid prevents air from coming in contact with the stored chemical and weakening it. If the tank is more than 1 gallon it is almost a necessity to have a spigot with which to draw off chemicals. These Nalgene tanks are good examples of bulk chemical storage tanks.

Photo courtesy of Nalge Company, Division of Sybron Corporation.

Storage Containers. These Falcon chemical containers have become the standard in the field. They are well made, durable, and have a convenient labeling system that allows you to identify the chemical, the date it was mixed, and any other pertinent information.

Air Evacuation Bottle. Falcon has also developed a way to keep chemicals at top form longer. These bottles allow you to squeeze the air out thus prolonging the life of the chemicals by keeping air from contacting the surface.

Bulk Storage. Kodak makes bulk storage tanks with floating lids in 7-, 14-, 30-, and 55-gallon sizes.

Courtesy Eastman Kodak Company

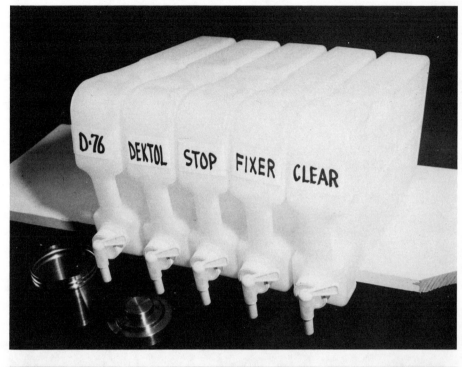

Pumps. If you have to store your mixed chemicals on a low shelf which prevents getting a graduate under the spigot, you can use one of these inexpensive pumps. Insert them in the top and pump the chemicals out.

Photo courtesy of Nalge Company, Division of Sybron Corporation.

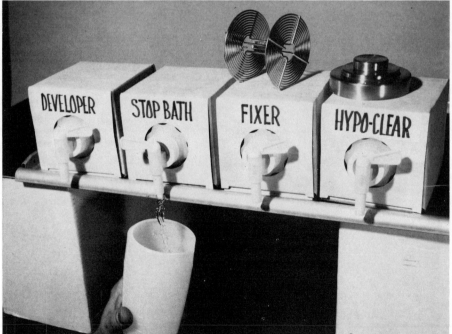

Shelf Storage. These two types of storage containers from Porters serve the same function. They allow both storage and pouring without removing the containers from the shelves. The space-saver model (top) can store a large number of chemicals in a relatively small shelf space.

141

7 Enlarging Equipment

Contents

Enlargers • **144**
Enlargers, cont. • **146**
Enlarging Lenses • **148**
Easels • **150**
Focusing Magnifiers • **152**
Negative Cleaning
and Dusting • **154**
Printing and Exposure
Controls • **156**
Negative Storage
and Proof Printers • **158**

Enlargers

The wide array of enlargers on the market is confusing to the prospective buyer because the criteria for selection are somewhat obscure. What separates a $99 enlarger from one that costs $200? Is the additional expenditure worthwhile and, most importantly, will it show in the prints themselves?

The most important elements in a black and white enlarger are that it be steady, optically aligned, and have a first-rate enlarging lens. The next most important criteria are the characteristics of the light source. This is secondary only because its choice is as much aesthetic as practical. Almost all other criteria for enlarger selection fall outside of the area of necessity into the area of convenience and comfort. Let's take a look at these criteria.

Steadiness. If an enlarger moves in any direction while an exposure is being made, the movement will decrease the quality of the print. The edges will lose definition and the overall sharpness of the image will be degraded. In many cases the effects are wrongly attributed to the film, camera, or enlarger lens. Enlarger design certainly affects how steady the system is at the time of the exposure, but any enlarger, even a heavy duty one already securely attached to a sturdy stand, can be made more solid by providing additional support for the top of the column. The steadiness of some enlargers is improved by wall mounting. (See page 110.)

Alignment. It is essential that the lens, negative, and printing surface be in perfect alignment to avoid image distortion, unevenness of illumination, and variations in focus from corner to corner.

Quality of Lens. This is probably the single most important element in any enlarging system, and is covered in detail on pages 150-151. With enough time and patience al-most every other enlarger short-coming can be overcome but there is nothing you can do about this element except make sure you have the best or buy another lens. In many cases the lenses that come with an enlarger are inexpensive and are thrown in as part of a package deal. With camera optics being what they are today almost any camera will outperform a cheap enlarger lens. This means that what you are getting on the negative is not what you are getting on the print. If possible always buy the enlarger without the lens or try to get a package price with a good lens substituted for the one that comes with the enlarger.

Light Source. The type of bulb used in an enlarger is relatively unimportant in black and white printing but it becomes critical for color work. There are three major types of bulbs in use today:

1. *Tungsten.* These bulbs have been around for a long time and are perfectly suitable for black and white printing. They are less suitable for color work because they tend to degrade in intensity over their life span and change color balance.

2. *Quartz-halogen.* These bulbs are used in color enlargers because they have a steady output throughout their life cycle and do not develop a build-up of emissions on the glass envelope which on tungsten bulbs changes the color characteristics of the transmitted light.

3. *Fluorescent tubes.* Some enlargers will use a series of fluorescent tubes as the light source. This is referred to as a cold light head and is discussed in more detail later.

Light Quality. The quality of light used in an enlarger varies from a highly diffused light to one where the light rays are as nearly parallel as possible. Generally the more nearly parallel the light rays (called collimation) the sharper and more detailed the print will be. Sharpness isn't everything, however, so other characteristics have to be taken into account. The major types of light available are:

1. *Point source.* This is a light source emitting rays that are almost parallel and give an extremely sharp print. With 35mm film excessive sharpness can be a problem because small imperfections such as dust or scratches will be magnified in proportion to the size enlargement being made. The sharper the image and the greater the enlargement the more these imperfections become apparent. Point source illumination is rarely used because of its ability to highlight these imperfections. Its major application is in the making of large-scale photo murals.

2. *Condenser heads.* The condenser enlarger uses a lens to focus the light from the source onto the negative plane. Because the light is focused, the image is sharp and imperfections in the negative are obvious on the print. Its quality of magnifying imperfections is overridden by its advantages in terms of sharp images and fast printing times. For these reasons it is the major form of black and white enlarger design.

3. *Diffusion heads.* The light from a diffusion enlarger source is unlike a condenser system in that the light is highly diffused (less collimated). This diffusion is achieved in several ways: opalescent glass can be inserted in the light path to mix the light; the light can be bounced back and forth in a mixing chamber to scramble it; in the latest design in the Vivitar VI the light is diffused by bouncing against the walls of a light pipe. In all cases the goal is to have the light scrambled at the point where it reaches the nega-

tive plane. This scrambled light results in a softer image on the printing plane and imperfections in the negative are less obvious on the prints.

4. *Cold light heads.* These are the ultimate in diffused light. The high level of scrambling is achieved by having a very diffused source, which is usually a series of fluorescent bulbs in the shape of a grid to cover a wide area of space. Because the source itself is large in relation to the negative area and because it is not focused through a lens system like the condenser system, it reaches the negative plane with the light rays heading in many directions.

Format. Enlargers work best in a relatively narrow range of film formats. If you plan on printing both 35mm and 8 x 10 negatives it is not a good idea to buy an 8 x 10 enlarger and use it in both formats. Generally, enlarger design is good enough to encompass a small range of film formats and can do equally well with 35mm and 2¼ square, for instance. An enlarger to handle both 5 x 7 and 8 x 10 negatives also makes sense.

Quality of Construction. The quality of construction is a main criterion for choosing an enlarger. This quality will become apparent if you take the time to work with a few enlargers before making a buying decision. The ease and smoothness of operation, the positive control of locking and focusing mechanisms, the quality of materials, and the detailing on the enlarger itself should all be considered. It is definitely worth it to buy a quality enlarger.

Modular Design. A fully equipped enlarger is expensive and long-lasting. A modular design allows you to buy a basic black and white enlarger now and add equipment to it as your interests change or

you shift into color printing. Regardless of what you think you may be doing five years from now, it is still wise to buy a modular enlarger. People's minds change and since modular design costs little extra you might as well make provision in case yours changes too.

Negative Flatness. If the image is to be undistorted and in focus at all points it must be held flat in the negative carrier. In 35mm this is normally accomplished by sandwiching the negative between two sheets of material that hold it flat but that have an opening over the image area. If the carrier is well designed this should be sufficient to keep the negative from buckling. Some enlargers in 35mm and many in larger formats use carriers with glass plates to hold the negative. These plates are made from special glass that does not make Newton rings where it comes in contact with the negative. These glass carriers hold the negative flat but provide additional surfaces for the light to refract off of, which lessens sharpness. They are also notorious collectors of dust and fingerprints.

Tilting Lensboard. Some enlargers have a provision for tilting the board on which the lens is mounted. This allows for the correction of distortion known as "convergence of parallels." If you have ever taken a photograph of a tall building from close up and had to tilt the camera to get the whole building in you may have been surprised at what you saw when the print came back. The parallel lines of the vertical walls of the building will not be parallel in the photograph but will converge as they move farther from the camera position. This effect is not unlike the apparent convergence of railroad tracks as they recede into the distance. A tilting lensboard will help correct this distortion by tilting the image the other

way when printing and thereby reversing the effect. The end result is a print with parallel lines.

Size of Enlargements. The height of the enlarger column determines the size of prints that can be made with a given lens/film format, because the main determinant for image size is the negative-to-easel distance. Most enlargers have a column long enough to print up to 11 x 14 on the baseboard, which is the size range that most photographers use. If you want to make larger prints, buy an enlarger that accommodates them on the baseboard, provides a capability to tilt the enlarger head to focus the image on a nearby wall, or build an adjustable baseboard (page 112). One shortcoming of tall columns is that they have a tendency to be unstable and cause vibration that results in unsharp images. For economy and convenience the adjustable baseboard is the best answer.

Keep in mind that the size of enlargement you want may be understated. For example, if you print 11 x 14 and buy an enlarger that accommodates that size you may be disappointed. If you decide to crop an image heavily you may discover that to make an 11 x 14 print of the section you want you must enlarge the total projected image to 16 x 20— beyond the capacity of your enlarger.

Filter Drawers. If you plan on using variable contrast papers or experimenting with color printing you will need a place to put the filters between the light source and the negative plane. A good enlarger will have a drawer into which they can be placed. If the enlarger does not have such a drawer you will have to buy much more expensive filters that can be placed between the lens and the easel.

Enlargers, continued

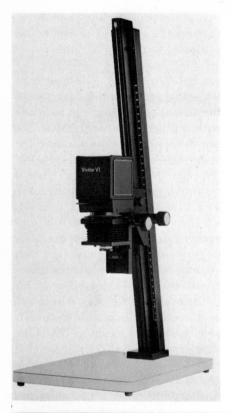

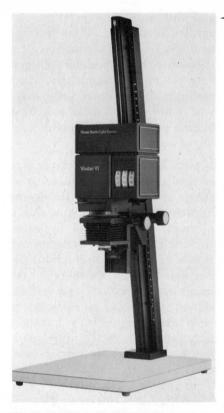

Modular Design. These two views show the advantages of selecting an enlarger with a modular design. The illustration on the left shows the basic Vivitar VI black and white enlarger and the one on the right the same enlarger with a color head in place. When first beginning in photography the basic black and white enlarger will suffice but should you decide to try color printing the color head can be added without having to buy a new enlarger.

Negatran. This Beseler negative carrier has been designed to transport the negative through the carrier without having to remove it from the enlarger. It makes changing negatives easier on you and on the negatives because it helps eliminate handling and fingerprints.

Level. Saunders Photo/Graphics supplies a level designed specifically to be used to align an enlarger. Its small size allows it to be used to level the negative stage and ensure that it and the baseboard are in perfect alignment.

How Do You Know the Lens, Negative, and Easel Are Parallel?

Having all the elements in the enlarger light path parallel is important if the image is to be sharp from corner to corner and undistorted. Project the image and focus as you would if you were making the final print.

Gradually move the enlarger or its lensboard to correct the image area to make the parallel sides equal in length.

Correctly Aligned Image. If the projected image is perfectly parallel to the negative plane, as it should be, the parallel sides of the image area will be equal in length. In this diagram the parallel sides A and A' are of equal length as are the sides B and B'.

Incorrectly Aligned Image. Measurements of the image area in the improperly aligned image reveal that although parallel sides

B and B' are of equal length those of A and A' are not. This indicates that either the easel surface, lens, or negative—or all three—are out of alignment.

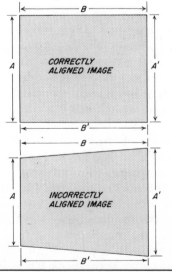

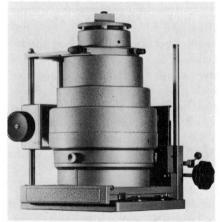

Beseler Point Source. This enlarger head is designed to be used with the Beseler CB-7 or any of their 4 x 5 series enlargers. Mainly used for production of mural-sized prints.

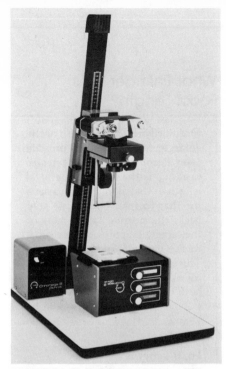

Slide Copier. Some enlargers, such as this Omega model, can be adapted for copying purposes, which eliminates the need for a separate copy stand to make copy prints or transparencies.

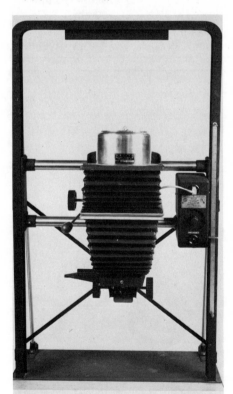

Aristo Cold Light Head. Aristo manufactures cold light diffusion heads for many of the major models of enlargers. Because of the type of light source, there is no heat on the negative plane and the highly actinic (photographically active) rays produce extremely fast printing speeds.

Printing a Black Border

Photography is like all other art forms in that it is periodically swept with waves of fashion. One of the recent waves is that what you shoot is what you print. That is, some photographers prefer to do all cropping in camera at the time the picture is taken, then print the entire image plus a narrow border of the surrounding unexposed film (clear on the film, black on the print). The black border has the added benefit of holding together what might otherwise be a loosely organized image. Here's how it can be done: The edges of the window in the negative carrier are filed down to increase the opening to a size slightly larger than the image area of the negative. Draw guide lines on the carrier and file both halves at the same time. Some carriers will already be slightly bigger than the image area and others will be slightly smaller so the amount of filing necessary varies. File only a small amount, insert the negative and hold it up to the light. If a narrow area shows around the negative image area it will print black because the light coming through it will be unrestricted by negative density. If the border around the negative area does not show, file in gradual steps until it does. File corners carefully—either rounded or squared, but all four the same.

The filing should be done as evenly as possible but mistakes can be evened out in the print by adjusting the blades of the printing easel. With the negative in the carrier focus the enlarger on the easel surface with the image enlarged to the size you want. Now, instead of using the easel blades to make sharp edges on the sides of the image area they should be backed off slightly to leave room for the black border. The distance the easel blades are backed off from the image area makes any fine adjustments of the width of the black border.

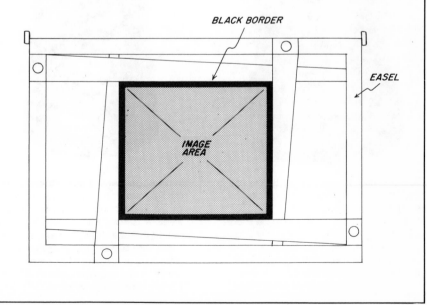

Enlarging Lenses

A chain is only as strong as its weakest link and the chances are that in most darkrooms the weakest optical link is the enlarging lens. Most of us are quite willing to spend $200 for a new wide-angle or telephoto lens, but are happy to accept a lens that came as part of the "package" when the enlarger was purchased. A top camera lens will not overcome the deficiencies of a cheap enlarger lens, so it's worth the extra money to upgrade your enlarger lens if need be. You may discover after printing with a better enlarger lens that your camera lens is better than you thought.

When purchasing an enlarger lens there are several factors to consider.

Optical Quality. Enlarging lenses differ from camera lenses: they are designed to project a flat image (the negative) onto a flat plane (the easel). When first buying a lens, you may have to rely on brand names to determine quality, but if you can test the lens before buying it, there are ways to check its quality.

Evenness of Illumination from Corner to Corner. For each lens aperture setting, expose a sheet of the paper size you normally use sufficiently to give you a middle gray tone. Try to obtain the same tone on each sheet (the Kodak enlarging calculator in the "Kodak Darkroom Guide" can be used to adjust times as apertures change). Compare the prints to see if any show the image tone becoming lighter toward the edges and corners. If so, those apertures should be avoided or the lens returned.

Resolution. Using a Kodak test negative and a low paper grade to reduce contrast, make a print at each of the lens's aperture settings. Compare them to see if they are sharp across the entire image area. If not, select the one that is sharpest and you have at least determined your lens's optimal setting.

What Enlarger Lens Focal Length?

Ordinarily the focal length of the enlarger lens needed to provide even illumination for a given size negative is the same as the focal length of the taking (camera) lens for that format. Going one step back, the normal taking lens of the camera is approximately equal to the diagonal of the negative. This means that the normal lens for a 35mm negative is 50mm for both the camera and enlarger. For a 2¼ x 2¼ negative it would be 75mm.

Focal Lengths

Negative size	Enlarger lens focal length
35mm	50mm
2¼ x 2¼	75mm-105mm
2¼ x 3¼	100mm
6cm x 7cm	100mm
4 x 5	135mm-150mm

Zoom Lens. The Schneider Betavaron is the first zoom lens to be developed for enlargers. Once the lens has been set, the desired enlargement can be made by rotating the lens ring. Sharpness and image quality are maintained throughout the entire magnification range of the lens.

Wide-Angle Lenses. Schneider's wide-angle enlarging lenses allow you to make larger prints with a given negative-to-easel distance. Reducing the negative-to-easel distance makes it easier to focus with a grain magnifier and still be able to reach the enlarger focusing knob. Lenses are available in 40mm, 60mm, and 80mm lengths.

Adaptors. You can use a camera lens on your enlarger with these flanges from Porters. Although enlarger lens design is significantly different from the design of camera lenses these adaptors are so inexpensive that they might be a good investment, especially if you do a small amount of work in a different format and decide to postpone the purchase of a high-quality lens.

Omega Rodenstock Lenses. Omega Rodenstock lenses are high-quality lenses that meet the most critical demands of the amateur photographer.

Schneider Lenses. Schneider Componon lenses have an excellent reputation. They perform extremely well through their entire range of apertures. They are expensive but worth every penny if you care about obtaining the sharpest possible images.

Schneider Componar and Comparon lenses are the less expensive line of lenses made by Schneider. They perform exceptionally well for their price.

Wide-Angle Lenses. Bogen was one of the first to introduce the concept of wide-angle enlarging lenses. These lenses reduce the negative-to-easel distance required for a given enlargement. They also reduce the vibration problem caused by raising the enlarger head on the column because they reduce the height to which it must be raised for a given image size.

Edwal Lens Cleaner. Enlarging lenses deserve the same care as your camera lenses. Use lens cleaner and lens cleaning tissue to keep them clean. When not using the lens, remove it from the enlarger and store in its box. If left in the enlarger, dust can settle on the lens reducing its sharpness and necessitating cleaning it more often than is good for it.

Easels

A seeming misnomer, enlarging *easels* are so named because early photographic enlargers were horizontal devices, and upright artists' easels were used to hold the print material in front of the lens. The steady evolution of these paper holders now offers the darkroom enthusiast a wide choice of easel types, styles, and, of course, sizes.

To the beginner, an easel is often an afterthought, selected on the basis of lowest cost to complete the enlarger outfit. Even limited darkroom experience, however, will show that the proper choice of easels will pay dividends in printing speed, convenience, and accuracy. Moreover, like the enlarger, the easel, if properly selected, is usually a one-time purchase whose useful life is usually measured in decades. The all-purpose easel is a bladed type, which permits adjustable border sizes. Most low-cost easels are two-bladed styles which are satisfactory for the beginner, although they have two limitations. First, paper is always registered into the upper left-hand corner and to position the paper under the enlarger lens, the easel is moved down and to the right of the baseboard. When making small prints, the easel can hang over the edges of the baseboard which can be awkward. Second, the range of border treatments and sizes is limited. Most professionals prefer a high-quality four-bladed easel which always stays centered on the baseboard and which permits making borders up to 2" or more. However, if price is crucial, you are better off with a good-quality two-bladed easel than with an inexpensive four-bladed one. There are also available a large number of special purpose easels ranging from ones that make test strips to ones that hold the paper flat with either static electricity or a vacuum.

How to Select an Enlarging Easel

1. Determine the largest paper size you commonly print (for very large prints, you will want to bench-mount or wall-mount your enlarger).

2. Decide what type of easel is best suited to your requirements—bladed, borderless, single-size (speed easel), multi-print.

3. When going to a camera store to look at easels, take along a fresh sheet of unprocessed paper of the maximum size you'll be printing (don't roll it and don't take a processed print since paper often stretches after processing).

4. Examine the easel you are considering on a solid table at a normal working height. After reviewing the instructions, operate the easel a few times to get used to it and then try loading and unloading it with your eyes closed. You will be surprised at the difference in registration and handling characteristics between different easels.

5. Check for border accuracy by tracing the blades with a sharp pencil. (Be sure your test paper is, in fact, square.)

6. Hold the easel at eye level and sight across the face, checking for flatness.

7. Look for good finish, a skid resistant bottom, smooth edges, good fit in hinges and working parts, accurate scales, adjustments that stay put, and blades that are absolutely flat and square.

4-in-1 Easels. This Premier 4-in-1 easel is typical of models that allow you to make more than one image size on a single easel. This model has three sizes on the front and a border for 8 x 10 printing on the back side.

Borderless Easels. Borderless prints in the past were made under glass until Saunders Photo/Graphic introduced their unique borderless easel with angled paper retainers. This easel is now widely imitated, but quality among other brands varies. These easels work on the "cone of light" principle, permitting the projected light from the enlarger to expose the very edges of the paper even while the print is securely held by retainers whose front edges match the projection angle. In judging these easels, look for smooth and straight paper retainers which are usually extruded aluminum. Check for perfect base flatness and smooth finish. The non-skid material on the bottom of the base is most important and the best borderless types use long cork strips along all sides.

Vacuum Easels. Rather than use blades to hold paper flat for printing, it is also possible to use a vacuum. This Kodak vacuum register pumps the air out from behind the paper so air pressure holds it flat against the easel surface.

Courtesy Eastman Kodak Company

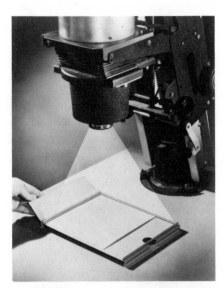

Single-Size Easels. When making quantity prints or for sheer speed and convenience, single-size easels are the logical choice. Ganz makes a full selection of easels of this type which are loaded by sliding the paper into a channel. These easels are lightweight, and can be taped to the baseboard to prevent their being pushed out of position.

All single-size easels have fixed borders, usually 3/16" or 1/4" all around. This is fine for publicity prints, catalog shots, or commercial shots which are to be placed in frames or folders.

Test Strips. Making test strips by exposing various portions of the negative for different lengths of times works only if the negative has equal values throughout its width or length. More often there is a particular section of the negative that should be exposed for various times to determine the correct exposure. Saunders makes an accessory test strip mask for their model PR810 easel that allows you to do this. It is especially helpful when making exposure and color balance comparisons in color printing.

Four-Bladed Easel. The Saunders Omega easel is the standard in the industry when it comes to four-bladed easels. The four blades allow you to center the image on the paper, leaving a white border on all sides. This makes the prints more attractive if you do not want to trim and dry mount them.

Saunders Vacuum Base Magnetic Distortion Control. A unique accessory for the darkroom. The vacuum base magnetic distortion control holds any metal easel at any desired angle for creative adjustments or distortion control. The vacuum base permits the unit to be easily attached to the baseboard or enlarging table. A flick of the lever releases it. The magnetic holding plate of the distortion control can be removed exposing a 1/4-20 tripod thread and allowing the base to be used as a "low boy" camera stand.

Focusing Magnifiers

When making an enlargement it is always desirable to have the image projected onto the paper plane as sharply as possible. If it is not, the resulting image will be blurry and the quality of both the taking and enlarging lenses will be undercut. Focusing with the naked eye is extremely accurate, assuming you have extremely accurate vision but natural selection being what it is these days, a lot of photographers cannot see as well as they should. In order to compensate and make us all equal, manufacturers have developed various focusing devices, all of which operate on the same general principle. They focus the projected image through an eyepiece so that what you see is the image as it appears on the easel surface, but enlarged many times making a small part of it very easy to see. This allows you to watch the magnified grain go from fuzzy to sharp to fuzzy again as you adjust the focus. You can then select the point at which the image is the sharpest. Since focusing on the film grain itself rather than on a part of the image (which might have been deliberately left out of focus) is the best way to ensure a sharp image, one of these devices can be a real time saver and can help to make better prints.

The main features to look for when buying a magnifier are the amount of magnification, the durability, and the lens construction. As with everything else in photography, price is usually a general indicator of quality, but you must determine what price meets your own needs adequately.

Omega Micromega Critical Enlarging Focuser. This focuser is the ultimate focusing device, with several unique features.

- It can focus almost everywhere in the projected image, giving you a chance to compare the focus of the lens at the center of the image and at the edges. The focus will normally be better at the specific aperture for which the lens was designed and the point of focus at the center and edges will generally get farther from each other as you move the f-stop farther from the best one for your particular lens. If you can't bring them together by focusing, perhaps you need a new lens (test a new one before you buy it).
- The mirror surface is deposited on the front of the glass surface rather than behind it. This lessens the distortion brought about by light passing through a surface.
- It has a blue filter to help compensate for chromatic aberration in the enlarging lens. Visual focusing is done at 4800 to 5600 angstroms in wavelength, and black and white printing paper is most sensitive to light from 3800 to 4300 angstroms. The blue filter eliminates some of the higher wavelengths in the tungsten light source, which allows you to focus on the shorter ones that are closer to what the paper will actually record.

How to Get the Sharpest Print

All focusing magnifiers are designed to focus on the same plane upon which their base rests. Therefore, if you focus with the grain magnifier on the easel surface and then use a piece of double-weight paper on which to make a print you have not focused and printed on exactly the same plane. To eliminate this problem you can put a piece of paper similar to the one on which you print under the base of the magnifier. If you use the same paper regularly you can glue a piece to the base of the magnifier, which eliminates the need to think about it every time you want to focus.

When focusing, the best way to find the sharpest image is the same way you would with a microscope or a ground glass on a view camera. You focus until the image comes into focus then goes slightly out. You then back up to the sharpest image and go slightly past it, repeating this back and forth while gradually narrowing the range of movement until you have the image focused without doubt.

Each f-stop of the enlarging lens will have a slightly different focus so either focus using the f-stop at which you plan to print or at least print at a smaller f-stop (which has more depth of field).

Bestwell Micro Sight. This is a well-made, durable focusing device that meets the needs of most photographers. It is sturdy and has the mirrored surface deposited on the front surface, eliminating optical distortion by the glass.

Paterson Major Focus Finder. If you have ever tried to focus the enlarger at a very high magnification, you might have wished you had an extra-long arm so that you could look through the focusing magnifier AND reach the focusing knob on the enlarger at the same time. Paterson has developed a device that will take the crick out of your neck and keep your print in focus at the same time. The eyepiece stands 14" above the paper surface so you can focus without doubling over out of reach of the focus control.

Focusing Magnifiers. The Scoponet focusing magnifier distributed by the Thomas Instrument Company is used extensively by experienced photographers. It is a simple straightforward design that is well built and easy to use.

Negative Cleaning and Dusting

Negative Dusting

Dust on negatives leaves enlarged white spots on prints because the dust enlarges at the same rate as the projected image. This can be especially serious with 35mm photography because of high magnification required to go from a small negative to a large print. It is usually easier to ensure that the negative is clean before printing it than it is to spot the print later. Dust on negatives can be caused by several factors, including the general cleanliness of the darkroom, the protective measures that have been taken, and the storage of the negatives themselves. Techniques to reduce the dust problem to a minimum include:

1. Do not mix dry chemicals in the darkroom. Fixer is especially injurious to negatives but any chemical powder will hang in the air to settle somewhere eventually. Mix these chemicals in another room separate from the darkroom and your stored negatives. (If you use a bathroom for a darkroom don't use talcum powder.)

2. Store negatives in envelopes or pages as recommended on page 158.

3. Install a doormat at the outside of the entrance to the darkroom to reduce the amount of new dust brought in.

4. Install filters over all vents and fans through which air enters the darkroom.

5. Install an electrostatic air cleaner to circulate the darkroom air and remove dust from it.

6. Keep the humidity between 45 and 50 percent to eliminate as much static electricity as possible. You might remember childhood days that were extremely dry when you could rub your feet across the living room carpet and zap your sister with a jolt of static electricity. This same effect is encountered in the darkroom and static electricity attracts dust and holds it to negatives. Moderate humidity lessens this occurrence.

Even if you take these precautions, there will still be dust on your negatives, but by then the problems should be minor and controllable. At the time of printing this remaining dust can be removed with an aerosol can of compressed air or an antistatic dusting brush.

Negative Cleaning

In addition to dust, negatives are sometimes marked with chemicals or fingerprints. The best solution to this problem is prevention, but if something does happen to one of your negatives, you should clean it. The acid in skin oils is especially harmful and if left on the negative can eventually etch itself permanently into the emulsion. You can remove fingerprints with Kodak film cleaner or careful rubbing with a very clean antistatic cloth. Should chemicals of any kind come in contact with your negatives, rewash them immediately.

Falcon Dust-Off. When it comes to making dust-free prints, there may be a conflict between your concern for the prints and your concern over the ozone layer. Many photographers have chosen to sacrifice the ozone layer, because its remoteness and size make it harder to comprehend. Aerosol cans containing compressed air such as this product by Falcon are effective for blowing dust off of your negatives.

When using an aerosol can, remember that you should never shake it before using. Shaking makes the propellant mix with the chemical and escape through the valve. The sudden decompression can dramatically lower the temperature of the propellant and can actually freeze your negatives, causing serious damage.

Antistatic Cloth. If you are very careful, you can use a cloth such as this Beseler antistatic cloth for negative cleaning. To be effective, it must be perfectly clean; any dirt on it can scratch a negative.

Zerostat. Zerostat eliminates static without the use of polonium nuclear material. It works on the principle that when a piezoelectric element is put under stress it generates a high voltage that ionizes the air. This ionized air neutralizes static electricity within 12" of the nozzle.

Staticmaster Brush. The difficulty experienced in dusting negatives arises from the static electricity that is generated by pulling the negative strip from its envelope and increased by the stroking action of the brush used to remove it. An antistatic brush eliminates the static electricity and allows the dust to be removed more easily. These brushes contain a polonium element that ionizes the air in contact with the negative and eliminates the static electricity charge. Polonium emits alpha-particles, and therefore presents a radiation hazard, but it can be used safely as an antistatic device when contained in gold foil. These brushes should be kept away from small children and should not be disassembled.

Cotton Gloves. When doing extensive handling of negatives (or prints) an ounce of prevention is worth a pound of cure. The best insurance against fingerprints is to wear a pair of clean, lint-free cotton gloves like these from Porters Camera Store. They are inexpensive and reduce the worry of damaging the negatives as a result of a mistake.

Compressed Air. Compressed air, although somewhat luxurious for most darkrooms, is invaluable for chasing dust from negatives and equipment. If you have access to a small electric compressor, make sure the air is made dry and oil-free by proper filtration.

Photo by Metzger Studio, Rochester, New York.

Printing and Exposure Controls

Beginning photographers often experience difficulties when making their first prints. The density of their negatives tends to vary from greatly underexposed to greatly overexposed. Each print becomes an exploration in patience when you try to find the proper exposure. The problem is compounded because densities vary within the negative itself and therefore there may not be a perfect printing exposure for the entire negative. Luckily there are devices available and certain techniques that can be learned to make it easy to find the correct exposure for the print as a whole and also to modify the exposure of various portions within the print.

The Correct Exposure

Expensive electronic exposure meters are not necessary for making high-quality prints. They are used by labs making large quantities of prints but most photographers prefer the quite accurate method of making a test strip, which is a piece of printing paper on which a series of exposures are made at progressively longer times. By reviewing the test strip after it has been developed and fixed, it is easy to pick out the part of the strip that looks best.

The Work Print

The time on the part of the test strip that looked right is then used to expose the entire image on what is called a work print. This print is developed and fixed and then evaluated in terms of the tonal values. Some areas may be too dark and others too light. At this point a decision must be made as to how to change the various tones. You can accomplish this by changing paper grades (the higher the grade the higher the contrast) or by local burning and dodging. Burning means increasing the exposure time for various parts of the print to make them darker; dodging is holding back light from sections to make them lighter.

The Final Print

The final print can be the same as the work print if everything is satisfactory. Normally however, the final print will have to be manipulated to some extent to make it a more interesting or effective image. The tools needed to control the values in the print are simple and can be made out of cardboard. Some are also available commercially and are described in this section.

Kodak Projection Print Scale. This projection print scale consists of a plastic sheet with each pie-shaped slice having a different density. When placed over the printing paper so light passes through it during the exposure, the finished print will show wedges of varying darkness. By comparing the one that seems right with the print scale you can determine the correct exposure time for the work print.

Courtesy Eastman Kodak Company

Exposure Meters. This Labosix meter by Omega is typical of exposure meters used in making enlargements. They are useful mostly if you print negatives with many different densities, and time is important. If you work with widely varying negative densities, they can help you save paper by reducing the number of test strips you will need to make.

Dodging and Burning

You can make dodging tools at home out of pieces of black cardboard cut from empty printing paper containers and taped to a piece of wire coathanger. Circles or other shapes of various sizes can be made to hold back light from larger or smaller areas.

Burning tools do the opposite of dodging tools: they hold back the light from the majority of the print while increasing the exposure of a relatively small portion of it. Several pieces of cardboard, each with a different size hole, will be useful. The holes can be circular or cut to the general shape of the area you want darkened. Vignetting tools are similar to those used in burning but they generally have a larger opening, often with a serrated edge, so that when the tool is moved about in the beam of light from the lens it will leave a smooth and gradual line between the dark and light areas.

Vignetter. This Testrite vignetter can be varied in size to fit the size area you wish to vignette. It can also be used as a burning tool by changing the size to fit the area you want burned. Oscillate it smoothly and continuously in the light beam while making the exposure.

Durst Dodging Kit and Wheel Vignetter. Durst also manufactures a set of kits for dodging and burning.

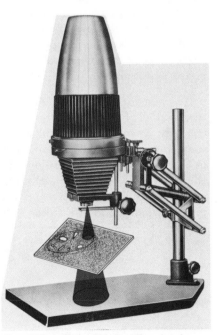

Wheel Vignetter. This Testrite wheel vignetter has a series of openings on the same card. You select the opening that most resembles the shape of the area you wish to burn in. Keep the vignetter in constant motion and the edges will blend in with the rest of the print.

| 8 sec. | 6 sec. | 4 sec. | 2 sec. |

Test Strip. This test strip is typical of how they can be made. Each successive strip has an increased exposure over the previous strip. By looking at the strip you can tell what the correct printing time should be. One of the key points to remember is to place a part of the print that shows all of the tonal values to be considered in each segment of the test strip. If this is not done it will be impossible to judge the correct exposure as it relates to both highlights and shadows.

Texture Screens. A texture screen superimposes a texture or pattern on an image during printing, which makes the print look different from the way it would if it were printed "straight." Many different patterns are available. Generally the screens fall into two classes based on the location of the screen at the time the print is made. The first type is designed to be sandwiched with the negative in the carrier. This allows the screen to be relatively small and inexpensive. It also means that the texture will be enlarged to the same magnification as the print. The second type is sandwiched with the paper in the easel requiring a larger screen but permitting more subtle effects because the screen pattern is not enlarged and will give the same effect regardless of the size of the print. Paterson makes sets of screens designed to be sandwiched with the negative in the carrier. The larger screens that can be sandwiched with the printing paper are available in a wide variety of patterns from art or graphic art supply stores.

Negative Storage and Proof Printers

After the camera has been unloaded and the film developed, it's important that the negatives be stored carefully and that you can see what is on them. A negative is an irreplaceable record and should be treated with the care that all such items deserve. The history of photography is replete with stories of valuable negatives being destroyed. Many Civil War negatives on glass plates, including some Brady negatives of Lincoln, were recycled into such useful items as greenhouses. You may not want to preserve your negatives for posterity but you may want to make prints from them in the future so they should be maintained in as good a condition as possible.

Contact printed proof sheets can be made to show you what the negatives contain. They are made by laying the negatives, emulsion side down, on a sheet of printing paper, holding them flat with a piece of glass, and exposing them with the enlarger light. The resulting images are the same size as the negative image. Making proof sheets serves several purposes:

1. It lets you more easily find a given negative by allowing you to look at positive images rather than holding negative strips up to the light.

2. If contact sheets are made correctly the proof will tell you not only the subject matter of the negative but also its quality in terms of exposure, density, sharpness, and so forth. To determine the density

of a given negative it is important to print all of your proof sheets to the same standard. In this way you can tell by looking if the negative is under- or overexposed or is satisfactory.

How to Standardize Proof Sheets

Many photographers try to make their proof sheets look like a series of little gallery prints. The problem with that approach is that it makes it difficult to evaluate negatives that are selected for enlargement. It makes a great deal of sense to standardize the exposure given to all proof sheets so you can tell immediately by looking at them if a given negative is well exposed or is under- or overexposed. You will also be able to tell if you are consistently underexposing or overexposing the film.

To standardize the printing of proof sheets you must determine the exact exposure time required to print pure black in the areas of the negative lacking in detail (very dense shadow areas). This is accomplished by testing to determine how much exposure is necessary to obtain pure blacks in the unexposed edges of the film.

The edge of 35mm film has a series of sprocket holes used to transport the film when it is advanced in the camera. These holes are completely transparent because the film has

been removed from them. The area around the holes appears to be transparent but it actually has some density (called film base plus fog). To determine the correct exposure you have to determine at what point the area around the sprocket holes turns just as black as they are. Here's how:

1. With a negative in the enlarger, focus it as if you were planning to print a full-frame 11 x 14 enlargement. Remove the negative.

2. Make a test strip using the negatives and proof printer giving increasingly longer exposures to each successive strip, that is, 5, 10, 15, 20 seconds.

3. Process the print sheet and examine it under good lighting. You will notice that the area under the sprocket holes turns pure black much earlier than does the area surrounding them. At some point on the test strip the holes should no longer be distinguishable from the surrounding area because both the holes and the surrounding area are pure black. The time of exposure needed to make this happen is the correct exposure to make all subsequent proof sheets.

If as a result of standardizing you find that all of your proof sheets are too light or too dark you will know that you have a tendency to over- or underexpose. You should make the correction at the time the picture is taken (or later, when the print is made), and not tinker with the proof sheets.

Negative Carrier. Saunders Photo/ Graphics has developed a negative carrier that can be used in a 4 x 5 enlarger to make enlarged proof sheets. The problem with standard 35mm proofs is that it is very difficult to evaluate accurately the image because of its very small size. With this unit the proof sheets have enlarged images that are easier to evaluate.

Print File. Although some negative storage envelopes on the market require you to remove the negatives from the sheet to make a proof sheet, this step has been eliminated by some of the newer envelopes that allow you to print right through the sheet holding the negatives. In addition to being a great time-saver this also subjects the negatives to less handling and therefore reduces the possibility that they will incur any damage. Print File makes a complete line of these negative storage envelopes for different film formats. They are also designed to fit any 3-hole binder which eliminates the additional expense of having to pay a higher price to fit a nonstandard storage binder.

Contact Printers. Most photographers who work in 35mm think of contact prints only as a way to evaluate and inventory their images. This is primarily because there is no market for images as small as a 35mm negative. Those who work in larger formats, such as 4 x 5, do think of contact prints somewhat differently: they can use them as the final print. A contact print is by far the sharpest possible image because no lens impinges on the image being projected. In the contact print the emulsion is pressed flat against the paper surface and the loss of image definition in the resulting print is minimal.

Contact prints can be made by exposing the negative/paper sandwich under an enlarger light, but if many prints are made special contact printers are available that make the job easier and give the photographer more control. This Arkay model is an example. Individual switches control 18 lamps for dodging and burning.

Proof Printer. Print File and others also make proof printers that hold the negatives flat against the printing paper, which is absolutely necessary if your proof sheets are to have accurate, sharp images. This can be done with a piece of clear glass but if you print a number of rolls at one time the hinged proof printer makes it much easier and faster.

Negative Storage in Boxes. Print File makes stackable boxes in which the negative strips and contact strips from the roll form can be filed.

Print Files in Rolls. For those who would prefer a storage system not based on 3-ring binders, Print File makes a system of negative preservers that come in rolls and can be cut to the desired length. They can be printed through just like the sheets, eliminating the need to remove the negative from the preserver when making proofs.

159

Contents

Introduction to Color • **162**
Color Enlargers • **164**
Color Analyzers
and Calculators • **166**
Color Processors • **168**

Introduction to Color

With the introduction during the past few years of greatly simplified color print chemistry there has been a phenomenal increase in interest in this area. More and more home darkroom photographers and professionals are making their own color prints. Until a few years ago the time, effort, and expense involved made it impractical for anyone but a technical expert to do what anyone can do today.

The Starter Darkroom

One of the first questions a teacher of color photography is usually asked is, "What kind of a darkroom do I need?" The assumed answer is that something very elaborate is required. However, a color darkroom can be even simpler than one designed for black and white processing. Color printing paper is sensitive to light of most colors so it cannot be exposed to bright safelight illumination. (Some papers allow the use of dim safelights but the illumination is so weak it provides little help.) This shortcoming is actually a blessing; once the paper is exposed under the enlarger it is placed into a light-tight drum for processing. All of the following steps can then be completed in normal daylight. Most darkrooms are made light-proof so that the paper can be processed without being exposed to light; a color darkroom does not need to be light-proofed except in the area where the printing exposure is made. A number of tent-like contraptions have been designed to cover the enlarger, the easel, and the person printing. These can be set up in a corner of the kitchen and the developing done right in the kitchen sink.

This section is a general overview; additional information can be found in the following sections of this chapter. As a primer, however, here are the basic materials needed to convert a black and white darkroom to color:

- CP (color printing) filters
- Kodak Print Viewing Kit
- Kodak Color Data Guide
- Kodak Book "Printing Color Negatives" (E-66) or "Printing Color Slides" (E-96)
- Processing drum for the paper prints
- Roller to keep the prints agitating in the solutions (optional)
- Hair dryer to dry the prints for quick evaluation

The equipment used by a professional or serious color printer differs very little from the basic starter unit. In place of the CP filters a professional setup would have a color head on the enlarger with dichroic filters; the processing drum would be capable of being placed in a water bath to maintain the critical temperature accuracy that color printing requires; the enlarger would be connected to a voltage regulator to ensure that each exposure is the same as the last; the water would be supplied through a temperature regulating valve to reduce the trouble of keeping it at the correct temperature; and the hair dryer would be replaced with a good RC dryer. Everything else would be pretty much the same.

Unique Solution

If you want to make color prints but don't want to worry about chemicals and processing, you can use Saunders' special easel designed to hold the Polaroid 8 x 10 sheet film. Put a slide in the negative carrier, insert a sheet of 8 x 10 film in the easel, focus on the top light shield, expose, and in 60 seconds you have a full color print. Keep in mind that 8 x 10 Polaroid film is expensive.

Printing Enclosure. A cloth version of R2D2? No, it's a printing enclosure that can be set up on the kitchen table. Color printing requires that the print not be exposed to light of any kind, including safelights. With this enclosure fitted over the enlarger and baseboard the exposure can be made and the print then loaded into a daylight print processing drum (see page 168). Once it is in the drum, further processing can be done in daylight without fear of the print being exposed to unwanted light. This model is made by Cosar-Mornick.

The Starting Equipment

Kodak Print Viewing Kit.

Courtesy Eastman Kodak Company

Processing Drum.

Kodak Color Data Guide.

Courtesy Eastman Kodak Company

Drum Roller.

Hair Dryer.

Color Printing Filters.

8 x 10 Polaroid Easel.

Color Enlargers

Color printing has several problems that are not encountered in black and white work. These problems have influenced enlarger design, and to a large extent the difficulties have been overcome by modern equipment.

Filtration

Most color negatives, or slides that are used to make color prints, are not in perfect color balance. If they are, the enlarger light source is not or the print emulsion reacts differently from what is expected. Any of these variables can throw a print out of balance. To remedy this, color filters are inserted somewhere between the light source and the print to correct the light. There are three possibilities.

1. CC (color compensating) filters. These are very expensive because they are gelatin filters used between the lens and the paper. The image passes through them, so they must be optically pure. Because of their high cost they are not often used in the average darkroom.

2. CP (color printing) filters. These are used between the light source and the negative. Because the image does not pass through them, they can be made of a less expensive material. Most enlargers have a filter drawer that can be used to hold these filters. They do have the advantage of being inexpensive but, at the same time, since they are made of a dyed acetate-polyester, they tend to fade with age and lose their color-correcting ability.

3. Dichroic filtration. These filters are made of glass. They are not used in the same way as acetate filters; they accomplish the filtration by being moved partially into or out of the beam of light. The farther into the beam the more filtration they achieve. Because only part of the light goes through the filter the total amount of light reaching

the negative is higher for the same degree of filtration than with acetate filters. They are also much more permanent than other types of filters and can therefore be counted on to give consistent results over their lifetime. They also allow finer filtration steps. They can be varied in steps of .01 whereas acetate filters come in steps of .025.

Voltage Variations

The color balance of an enlarger bulb depends to a large degree on the voltage that is used to light it. Variations in the voltage will cause variations in the color balance. The same effect is at work in black and white printing but the slight variations are not sufficient to be noticeable in the print. Because successful printing is based on eliminating as many variables as possible, manufacturers have devised voltage regulators for use with color enlargers. These regulators give the same output voltage to the enlarger bulb regardless of variations in the incoming line.

Consistent Light Source

Tungsten light sources, which have been used for years in black and white enlargers, have problems when used for color printing. They tend to change their color balance over their life cycle, because of aging of the element and the build-up of emissions on the inside of the glass envelope in which they are encased. This change in color balance makes it difficult to obtain consistent results over a long period of time. If you print a negative this week and then use the same negative and filter pack a month from now the filtration will be off because of a change in the light bulb. To overcome this problem modern enlargers use a quartz-halogen lamp which does not have a build-up of emissions on

the inside of the envelope and maintains a consistent color balance throughout its life cycle.

Heat on the Negative Plane

Heat on the negative plane is caused by the infrared part of the spectrum and can cause buckling of the negative, especially during long exposures. To overcome this problem the designers have developed several techniques including filters and light pipes. The Vivitar VI enlarger, one of the most innovative, uses a combination of fiber optics and an infrared reflector that passes the visible light but reflects the heat-producing light out of the optical path. Another solution has been to install a cooling fan in the enlarger head, but this can cause vibration problems.

Enlarger Bulbs

This graph shows the relative behavior of both tungsten and quartz-halogen bulbs. The quartz bulb tends to maintain a consistent color balance over its life compared to the gradual decay of the tungsten bulb. If your enlarger is already equipped with a tungsten bulb the best solution is to reserve a special bulb for color printing only. This way if you print color only occasionally between long sessions of black and white printing the bulb will not change as drastically as it would if you were using it for both kinds of printing.

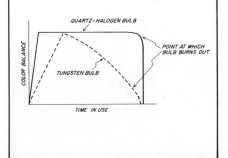

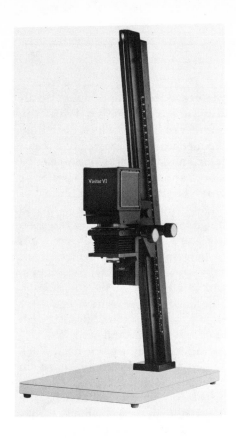

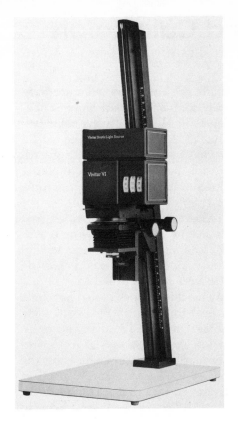

Color Heads. Most major brands of enlargers can be purchased with a black and white condenser head and later be converted to color. These two pictures of the Vivitar VI enlarger show it with and without the color head. In many enlargers the addition of the color head changes the enlarger from a condenser to a diffusion light source. The Vivitar VI is one of the few condenser color heads available. It includes dichroic filtration that is much easier to use and is generally superior to acetate filters. The enlarger can be used for color printing without the color head by inserting filters in the filter drawer just below the top unit.

Color Printing Filters. The least expensive way to convert a black and white enlarger for color work is to purchase a set of color printing filters to be inserted into the filter drawer of the enlarger. They come in a series of densities that can be combined in various ways to give the correct color balance to the print.

A complete set of filters will contain series of cyan, magenta, and yellow filters and an ultraviolet (UV) filter. These filter sets come in different sizes so make sure you measure your filter drawer before making the trip to the camera shop.

The light emitted by an enlarger bulb contains a portion of ultraviolet light that tends to affect the blue layer of the print emulsion. To remove this light and allow for better color balance a UV filter must always be inserted in the filter drawer. In most color heads they are permanently installed.

Voltage Regulators. These devices will keep the voltage supplied to the enlarger lamp at an even 115 volts despite any variations in the input from the electrical company. This ensures that every print you make will have the same enlarger light brilliance and this consistency eliminates one of the major sources of different print densities and color balances.

A 5-volt change will affect the color balance about as much as a CC10 filter with the effect most noticeable at the blue end of the spectrum.

Some color enlargers use step-down transformers to reduce the voltage to the lamp (quartz-halogen) and act as voltage regulators. The control they give is sufficient and make a separate voltage regulator unnecessary.

Infrared Filters/Heat Absorbing Glass. The infrared portion of the spectrum carries heat from the lamp to the negative plane. To keep the negative from getting hot enough to buckle or burn, this infrared portion must be removed. Many color heads will have a filter built in but if you use color printing filters you can insert an infrared filter into the filter pack to remove this part of the spectrum.

Color Analyzers and Calculators

When printing in black and white the photographer is primarily concerned with determining the correct exposure time and the contrast range of the print. In color printing these basic concerns are only part of the problem. The major difficulty for beginning color printers is determining color balance so that the colors appear the way you want them to. Manufacturers have developed a number of products to reduce the problem of finding out what the correct color filtration should be to give you a print that you like.

Electronic Color Analyzers

Electronic color analyzers are devices designed to give you the correct printing time and color filtration required to make a high-quality color print. Unfortunately, to use one you first have to make a print with a color balance you like. You then use that print to calibrate the analyzer. Once the calibration is

made the analyzers will automatically compare any subsequent negatives or slides with the color balance of the "ideal one" used to calibrate. It will then indicate the filtration pack required to duplicate the color balance and exposure time of the "ideal" print.

There are two difficulties that you can expect when using one of these analyzers. The first is that you may have a problem making the first print needed to calibrate the machine. Since it does not come precalibrated you will have to make at least one good print by more traditional methods so that you have a standard to use in calibrating the machine. The second problem arises from the fact that it is almost impossible to use one "ideal" print to judge a large number of subsequent photographs. Sunsets are quite a bit different from snow-covered scenes and the analyzer cannot make judgments about how you want to interpret these scenes. All it can do is try to make each print look like the last and that is not the goal of most color printers. Some

analyzers are being designed to allow for programming with any number of "ideal" prints. Each time the machine is calibrated to a particular image the information can be stored and reused. After a period of time you can assemble a library of "ideal" images covering a broad range of possibilities. You can then use the "snow-covered" program to determine the exposure of all subsequent snow-covered scenes, and so on. If you have the money, buy an analyzer when you first start to print in color, but do it with your eyes open and with the expectation of doing some hard work on top of what the analyzer will do for you. A well balanced and exposed color print will still be the result of experience, which an analyzer cannot yet duplicate.

Light Required to View Color Prints

The quality of the light used to evaluate color prints is extremely important. The light should be as close as possible in its color make-up to the light that will eventually be used to view the print. Most prints are viewed in light close to daylight in color balance, so you should use a light source of the same quality. Fluorescent fixtures including GE Living White, GE Deluxe Cool White, Sylvania Deluxe Cool White, Westinghouse Deluxe Cool White, or Westinghouse Living White are suitable.

Color balance cannot be accurately checked unless the print is dry, so be sure you have the right light source and a dry print or you may be disappointed in the morning.

Calculator Grids. These are ingenious devices that help you select both exposure and filtration. The grid is placed over the print before it is exposed. A diffuser is placed over the lens of the enlarger to scramble the colors and give an even illumination of the print. The

print is exposed, processed, and dried. The portion of the print that is exposed to the value of 18 percent gray is the correct exposure. By reading the scales on the sides of the grid you can easily figure out the filtration required to achieve that exposure and color balance.

Print-viewing Filters. Print-viewing filters shift the apparent color balance according to the density and combination of filters used. With this device you can try a number of combinations to see which makes the print take on the color balance you would like it to have. Once you have located the right filter combination use the recommended filter pack and make another print. You can then do the same thing all over again to refine the balance even further.

Courtesy Eastman Kodak Company

The Kodak Ektacolor FilterFinder Kit. Printing from negatives is more difficult than printing from transparencies because the negative projected on the paper surface is not as familiar in its color balance (it's reversed) as a color transparency is. The Kodak Ektacolor FilterFinder kit (publication R-30) helps take some of the guesswork out of filter selection and exposure calculations when making prints from color negatives. The kit consists of a filterfinder matrix, locator, Kodak neutral test card (gray card), calculator dial, and simple, step-by-step instructions. It can be a great help in learning how to make those first color-balanced prints without wasting valuable photographic paper.

Courtesy Eastman Kodak Company

Kodak Color Data Guide. The Kodak Color Data Guide comes complete with a standard negative and print. Using the standard color negative to make your first color print takes a lot of the doubt out of the process because you have both a negative and a comparison print against which you can check your own results. Occasionally the Kodak comparison print will be out of balance because of the difficulty of maintaining absolute quality over the run of hundreds of thousands that are made for the book, but it is usually close enough to be helpful.

Courtesy Eastman Kodak Company

Color Analyzers. Color analyzers are about the most heavily advertised units in the photographic industry today. With so many photographers switching to color there is clearly a need for some well-developed aids. Many photographers have spent years developing a visual memory of what various tones will look like when translated into a black and white print but doing that and at the same time worrying about color balance and saturation is too much to handle. The color analyzer is a help, but certainly not the complete answer to all problems in producing color prints.

Color Processors

Color print processors all perform the same function: to move the print through the chemistry or move the chemistry over the print. Four basic designs are used today but with variations depending on the type of darkroom and the quantity of prints being processed. Theoretically it is possible not to use a processor at all. But you would need sufficient patience and a high enough threshold of claustrophobia to stand in a totally dark room while processing the prints in a tray just like black and white prints. Few of us have that patience and therefore choose to work with a processor.

The Four Main Kinds

Drum with Roller. This is simply a light-tight drum into which the exposed print is placed. It is then closed with caps at either end. The roller base agitates the drum after the chemistry has been poured in. Roller bases can be operated by hand or can be motorized. In some cases the roller is just a rim around the drum which allows the drum to be rolled back and forth on the counter to provide agitation.

Because of their simplicity these drum processors are used by almost everyone making color prints unless either their budget or their volume requires or allows a machine processor similar to those made by Kodak.

Kodak Processors. Unlike drum processors these are stand-up units into which the chemistry is poured. The print is then transported through the machine and the various chemicals by a roller transport mechanism. These processors must be used in total darkness because they are not light-proof and also are designed to use chemical replenishment rather than one-shot chemistry. They are also quite expensive.

Basket Processing. Basket processing allows you to process more than one print at the same time. A series of prints can be stored in a light-tight drawer and then placed in the basket for immersion in the chemicals. Most photographers rarely process more than one print at a time, and basket processing is therefore primarily a tool of commercial printers.

Daylight Processors. Some manufacturers have recently introduced light-tight processors where the print is transported through the various chemistries by a roller system. Because of the cost of chemicals, these units become cost-effective only if your volume is ten or more prints at a session. If you do not make this many prints (and many photographers do not in the course of an evening), you will be wasting chemicals and increasing the cost of each print. The processor has to be filled with a given amount of chemistry to operate well and that amount is sufficient to process more than ten prints. If you make fewer, the chemistry still has to be disposed of at the end of the session and the unused capacity, which you have paid for but not used, goes down the drain.

Drum with Motor Base and Water Bath. Colourtronic makes a drum unit that is immersed in a water bath while it agitates the print. This ensures that the chemistry being used is maintained at the correct temperature throughout the cycle. Without the water bath the tendency would be for the chemistry to rise or fall toward the temperature of the air in the darkroom, which is seldom within the allowable temperature variation—plus or minus ½ degree of the recommended temperature.

Medium Volume Basket Processor. This Unicolor unit is a basket processor for those photographers whose capacity has increased over what a drum system can handle but who cannot afford the cost of a continuous processing machine. It comes equipped with an in-tank heater and can be equipped with a Unicolor temperature controller to maintain a consistent temperature. The unit's capacity is ten 8 x 10 prints at one time. It can also be used to process black and white prints or sheet film.

Daylight Drum Processor. The Chromega Drum II is one of the most advanced drum processors on the market today. Unlike almost all other roller units this one agitates in two directions, which ensures the most even distribution of the chemicals across the face of the print. A drum that revolves in only one direction subjects the print to different concentrations of chemistry along the length of the print. This unit both revolves and rocks in a lengthwise direction, tipping the drum back and forth as it spins slowly on the rollers.

Drums for this and other units come in a variety of sizes and should match the print sizes you plan on making. If you print in more than one size it is cheaper to buy different drums because a small print in a large drum will waste expensive chemistry.

The Durst Daylight Processor Inside and Out. This Durst unit allows processing of color prints in the light. After placing the print in the unit and closing the cover the lights can be turned on while the print is being processed. The interior shot shows the roller transport system designed to carry the print from one processing stage to another in a continuous fashion. The unit's capacity is up to twenty 8 x 10 prints an hour and it will process all resin-coated papers except Cibachrome and Kodak Type 1993. Its capacity is 84½ ounces of developer, enough to handle forty-five 8 x 10 prints. Durst claims that chemicals can be left in the unit overnight without reducing their strength.

Processor Basket. This Leedal processor basket is typical of those used commercially. The cost and capacity of this kind of unit restricts it to the high-volume operator.

Kodak Color Print Processor. This Kodak Rapid Color Processor, Model 11, is a well-made processor within the price range of the average color photographer. It does have to be used in the dark because it is not light-tight but that is its main drawback.

The print is prewet and placed emulsion-side down on a hollow, textured drum. It is held in position by a nylon blanket which lies over the paper. As the drum rotates the textured surface brings fresh solution from a shallow tray into contact with the paper. The change from one process to the next is accomplished manually by tilting the tray to dump one solution, rinsing the tray and roller with water, and refilling the tray with the next solution.

Courtesy Eastman Kodak Company

Fully Automatic Drum Processing. Nord's fully automatic processor is an expensive unit but also the ultimate in drum processing. Chemicals are preheated, added, and dumped automatically. All chemical and wash cycles are controlled by a tape programmed timer. Can handle print sizes up to 20 x 24 inches.

9 Print Finishing

Contents

Dryers ● **172**
Mounting ● **174**
Matting and Storing
Prints ● **176**
Framing ● **178**
Surface Effects ● **180**

Dryers

There is something terrifying about the irreversibility of processing negatives. Most photographers don't mind ruining a print because it's done all the time and it's relatively easy to make another, but a ruined negative is gone forever. This mortality tends to keep experimentation to a minimum. Drying is the stage where negatives are most susceptible to damage, especially from streaking, dust, and scratching. Because of the softness of the negative emulsion at this stage, there is a great deal of controversy over how to dry them without damage. Many photographers use a wetting agent to assist the water to run off so it will not build up in drops that leave a residue when dried. After using the wetting agent, some photographers squeegee their negatives with a small viscous sponge specially manufactured for photo use (kitchen sponges scratch).

The negatives should always be hung in a dust-free area to dry. The ideal place is either an unused shower (run the shower for a few minutes first to settle any dust) or a sealed negative drying cabinet. Never use unfiltered hot air to speed drying because there is a good chance that all you will do is imbed dust in the negative emulsion. All negatives, when hung to dry, should be weighted at the bottom to eliminate curling.

Clothespins. There is no substitute for the humble clothespin as a negative dryer. You can clip one to the top of the film to hold it to a string strung across your shower, drying cabinet, or the darkroom. At the bottom of the film, clip another clothespin to keep the film strip taut, otherwise it will curl as it dries and stick to itself where it curls. A hook can be attached to one end of the clothespin to make it easier to hang on the string. Be sure to buy the spring-loaded clothespins, and not the ones that are a simple notch in a piece of wood.

Roll Film Dryer. This DSA/Senrac clock-controlled roll film dryer uses filtered air to dry film quickly while it is still on the reel. The timer can be set to turn the unit off at the end of any preset time up to 10 minutes.

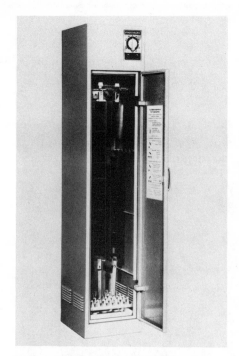

Drying Cabinet. Kindermann makes a series of negative drying cabinets similar to the one illustrated. They all feature filtered, forced air ventilation for drying almost any size of roll or sheet film. The temperature of the warm air can be adjusted and the fan and heater are connected to a timer that will shut the unit off at the end of a preselected period. Kindermann also makes a "Porta-Dri" model that has flexible plastic sides so the entire unit can be easily stored in a small space when not in use. The combination of rapid drying and a dust-proof environment for the film makes these units extremely useful.

Stainless Steel Film Clips. If you think clothespins make your darkroom look tacky, buy yourself a complete set of stainless steel clips such as these made by the Photo Materials Co. They come in two versions. The one illustrated is to attach the film to the string from which it hangs. The other version is weighted and when attached to the bottom of the film holds it straight while drying.

Print Dryers

Drying prints can be accomplished naturally or it can be accelerated through the use of either increased heat or increased air flow. The concerns in drying prints are their tendency to curl when drying, the archival quality of the print, the protection of the print surface, and the effect of heat or other drying methods on the image.

The safest way to dry prints is to squeegee the excess water from the surface using a smooth squeegee so the surface of the print is not scratched. Lay the squeegeed print on a fiberglass screen to have it dry evenly and with minimal damage (see pages 104-105).

If you have a high output that would overload a natural drying system, consider a dryer that uses air flow, temperature, or a combination of both to accelerate the drying process. RC papers are very sensitive to heat, as are color prints, and air impingement dryers are best for those materials. RC papers dry flat; the curl in regular papers can be minimized by using an electric or double-screen dryer that holds the print flat while drying. Curl can be removed, when it does occur, by heating the print briefly in a dry mount press or by stacking prints in piles under a weight of books.

Squeegee. Squeegeeing excess water off of the print prevents it gathering in pools or drops and leaving spots on the print when it dries. Get a well-made easily scratch the surface of the print if mistreated. This Premier model is well-designed with a handle large enough to give good leverage.

Roller. Paterson and others make print rollers that serve the same purpose as a squeegee. As they are rolled across the surface of a print they push the excess water ahead of them. They do not scratch the print but if any dirt is allowed to accumulate on the rollers, they can emboss the print on each revolution.

Forced Air Dryer. This Omega print dryer has a thermostatically controlled air flow to dry color and RC papers. It has a capacity of 120 8 x 10 prints per hour or 60 11 x 14s. The top of the dryer has been designed to be used as a squeegee board. The heated air is not continually vented into the darkroom although it does escape when the door is opened. With the racks removed the dryer can be used to dry film on stainless steel reels.

Drum Dryer. Before the advent of RC papers, prints were dried by the direct application of heat. If you still print on regular papers you can choose from models that accept one or two prints at a time, or you can choose a rotary model that will take a continual stream of prints. The manufacturer states these Premier dryers can also be used with RC papers if the temperature is set very low and the print inserted with the emulsion side away from the heated surface.

Fiberglass Screens. East Street Gallery makes an archival print dryer for air drying prints on fiberglass screens. Each unit has 6 screens and will dry 6 16 x 20 prints, 12 11 x 14s, or 24 8 x 10 at one time. Photo shows two earlier 5-screen units stacked on top of each other.

Fiberglass Screen Dryer. This attractive redwood and screen dryer has a relatively small capacity but additional units can be purchased and stacked on top of each other. The dryer holds 8 11 x 14 prints under tension between two fiberglass screens. The tension makes them dry flatter than they would if just laid on top of a screen.

Mounting

Many photographers mount their work to keep it flat for viewing. However, chemicals or impurities in adhesives can damage photographs, and once mounted, the photographs are very difficult to remove from the backing. So mounting is recommended only for photographs that do not need to be preserved for a number of years. Valuable artwork should be flattened and attached to a mat with acid-free hinges instead.

Several mounting processes are described below. From a conservator's point of view, dry mounting is the preferred process because the pH of the adhesive is within the accepted range. Whichever method you use, it is important to mount on 100 percent rag, acid-free board; chemicals in other boards will affect both the photograph and the board.

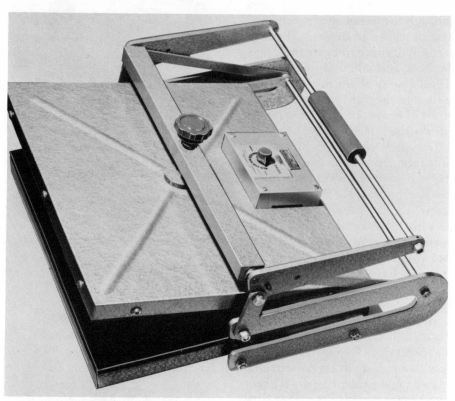

Dry Mount Press. The binding agent in dry mounting is a tissue which, with heat and evenly applied pressure, permanently adheres the print to the backing.

Dry mounting requires the use of a dry mount press like the one shown here. Presses come in several sizes from 8 x 10 to 40 x 60. You will need a press at least as big as the board on which you are mounting the print. You will also need dry mount tissue (there are different kinds for black and white, color, and resin-coated prints). Dry mounting is a quick process and doesn't involve messy adhesives that might accidentally get on the face of the print. However, it is not fool-proof. It is possible to ruin a print by trapping a bubble of air under it or by setting the temperature too high.

Spray Adhesive. 3M makes two kinds of spray adhesive. Photo-Mount forms a permanent bond after pressure is applied with a rubber roller. Spra-Mount bonds temporarily allowing the print to be removed and repositioned several times.

Roll-a-Mount. Technal's Roll-a-Mount dry mounting machine is an alternative to owning a dry mount press. The roller flattens the print, eliminating air pockets, before the heated element mounts the print to the backing. It can be used only for prints 8 x 10 or smaller.

Tacking Iron. The tacking iron is an auxiliary dry mounting tool. It is used to mount the photograph to the backing in one spot so it won't slip out of place when you put it in the press.

Positionable Mounting Adhesive. Positionable Mounting Adhesive is a layer of adhesive between two sheets of waxy paper. It's easy to use—remove one piece of paper and squeegee the adhesive sheet onto the back of the print. Then remove the other piece of paper and place the print on the mounting board. The print can be moved until you apply pressure again with the squeegee to mount it permanently.

Cold-Mount. The Cold-Mount process by Coda is a board coated on one side with pressure-sensitive adhesive. The rubber roller bonds the print to the backing but keeps the unmounted part of the print away from the adhesive eliminating any chance of air pockets. Coda also makes a special Cold-Mount press which will mount prints up to 20" wide.

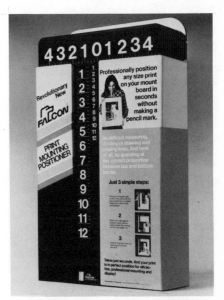

Perma/Mount. Perma/Mount is a sheet with adhesive on both sides. The process is simple: stick the print to one side of the card; trim off the extra card; peel off the protective covering on the back of the card exposing the adhesive; and apply pressure to mount the print to the backing. It is available for 8 x 10, 11 x 14, and 16 x 20 prints.

Print Positioner. The print mounting positioner made by Falcon is a time-saving device which helps you position the print in the optical center of the board without measuring or drawing lines.

Matting and Storing Prints

Because the surface of a photographic print is so easily damaged by fingerprints, dirt, or scratches, a good storage system for finished prints is an essential part of preserving them. The major considerations when you're choosing a system should be whether you need to transport your prints or simply keep them in your studio, whether you will be matting them to make them presentable for viewing or storing them without mats, and whether you want to use archival methods to preserve them.

For storage in the darkroom, the best idea is to put each print in an envelope to protect the surface and then place them all in a storage box for further protection.

The most common envelopes made for storing prints are glassine envelopes. These protect the surface of the print from damage and they're fine for prints that aren't valuable. However, they are not archival because the acidic content of both the paper and the glue can damage the print over a long period of time.

For archival protection Light Impressions supplies white storage envelopes of Perma-Life paper in two sizes, 8½ x 10½ and 11½ x 14½.

If you will be showing your prints to people from time to time, you will probably want to place each print in a mat and backing, protecting the print surface with a sheet of tissue which can be lifted for viewing.

Interleaving tissue is an acid-free tissue used for this purpose. It is placed under the mat and over the surface of the print. It can also be used instead of envelopes between unmatted prints in a storage box. Light Impressions supplies it in sizes from 11 x 14 to 16 x 20.

Wooden Boxes. The redwood and brass portfolio box shown here is designed for transporting and viewing mounted work. The top and one side detach for viewing prints and the inside is sealed against wood vapors, which are harmful to photographs. The strong construction, attractive materials, and easy conversion from carrying case to display box are the important features of this storage system available from Depth of Field. All boxes are custom-made any size you want.

Portfolio Box. The portfolio box shown here folds together in a clamshell design. Made of high quality neutral pH materials, it is excellent for archival storage and display of matted or unmatted prints. It is deep enough for eighteen matted prints and comes in three sizes to accommodate 11 x 14, 14 x 18, and 16 x 20 prints or mats. The advantage of this kind of box is its flexibility for carrying or folding out to provide a very attractive display. Available from Light Impressions.

Drop Front Storage Box. The drop front storage box is made of archival-quality materials with metal corners to strengthen the construction and eliminate the need for adhesives which might damage the paper. Light Impressions has them in two sizes: 15 x 11 x 3 and 16½ x 20½ x 3. The larger can be divided into four 8 x 10 sections for storing large numbers of unmatted prints. This box is the least expensive of those illustrated here and is used more often for utility storage than for display.

Shipping Case. This one is not just a storage box, but a shipping case. It's made of tough Vulcan fiber with heavy gauge steel corners and a cardholder for addressing the unit in transit. It comes in three sizes—11 x 14, 14 x 17, 16 x 20, all 3″ deep, from Light Impressions.

Mat Boards

There are two kinds of mat board, wood pulp board and museum-quality board. Wood pulp board comes in a variety of colors, but it is highly acidic. The acid content will, over a period of years, cause both the print and the mat board itself to discolor and become brittle. The alternative is non-acidic museum board, usually of 100 percent rag content. Because it contains no acid, it will not have any adverse effects on the print. However, it is more expensive than ordinary wood pulp board and it comes in a very limited selection of whites, neutral colors, and black. If you want archival protection for your prints you must use acid-free board for the overmat as well as for the backing immediately behind the print. Many photographers use 4-ply board for the overmat and 2-ply board for the backing. In a frame, an additional backing such as corrugated cardboard or Fome-Cor is needed for stiffness.

Mat Cutting Tools

Cutting the outside of a mat is not difficult. You can use a simple mat knife and straight edge, or a paper cutter designed to take mat board, or the mat and glass cutter described in the framing section of this book.

Cutting mat window openings is a little more tricky, and because a poorly cut mat will detract from the overall effect of the picture it is important to find a mat cutting tool with which you are comfortable. Tools range from the inexpensive Dexter cutter to the rather expensive but much more efficient Keeton Kutter.

It's very difficult to cut professional looking circular or elliptical mat openings with a simple hand cutter. A sophisticated machine such as the Keeton Oval Kutter is generally required.

Keeton Kutter. The most efficient and most accurate machine for cutting mats is the Keeton Kutter. The bar clamps the mat board tightly in place while you cut and the cutting blade is actually mounted on the straight edge to ensure a straight cut. It's quite expensive but probably worth the investment if you cut a lot of mats.

Mat Knife. A mat knife is the most basic mat-cutting tool. It's a good idea to get one with a retractable blade for safety's sake. You can also purchase a metal straight edge with a no-slip rubber backing from Light Impressions.

Dexter Mat Cutter. Of the simple hand cutters, the Dexter is the least expensive and the most widely used. Use a straight edge with a no-slip backing as a cutting guide. The blade can be clamped in place at any angle to allow straight or bevelled cuts. Available from Brookstone.

Paper Cutter. The guillotine-type cutter shown here is one of several models designed to cut mat board as well as paper. It's also available with a safety guard.

Mat Cutter. The cutter shown here operates on the same principle as the Dexter, but it comes with its own straight edge, mat guide, and measuring system. You can order it from Saunders.

Attaching the Photograph

Photographs may be held in place in the mat with archival quality photo corners or with an archival quality tape, never with masking tape or cellophane tape. The most suitable mounting tape is white linen tape, a cloth tape with a water-activated acid-free adhesive on one side. You can get the photo corners or rolls of tape from Light Impressions.

When using tape, attach the photograph to the backing with only two small squares of tape placed along the top edge of the photo near the corners. If it is taped along the sides and bottom as well, it will buckle with changes in humidity.

Framing

When choosing a frame, the first thing to remember is that the frame should not call attention to itself but should focus the viewers' attention on the picture. With photographs, simple frames with white or neutral color mats are generally most successful. There are several choices. Clip frames, metal frames, and Dax plastic frames are all quite contemporary looking and are available in kits which are easily and quickly assembled at home. Wood frames come in an infinite variety of profiles, colors, and finishes, so you can choose a frame that exactly suits the mood and period of your photographs. However, wood frames do take more time to assemble, and require some special tools if you plan to build them yourself.

Whenever you are putting a photograph in a frame with glass, you should also use a mat. Moisture can condense easily on the inside of a sheet of glass and if the photograph is in contact with the glass when this happens, it can be ruined. The mat provides a space between the surface of the glass and the surface of the photograph so that the photo won't be affected. Acrylic is less likely to condense moisture, and therefore is often used instead of glass when framing unmatted pictures, but this is not considered archival framing.

If you must frame without a mat to get the visual effect you want, the only archival solution is to use spacers between the glass and the photograph. A spacer is a thin strip of wood or mat board attached to the inside surface of the frame after the glass is in place. The edges of the photograph then rest against the spacers instead of the glass. Nielsen makes a metal frame with a spacer to separate the glass from the photograph.

Dax Frame. Of the ready-made frames, the Dax frame is the simplest and quickest to use. It is a clear acrylic box with an open back and a slightly smaller cardboard box that slips in to hold the picture in place. All you have to do is mat your photograph, or attach it to the inner cardboard box if you choose not to mat it, then slip it into the frame. Dax frames come in several standard sizes from 5 x 7 to 24 x 30 which can be hung horizontal or vertical. They come with clear plastic sides and an assortment of color finishes. All have a contemporary look. The Dax frame is especially convenient if you want to change pictures often.

Metal Frames. Metal frames are quite contemporary and easy to assemble. The only tool you need is a screwdriver. The Nielsen frame, shown here, is held together by metal angles which slip into the slot at the back of the frame. Glass, mat, and backing are held securely against the lip of the frame by metal springs inserted after the frame is assembled. Pre-cut lengths are sold, two to a package, along with instructions and assembly hardware, and you buy two packages to make a frame the size you want. Only a few styles and colors are available in kit form, however. You will find a much wider selection if you go to a store that carries the complete line, and you can have them cut to exactly the size you need.

Eubank Frame. Clip frames are another simple, easy-to-assemble framing alternative. The Eubank frame shown here and the plastic version, the Uniframe, are sturdy and quite attractive. Clips hold the glass and backing together in eight places and a string or wire on the back holds the clips securely in place and provides a means for hanging the completed frame. Kits that clip the glass to the backing in two or four places, such as Braquettes, Fast Frame, and Gallery Clips are suitable for small pictures. But since the glass and backing tend to separate over long unsupported distances, larger pictures need to be clipped in eight places. Clip frames are adjustable and can be re-used on pictures of different sizes and shapes.

Framing

Custom framing can be quite expensive, but there are cheaper alternatives for anyone who is willing to spend some time framing. Do-it-yourself frame shops will cut materials to size for you and show you how to assemble them yourself. If you've never built a frame before, this is the best way to begin, because you'll have professional help. Or you can invest in a few tools and set up your own work space for cutting and assembling frames.

You can cut framing materials with fancy equipment or relatively inexpensive tools and get good results either way. The main difference with the more specialized tools is that they make the job easier and save you a lot of time.

The simplest and least expensive tool to use for cutting wood molding is a miter box. Because the angle of the cut is crucial when you're building a frame, it's best to purchase one with some kind of clamping device for holding the saw. Some miter boxes cut only 45° or 90° angles. So if you might at some point want to make six- or eight-sided frames, buy one that will adjust to the appropriate angles. You'll also need a good sharp back saw, fourteen teeth per inch or finer.

Most professional framers use choppers instead of miter boxes because the chopper is quicker and more accurate and makes a smoother cut than does a back saw. However, the chopper cuts only wood, so many people who deal in metal or plastic frames do all their cutting with a power saw such as the Keeton Kut-All Saw.

Frame assembly requires several tools and supplies that you can pick up in a hardware store if you don't already have them: tack hammer, nail set, wood glue, wire brads, hand drill, and pliers. The only special tool you need is a corner clamp. A fitting tool, while not absolutely necessary, will make the job easier.

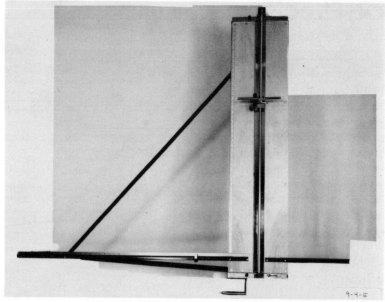

Keeton Kutter. The ultimate device for cutting glass, mat board, and backings is the Keeton Cardboard and Glass Kutter. The piece to be cut sits on the horizontal bar at the bottom which also has a measuring guide on it. The blade or glass cutter moves along a vertical track. A straight cut is guaranteed and the time taken to measure is practically eliminated. It's expensive but worth it if you do a lot of framing.

Square-Head Hammer. Wire brads are used in the back of frames to hold the contents in place. The framing hammer shown here is designed specifically for tapping those brads gently into place. Available from Brookstone.

Fitting Tool. The fitting tool, also available from Brookstone, is used to squeeze brads into the back of the frame. Because it doesn't jostle the frame, you don't run the risk of breaking the glass or weakening the glued corners.

Miter Trimmer. This miter trimmer available from Brookstone is one of the simplest choppers available. You must first rough-cut the molding a little longer than you want it. Then trim it exactly to size with the trimmer. It cuts any angle from 45 degrees to 90 degrees.

Keeton makes a larger chopper that is similar to this one, and quite a bit more expensive.

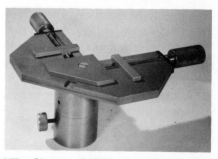

Miter Clamp. A miter clamp is essential for holding the corners of the frame tightly in place while the glue sets up. The simple, inexpensive corner clamps available in most hardware stores are fine for most frames but are limited in the size of the moldings they can accept. The Keeton Frame Designer shown here is a sturdy and versatile clamp made specifically for framing.

Surface Effects

Most photographers, after making the final print, consider the job complete once the print has been spotted to hide dust spots. However, some photographers use the final print as an intermediate step by adding texture or colors. The range of possibilities is quite wide and experimenting with some of the print finishing products can add enjoyment to the photographic process.

The possibilities for working on the print include:

1. Spotting black and white prints to hide dust spots.

2. Adding color to black and white prints.

3. Using color to spot or add color to color prints.

4. Adding texture to the print surface after it has dried. Texture can also be added to the image at the time the print is made.

5. Spraying the surface of the print to change the overall surface appearance.

6. Ferrotyping glossy paper to give it a high gloss finish.

In this area your imagination should be your only guide. There are no rules as to what is acceptable or interesting. Anything goes that works for you.

In many cases the trial prints leading up to the final print can be used as practice prints. A print that is slightly light makes a good candidate for handcoloring. Once you have practiced the new techniques you can then try them on your best prints.

Ferrotyping. The papers you buy that are categorized as glossy will not have a high shine unless they are ferrotyped (RC glossy papers are an exception). This step is performed after the final wash is completed. The print is placed face down on a chrome-plated ferrotype plate and squeegeed to the surface. It is allowed to dry in this position and if squeegeed properly it will automatically release itself from the ferrotype plate when dried. The plate must be highly polished and it helps if the print is soaked in a chemical such as "Edwal Super-Flat" gloss agent. These steps ensure that the gloss will be even across the print surface and that no matte (nonreflective) spots will destroy the effect.

Spotting Color Prints. Spotting black and white prints is relatively easy because you have to be concerned only with the darkness of the dye within a relatively narrow range of hues from brown-black to blue-black. Color prints require that you be concerned with the full spectrum of hues. Both Marshall's and Berg Color-Tone make complete sets of dyes and provide instructions for their use.

Texturizing and Mounting. Seal, the leading dry mount company, has introduced a product called "Exhibitex" that can be used to obtain interesting effects. The process allows you to mount the print to a wide variety of materials, including cloth. The print will pick up the surface texture of the material to which it is mounted. In this way prints can be given the surface texture of silk, canvas, or any other textured material. The process requires the use of a dry mount press.

Spotting the Print. One of the major problems resulting from small format 35mm film is that the degree of enlargement needed to make a print of even moderate size also causes dust on the negative to be enlarged. These flaws appear on the print as white spots or lines and can rarely be totally eliminated by darkroom cleanliness. The only solution is to learn how to "spot" the prints with dyes made especially for that purpose. Retouch Methods Co., which makes Spotone, is the leader in this field and makes dyes that can be mixed to match almost any black and white print tone. The dyes are applied to the print using fine sable brushes.

Coloring the Prints. Black and white prints can be colored by hand using either colored pencils or paints made especially for this purpose. The leading supplier is Marshall, which supplies a wide range of print coloring materials. These colors usually work best on papers with a nonglossy surface texture so if you have a specific image in mind to be colored it's best to buy the set of colors and read the instructions before making the actual print with which you will experiment. The colors are easy to use and their transparent nature allows the fine details of the print to show through.

Changing the Surface of the Print. In addition to selecting a paper surface before making a print, you can also change it to some extent after the print has been made. The surface reflectivity of glossy paper can be matte or semi-matte in appearance. Cibachrome and others make a variety of sprays that can be applied to the print surface to change its degree of gloss.

Index _____

Abbott, Berenice, 16-17
Accessories, wet side, 123, 132-133
Air cleaner, 114
Air conditioner, 114
Air quality, 114-115
Adams, Ansel, vi
Atget, Eugene, 16

Bathrooms, darkrooms in, 32-33, 100
Braithwaite, Erica, 22
Building, 58-91
 adjustable enlarger base, 112-113
 darkroom interior, 92-119
 electrical work, 82-91
 hanging doors, 62-63
 installing counters, 102-103
 installing partitions, 60-61
 installing sheetrock, 64-65
 light table, 108-109
 plumbing, 66-81
 print drying rack, 104-107
 sink and sink stand, 98-101
 tools required, 58-59, 68, 69, 70-71, 86
Burning, 156, 157

Callahan, Harry, 4-5, 36
Chemical storage, 140-141
Closets, darkrooms in, 28-29
Color printing, 162-169
 color analyzers and calculators, 166-167
 and enlargers, 145, 164-165
 processors, 168-169
 starter darkroom, 162-163
Color prints, spotting of, 180
Comforts, special, 118-119
Construction. See Building
Contact printers, 159
Counter space
 in bathroom darkroom, 32
 in closet darkroom, 28
 in kitchen darkroom, 30
 in workrooms, 36

DeMaio, Joe, 20-21
Design, darkroom, 40
 elevations, 40, 41, 54-55
 layouts, 40, 41, 46
 working drawings, 40
Design cut-outs
 dry side, 46-47
 drying rack, 53
 light trap, 50-52
 wet side, 48-49
Dodging, 156, 157
Dry darkroom, 28
Dry mounting, 174
Dry side
 in bathroom darkroom, 33
 and elevation design, 41, 54-55
 equipment planning checklist, 43
 installing counters and storage, 102-103
 and layout design, 46-47
 in spare room darkroom, 35
Drying frames, building, 106-107
Drying racks, 52-53
 cut-outs for, 53
Dust, problems with, 114, 154

Easels, enlarging, 150-151
1880s, darkrooms of, viii-ix
Electrical wiring, 82-83
 building modular control panel, 90-91
 power requirement calculations, 84-85
 tools and materials for, 86
 wiring the circuits, 88-89
Elevations, 40, 41
Enlargements, 111, 145
Enlarger lenses, 148, 149
 adaptors, 148
 cleaner, 149
 focal length, 148
Enlargers, 144-147
 and aligned image, 146
 in bathroom darkroom, 32, 33
 building adjustable baseboard for, 112-113
 in closet darkroom, 28
 and color printing, 145, 164-165
 in elevation design, 54, 55
 and focusing magnifiers, 152-153
 in kitchen darkroom, 30
 in layout design, 46, 47
 mounting of, 110-111
 and printing black borders, 147
 and print size, 111
 as slide copier, 147
 vibration of, 110
Exhaust vents, 115

Ferrotyping, 180
Film cartridge openers, 135
Film tank agitator, 135
Film tanks and reels, 134-135
Floor mats, 118
Flowmeters, 129, 137
Focusing magnifiers, 152-153
Framing, 178-179

Graduates, 127

Heaters
 immersion, 127
 recirculating, 127
Humidity, regulation of, 114, 115

Instant-load developer, 135

Jackson, William Henry, vi, vii
Jacobs, Lou, 18-19

Kitchens, darkrooms in, 30-31

Layouts, 40, 41
 preparation of, 42-43, 44-45, 46-47
 transferring to floor, 60
Lenses, enlarging, 148-149
Light box. See Light table
Light table, 94, 95, 96
 building, 108-109
Light traps, 50-51, 52
 cut-outs for, 50, 51, 52
Lighting, 166
 in closet darkroom, 28
 circuits, 94-95
 equipment, 96-97
 in workrooms, 36
Light-proofing, 116-117
 in kitchen darkroom, 30

Matting procedures, 176-177
Mounting procedures, 174-175

Negatives
 cleaning of, 154, 155
 drying of, 172
 dusting of, 154, 155
 and enlarger, 145
 storage of, 158-159

Paper safe, 117
Phone, 118
Placement, darkroom, 26-37
Plumbing, 66-69
 in bathroom darkroom, 32
 installing drain, 76-77
 installing supply lines, 74-75
 modular systems, 80-81
 roughing in, 72-73
 tools and materials, 68, 69, 70-71
 typical, 70-71
 unique solutions, 78-79
Print drums, 131
Print dryers, 173
Print drying racks, 52-53
 building, 104-105
 making frames, 106-107
Print finishing
 drying negatives, 172
 framing, 178-179
 matting and storing, 176-177
 mounting, 174-175
 surface effects, 180-181
Print size, increasing, 111, 145
Print tongs, 131
Printing exposure controls, 156-157
Print-viewing lights, 94, 95
 calibrated, 95
Processing equipment, 120-142
Processing trays, 130
Processors, color print, 168-169
Professionals
 darkrooms of, 4-25
 workrooms of, 36, 37
Proof printers, 158-159
Proof sheets, 158

Safelights, 94, 95, 96-97
 test, 117
Savage, Naomi, 12-13, 37
Shaw, Bill Eglon, 22-23
Sieff, Jeanloup, 10-11
Sinks, 122-123
 accessories for, 123
 in bathroom darkroom, 32, 33
 building, 98-101
 in layout design, 48-49
Siskind, Aaron, 6-7
Size, darkroom, 42, 46
Slavin, Neal, 14-15, 37
Smith, W. Eugene, 24-25
Spare room, darkroom in, 34-35
Special comforts, 118-119
Spotting, print, 180-181
Steichen, Edward, 8, 12
Stereo, 118
Storage
 chemicals, 140-141
 in closet darkroom, 28
 negatives, 158-159
 prints, 176
 in wet-side elevation design, 54
 in workrooms, 36
Surface effects, 180-181
Sutcliffe, Frank Meadow, 22

Television, 118
Temperature, 114
Temperature regulation, 126-127
 automatic, 128-129
 equipment, 115, 123, 128
 and plumbing design, 68
Texturizing and mounting, 181
Texture screens, 157
Thermometers, 133
 and temperature regulation, 127, 129
Thermostatic valves, 128
Tice, George, 8-9, 37
Timing systems, 138-139
Timers, 138, 139
 and enlargements, 138, 139
Tools
 for building darkroom, 58-59, 68, 69, 70-71, 86
 for framing prints, 179
 for printing controls, 156, 157
 for print matting, 177
Tray racks, 130

Ventilation
 in closet darkroom, 28
 control of, 114, 115
Ventilator fans, 115
Vibration, enlarger, 110

Washers
 negative, 136
 print, 136, 137
Water baths, 126, 127
Water chiller, 129
Water distiller, 124, 125
Water filters, 124, 125
Water quality, 124-125
Water softener, 125
Weston, Edward, vi
Wet side
 accessories for, 132-133, 138
 and elevation design, 41, 54-55
 equipment planning checklist, 43
 and layout design, 46, 48, 48-49
 in spare room darkroom, 35
Wiring. See Electrical wiring
Work print, 156
Working space
 and layout design, 46
 See also Counter space in workrooms
Workrooms, 36
 equipment planning checklist, 43
 of professionals, 36, 37

List of Manufacturers

ABBEON CAL INC. (115)
123-31G Gray Ave., Santa Barbara, CA 93101

ALSONS CORP.
525 E. Edna Pl., Covina, CA 91723

AMBICO, INC. (130)
101 Horton Ave., Lynbrook, NY 11563

ARISTO GRID LAMP PRODUCTS, INC. (147)
Box 769 A, Port Washington, NY 11050

ARKAY CO. (123, 127, 130, 137, 159)
228 South First St., Milwaukee, WI 53204

BEL-ART PRODUCTS (127, 132)
6 Industrial Rd., Pequannock, NJ 07440

BERG (180)
P.O. Box 16, East Amherst, NY 14051

BERKEY MARKETING CO. (131, 134, 139, 147, 149, 152, 156, 169, 173)
25-20 Brooklyn-Queens Expressway West, Woodside, NY 11377

BESELER PHOTO MARKETING CO., INC. (146, 155, 163, 165)
8 Fernwood Road, Florham Park, NJ 07932

BESTWELL OPTICAL INSTRUMENT CO. (153)
209 Beverly Rd., Brooklyn, NY 11218

BLACK & DECKER (59)
701 E. Joppa Rd., Towson, MD 21204

BOGEN PHOTO CORP. (149, 174)
100 S. Van Brunt St., Englewood, NJ 07631

PATERSON/BRAUN NORTH AMERICA (132, 134, 136, 153, 173)
55 Cambridge Parkway, Cambridge, MA 02142

BROOKSTONE CORP. (179)
122 Vose Farm Rd., Peterborough, NH 03458

BURKE & JAMES, INC. (117)
44 Burlews Ct., Hackensack, NJ 07601

BURLEIGH BROOKS OPTICS, INC. (134)
44 Burlews Ct., Hackensack, NJ 07601

CALIFORNIA STAINLESS MFG. (129)
212 Eucalyptus Dr., El Segundo, CA 90245

CALUMET SCIENTIFIC, INC. (122)
1590 Touhy Ave., Elk Grove, IL 60007

CHEMICAL PRODUCTS CO. (97)
10 Beach St., North Warren, PA 16365

CODA INC. (175)
196 Greenwood Ave., Midland Park, NJ 07432

COLENTA AMERICA CORP. (113)
20 Powers Dr., Paramus, NJ 07652

COLOURTRONIC (166, 168)
9716 Cozycroft Ave., Chatsworth, CA 91311

COSAR-MORNICK, COSAR CORP. (162, 165, 167)
3121 Benton St., Garland, TX 75042

DAHLE U.S.A., INC. (177)
Commerce Park, Danbury, CT 06801

DAX MANUFACTURERS, INC. (178)
432 East 91 St., New York, NY 10028

DEPTH-OF-FIELD PHOTOGRAPHIC (173, 176)
P.O. Box 141, Madison, WI 53703

DIMCO-GRAY CO. (138)
8200 S. Suburban Rd., Centerville, OH 45459

DISCWASHER, INC. (155)
1407 N. Providence Rd., Columbia, MO 65201

DSA/PHOTOTECH, INC. (172)
906 Jonathon Dr., Madison, WI 53713

EASTMAN KODAK CO. (96, 97, 124, 133, 137, 139, 141, 151, 156, 167, 169)
343 State St., Rochester, NY 14605

EAST STREET GALLERY (137, 173)
723 State St., Grinnell, IA 50112

EDMUND SCIENTIFIC CO. (96, 124)
7782 Edscorp Bldg., Barrington, NJ 08007

EDWAL SCIENTIFIC PRODUCTS CORP. (124, 149, 180)
12120 S. Peoria St., Chicago, IL 60643

EHRENREICH PHOTO-OPTICAL INDUSTRIES, INC. (96, 125, 135, 157, 169, 172)
101 Crossways Park West, Woodbury, NY 11797

ELECTROTHERM, ELECTROMEDICS INC. (133)
2000 S. Quebec St., Denver, CO 80231

ELJER PLUMBINGWARE, WALLACE MURRAY CORP. (123)
3 Gateway Center, Pittsburgh, PA 15222

FALCON SAFETY PRODUCTS, INC. (140, 154, 175)
1137 Route 22, Mountainside, NJ 07092

FILTERITE CORP. (71)
2033 Greenspring Dr., Timonium, MD 21093

A.J. GANZ CO. (151)
115 N. LaBrea Ave., Hollywood, CA 90036

HANSON CYCLE SELECT (135)
3422 Dover Rd., Cheyenne, WY 82001

RUSSELL HARRINGTON CUTLERY (177)
Southbridge, MA 01550

HUDEE MANUFACTURING CO. (108, 109)
2254 Valdina, Dallas, TX 75207

ILFORD CIBACHROME, INC. (162, 165, 181)
70 West Century Rd., Paramus, NJ 07652

INDUSTRIAL TIMER CORP. (139)
US Highway 287, Parsippany, NJ 07054

INTERNATIONAL ROGERSOL CORP. (96)
5331 S. Cicero Ave., Chicago, IL 60632

KEARSARGE INDUSTRIES, INC. (139)
1890 Michael Faraday Dr., Reston, VA 22090

KEETON PRODUCTS INTERNATIONAL, INC. (177, 179)
P.O. Box 9442, Jackson, MS 39206

KOHLER CO. (71, 123)
Kohler, WI 53044

LEEDAL, INC. (103, 114, 125, 127, 129, 130, 136, 169)
2929 South Halsted St., Chicago, IL 60608

LIGHT IMPRESSIONS CORP. (176, 177, 178)
P.O. Box 3012, Rochester, NY 14614

J.G. MARSHALL MFG. CO. (180)
167 N. 9 St., Brooklyn, NY 11211

MAXWELL PHOTO-MURAL TANKS (131)
999 E. Valley Blvd. #6, Alhambra, CA 91801

METZGER STUDIOS (31, 155)
Rochester, NY

MEYNELL VALVES, INC. (128)
58 State St., Westbury, NY 11590

NALGENE CO. (132, 140, 141)
P.O. Box 365, Rochester, NY 14602

NIBCO, INC. (70, 71, 74, 75)
500 Simpson Ave., Elkhart, IN 46514

NIELSON MOULDING DESIGN (178)
Townsend, MA 01469

NORD PHOTO ENGINEERING, INC. (169)
529 South 7 St., Minneapolis, MN 55415

NU ARC CO., INC (122, 123)
4100 W. Grand Ave., Chicago, IL 60651

NUCLEAR PRODUCTS CO. (155)
P.O. Box 5178, El Monte, CA 91734

PFEFER PRODUCTS (32, 127, 137)
485 Easy St., Simi Valley, CA 93065

PHOTO MATERIALS CO. (117, 132, 150, 172, 173)
500 N. Spaulding Ave., Chicago, IL 60624

PHOTOQUIP INC. (130, 131)
P.O. Box 732, Fernandina Beach, FL 32034

PHOTO-THERM (127, 129)
110 Sewell Ave., Trenton, NJ 08610

E.W. PIKE & CO., INC. (97)
P.O. Box 4, Elizabeth, NJ 07207

PORTER'S CAMERA STORE, INC. (96, 113, 115, 135, 141, 148, 155)
Box 628, Cedar Falls, IA 50613

PRINT FILE CO. (159)
P.O. Box 100, Schenectady, NY 12304

RETOUCH METHODS CO. (181)
P.O. Box 345, Chatham, NJ 07928

REYNOLDS METAL CO. (107)
Richmond, VA 23261

RITZ CAMERA CENTERS (130)
11710 Baltimore Ave., Beltsville, MD 20705

ROCKWELL INTERNATIONAL (58)
Suite 600, Poplar Towers, Memphis, TN 38138

ROLLEI OF AMERICA, INC. (117, 135)
5501 S. Broadway, Littleton, CO 80121

SAUNDERS PHOTO/GRAPHIC, INC. (150, 151, 158, 163, 177)
P.O. Box 11, Rochester, NY 14601

SCHNEIDER CORP. OF AMERICA (148, 149)
185 Willis Ave., Mineola, NY 11501

SEAL, INC. (181)
251 Roosevelt Dr., Derby, CT 06418

SPIRATONE, INC. (115)
135-06 Northern Blvd., Flushing, NY 11354

THE STANLEY WORKS (58, 59, 106)
Box 1800, New Britain, CT 06050

STEARLING-HOWARD CORP. (108)
236C South Station, Yonkers, NY 10705

TEAMWORKS (137)
Box 485, Newhall, CA 91322

TESTRITE INSTRUMENT CO., INC. (157)
135 Monroe St., Newark, NJ 07105

THOMAS INSTRUMENT CO. (97, 153)
1313 Belleview Ave., Charlottesville, VA 22901

3M COMMERCIAL TAPE DIV. (174)
P.O. Box 33600, St. Paul, MN 55133

UNICOLOR DIVISION, PHOTO SYSTEMS, INC. (168)
7200 W. Huron River Dr., Dexter, MI 48130

UNITED STATES GYPSUM CO. (64, 65)
101 S. Wacker Dr., Chicago, IL 60606

VIVITAR CORP. (138, 146, 165)
1630 Stewart St., Santa Monica, CA 90406

WEBSTONE CO., DIV. OF GODDARD INDUSTRIES (79)
38 Harlow St., Worcester, MA 01650

The numbers in parentheses refer to the page numbers on which the product or products appear.